BUONA PART.

Eugène Delacroix
Prints, Politics and Satire
1814–1822

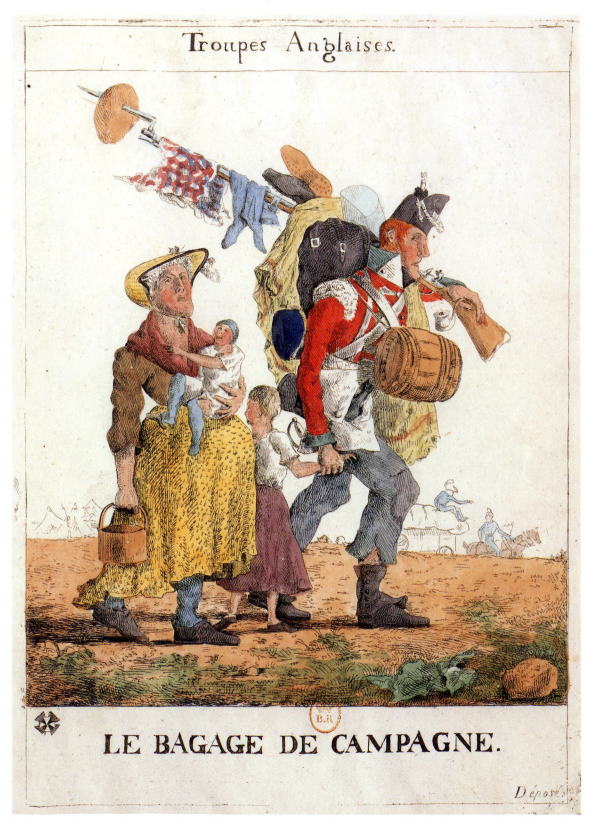

LE BAGAGE DE CAMPAGNE.

Delacroix, *Troupes anglaises. Le bagage de campagne*, 1815. Etching, Paris, Bibliothèque Nationale, Cabinet des Estampes.

EUGÈNE DELACROIX

Prints, Politics and Satire
1814–1822

Nina Maria Athanassoglou-Kallmyer

Yale University Press
New Haven and London
1991

Designed by Mary Carruthers
Set in Linotron Bembo by Excel Typesetter Ltd., Hong Kong
Printed by Kwong Fat Offset Printing Company Ltd, Hong Kong

Library of Congress Cataloging-in-Publication Data

Athanassoglou-Kallmyer, Nina M.
 Eugène Delacroix: prints, politics, and satire (1814–1822) / Nina
Maria Athanassoglou-Kallmyer.
 p. cm.
 Includes bibliographical references and index.
 ISBN 0-300-04931-5
 1. Delacroix, Eugène, 1798–1863 – Political and social views.
 2. French wit and humor, Art – Pictorial – History – 19th century.
 3. France – History – Restoration, 1814–1830 – Caricatures and
cartoons. I. Title.
NC1499.D36A9 1991
741.5′092 – dc20 90-49494
 CIP

Endpapers: Delacroix, *Buonaparte* and other sketches (detail), 1814.
Paris, Bibliothèque Nationale, Cabinet des Estampes.

CONTENTS

In a way that is how history has always been studied. The making visible of what was previously unseen can sometimes be the effect of using a magnifying instrument . . . But to make visible the unseen can also mean a change of level, addressing oneself to a layer of material which had hitherto had no pertinence for history, and which had not been recognized as having any moral, aesthetic, political or historical value.

<div style="text-align: right">

Michel Foucault, Power/Knowledge, *New York, 1980, pp. 50–1*

</div>

ACKNOWLEDGMENTS

This book grew out of a conviction that marginal and even whimsical forms of artistic expression matter; and that the periphery defines the center as much as it is defined by it.

The Swann Foundation for Caricature and Cartoon generously provided funds for research trips to France and England, and covered most of the photograph and reproduction costs.

The manuscript was read and helpfully criticized in its various stages by Petra Chu, Lorenz Eitner, Suzanne Lindsay and James Rubin. John McCoubrey, Beatrice Farwell, Robert J. Goldstein and Lee Johnson offered valuable advice.

Christine Brousseau and Evelyne Dubois-Courchinoux, making good of decades of friendship, provided sustenance of all sorts in Paris. To Yale University Press and John Nicoll I am, as always, most thankful. Mary Carruthers contributed her editorial experience and good taste.

My husband, Neil, who laughed with Delacroix's wit and Restoration satire as he read along, gave me more encouragement than he knows.

INTRODUCTION
"Péchés de jeunesse"

THIS BOOK EXAMINES a neglected body of work in Eugène Delacroix's well-studied *oeuvre*: his sixteen political cartoons, five etchings and eleven lithographs, created between 1814 and 1822.[1] This was the only cartooning episode in Delacroix's entire career. After 1822, he never touched caricature again. All but one of these prints were offered for sale, either as separate pieces marketed by Parisian publishers-printsellers, such as Martinet, Motte and Langlumé, or as special "bonuses," offered to the subscribers of the anti-government paper *Le Miroir des spectacles, des lettres, des moeurs et des arts* with which Delacroix collaborated from May 1821 to May 1822.

Although dutifully listed through the years by the eminent cataloguers of his work, including Adolphe Moreau,[2] Alfred Robaut[3] and Loys Delteil,[4] Delacroix's caricatures have so far attracted little scholarly attention. This is in no way surprising. Caricature's topical and recondite nature has, as a rule, constituted an armory, in E. H. Gombrich's words, formidable enough to defy art-historical investigation, a riddle left to the dissecting care of the historian and the archivist.[5] In addition to this, the traditional ranking of caricature among the marginal "low" genres, with respect to "high art," has been the cause for a longstanding prejudicial view of the cartoonist's work which only recent scholarship has undertaken to abolish.[6]

In Delacroix's case, the dilemma confronted by earlier scholars was also one of incongruity: Delacroix's youthful graphic works, mundane in content and grotesque in form, appeared as not only the absolute negation of the sublime aspirations of his paintings, but also, in their lighthearted irreverence, as unfortunate blemishes defacing the lofty image of the artist respectfully preserved by his biographers. So that when they were not altogether ignored, the cartoons were dismissed as an aberration, inconsistent with the rest of Delacroix's output and injurious to his memory. Yorick had to step in the shadow of Hamlet.

Thus Achille Piron[7] and Philippe Burty[8] only briefly mentioned them in their attempt to retrace the archaeology of the artist's beginnings. Raymond Escholier dubbed them "youthful sins [*péchés de jeunesse*]" unworthy of the great painter.[9] Ernest Chesneau criticized their lack of technical skill and cited them, with relief, as evidence of Delacroix's inability to come to terms with the lowly

realities addressed by satire.[10] In the same vein, Eugène Véron declared that "caricature was not the right field for this proud genius [*n'était pas le fait de ce fier génie*]."[11] Nearly three decades later, Étienne Moreau-Nélaton still agreed that "in the field of caricature, he [Delacroix] is not at home. His imagination rambles, and his drawing loses its originality. *La Consultation*, one of the best pieces of the lot, is nevertheless no more than a macabre satire, more grotesque than witty, and devoid of all artistic spirit."[12] More recent monographs by Frank A. Trapp and Maurice Sérullaz, among others, reflect such attitudes in their partial or total neglect of the cartoons.[13]

So far, the only comprehensive study of Delacroix's graphic satire is Jean Laran's short article "Péchés de jeunesse d'Eugène Delacroix," published in 1930.[14] In many respects this is a pioneer essay, for it is first to acknowledge the caricatures as a special and meaningful body of images in Delacroix's output, while also fruitfully re-examining issues of dating and authenticity. But aside from this, Laran makes no significant progress in deciphering and interpreting his intriguing subjects, nor does he discuss their function as documents with political and social value, or their role in Delacroix's career and aesthetic development. Ultimately, his overall attitude toward the cartoons does not differ from mainstream Delacroix scholarship. Even his title, with its appropriation of Escholier's dismissive definition of the cartoons as youthful sins, only reinforces the prejudicial sanctions of other Delacroix scholars.

Such sanctions purport to ignore or even directly to counter the esteem, allegedly, in which Delacroix himself, years later, mature and successful, held his youthful satirical works. Granted, he did occasionaly mention one or two of them disparagingly as "a horrible lithograph of my own style," or as "very obscure and unworthy of attention,"[15] but more often still he stressed their importance as heralds of later developments, and to Philippe Burty he insisted that they all be included in the comprehensive catalog of his graphic work. For, he explained, "even the earliest among them contains precious seeds [*germes précieux*] especially [the cartoon] *La Consultation*."[16]

Insisting on the commercial nature of the undertaking is one way in which earlier studies have attempted to justify the annoying presence of the cartoons. In his youth, they argue, Delacroix, struggling and impecunious, supplemented his small income by making and selling cartoons to printshops and satirical dailies.

This, to a degree, is undoubtedly true. Delacroix's foray into caricature unraveled against the setting of national disaster and economic disarray of post-Napoleonic France, as well as against the more personal context of family hardship. At the time of his first experiment with etching, in 1814, Delacroix's situation was undergoing a critical shift. His father, a prefect of the Empire, had died in 1805 and since that time the young Eugène and his mother had been living on a civil servant's by no means generous pension. Of his two older brothers, one, Henry, had fallen on the imperial battlefields; the other, Charles, a general of the Empire, was put on half pay by the Restoration regime. His mother's death, in September 1814, when he was just sixteen and a student at the Lycée Impérial (renamed Lycée Louis-le-Grand during the Restoration), left him to the grudging care of his older sister, Henriette de Verninac. Henriette, married to Raymond de Verninac de Saint-Maur, was herself in financial straits. Although Raymond had had a brilliant début, as a diplomat under the Revolu-

tion and the Directory and as a prefect under the Consulate, he had fallen into disgrace with the Emperor at about the time his father-in-law had died. His career floundered, and even his efforts to re-enter the political limelight as a deputy under the Restoration fell through. This probably accounts for Henriette's tightfisted managing of the family finances and for the young Delacroix's worries. It also explains the Verninacs' decision, around 1816, to leave Paris and take residence in their country estate at the Forest of Boixe, near Mansle in the Charente region, where the cost of living would be lower and Raymond would be able to start a profitable agricultural business. Delacroix, already attending Pierre Guérin's studio since 1815 and enrolled, since March 1816, at the École des Beaux-Arts (where Guérin was soon to be appointed professor as well), stayed behind in the family apartment, at 114, rue de l'Université. Since 1815 he had begun doing caricatural drawings for sale. After his sister left, he supplemented his exiguous allowance with the proceeds of more caricatures (although we have no record of what Delacroix was payed for his drawings, it could not have been much given that caricatures sold for a few sous. In 1824, Delacroix himself mentions purchasing an engraving after Raphael for just 10 sous. Caricatures would have sold for far less than that.) He was still in Guérin's studio when he received his first commission, in 1819, for *Our Lady of the Harvest*, a painting for the parish church of Orcemont, near Rambouillet. It brought him a paltry 15 francs, enough to pay for a few meals and even fewer sessions with the model. (His modest daily expenses, recorded in his diary in 1822, show that a meal would cost him a little more than 1 franc, while his models received 5 francs a day.) Along with caricatures, he also now executed mechanical drawings to illustrate engineering invention patents, another contingency device. His next major work, the *Triumph of Religion*, destined for the Cathedral of Nantes, was a state commission passed on to him in the summer of 1820 by Géricault, whom he had met at Guérin's a few years earlier. Delacroix completed it in late 1821 and, some time in 1822, must have received at least half of the 2,400 francs that the state paid to Géricault.[17] By that time he was also regularly contributing lithographic cartoons to the *Miroir* and, although we do not know the exact sum each piece fetched, his financial situation must have eased up somewhat. The purchase by the state of his *Barque of Dante* for 2,000 francs, at the Salon of 1822, signaled the end of his days of need. Significantly, the cartoons come to a standstill that same year.

But mercenary imperatives, no matter how powerful, are certainly not the sole prompting force behind the cartoons. To earn a living, Delacroix could have exerted his skills in a variety of commercial imagery, other than political caricature: he could have, for example, produced fashion prints for ladies' magazines, like his contemporary Horace Vernet, or caricatures of social customs and picturesque types like Pigal, or even anecdotal genre scenes like Boilly and erotic fantasies like Achille Devéria.

Without denying its commercial motivation, Delacroix's interest in political cartooning is, I believe, a more significant affair. First, as my study shows, a close reading of the cartoons against the events and ideas of Restoration political and cultural life and the satirical mythology they gave rise to confirms, substantiates and amplifies previous suggestions regarding Delacroix's youthful radicalism.[18] As opposed to the relative ideological ambiguity of his early

paintings, for example, the cartoons and caricatural drawings related to them contain Delacroix's most explicit and violent statements against royalty, court, nobility and clergy. In them Delacroix openly declared himself the defender of the values of a Liberal Bonapartist bourgeoisie, born of the Enlightenment and the Revolution and adamantly opposed to the revival, after 1815, of an aristocratic ideal with Ancien Régime overtones.[19] It is as part of this proud Liberal and bourgeois identity, that Delacroix the cartoonist embraced with enthusiasm the modern era and its belief in progress, renovation and a democratic meritocracy (ideas, in fact, that he would later renounce in part or totally). It is from such a position, too, that he heaped satirical scorn on the conservative old guard that he associated with political, intellectual and aesthetic reaction.

A member of the rebellious *jeunesse bourgeoise* in quest of novelty and modernity, in his cartoons Delacroix waged war against classicism in its officially sponsored post-Davidian and academic form. Along with fellow Liberals, such as Stendhal with whom he collaborated at the *Miroir*, as I show, as early as 1821, he regarded academic classicism as representative of the loathed political reactionaries. He consciously and militantly, therefore, opted for romanticism, a movement rife with the innovative promises of the new age. Caricature, a genre transgressive in both content and form, proved an ideally suited medium for jointly combating ideological and aesthetic obsolescence.

My study also places Delacroix as a maker of caricatures within the context of current ideas about the tragic/comic duality of the romantic hero, and the caricatures themselves within the continuing theoretical debate, spurred by the emerging romantic movement, over the aesthetic value of the grotesque as the antithetical complement of the sublime. Developments in romantic perceptions of the comic, comedy and laughter, moreover, show that in their fusion of purposeful, realistic satire and wildly surreal imaginativeness the cartoons embodied the new idea of a militant romantic comic advocated by Stendhal and exemplified by fellow Restoration radicals and satirists, such as the poet Pierre-Jean Béranger and the pamphletist Paul-Louis Courier. An attempt to link Delacroix's caricatures to aspects of his later prints and paintings concludes the study.

With the exception of Chapters 1 and 7, the organization of this book revolves around the cartoons as single pieces or grouped according to related thematic and ideological concerns. Such a structure inevitably calls for a breakdown of the chronological sequence of the prints. A first Appendix, a checklist of Delacroix's caricatures, restitutes the prints to their rightful order in time. A second Appendix reproduces the explanatory texts which accompanied Delacroix's lithographs for the *Miroir* and from which I have only partly quoted in the main body of my text. The titles of the prints conform to the style of their original captions; titles of paintings have been translated into English.

Focusing attention on Delacroix's early cartoons has also allowed for a broader view of Restoration caricature in general. This period is perhaps one of the least explored – especially in comparison with its two neighboring eras, the Revolution and the July Monarchy – from the point of view of graphic satire.[20] Considered in context, Delacroix's caricatures fall right into the mainstream of Restoration satirical imagery, and show that the artist was not only in tune with the current themes and the visual and verbal conventions of graphic satire, but

was also shrewdly aware of the political and social realities of his day. Despite romanticism and idealism, these are the works of no starry-eyed youth.

In the end, however, and like any study of past satire, this book aims at an almost unattainable goal: for in its concern with the means by which caricature conveyed message and mirth in early nineteenth-century France, it attempts to recapture a notion as elusive and fragile as the sense of humor of a vanished age.

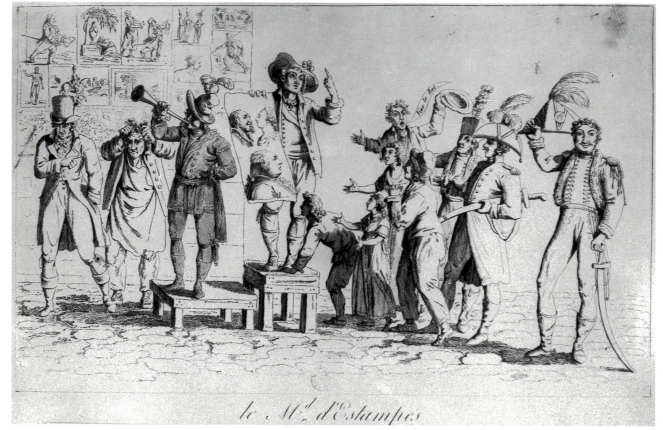

1. Anonymous, *Le Marchand d' estampes*. Etching, Paris, Bibliothèque Nationale, Cabinet des Estampes.

CHAPTER 1
Prints, Politics and Satire under the Restoration

> Caricature, along with the newspaper, is the cry of the citizens. What these cannot express is translated by men whose mission is to shed light on the intimate sentiments of the people.
>
> Champfleury, *Histoire de la caricature moderne*, Paris, n. d., p. vii

IN 1815, A VISITOR, strolling through the crowded boulevards and quais of Paris, would be met with a captivating sight: for there, tightly lining the windows of bookstores and printshops or hanging in the open-air stalls of *colporteurs*, a bewildering patchwork of printed images, etchings, engravings, aquatints and lithographs would be vying for his attention (Fig. 1). There would be stately portraits of the recently restored Bourbon King Louis XVIII, of his martyred brother Louis XVI, and royal family members; scenes from military life, humorous or heart-rending, featuring tattered Grande-Armée soldiers or strapping officers of the Royal Guard; social or professional types; and illustrations of contemporary life and fashions, witty, sentimental or downright erotic.[1] But, above all, there would be caricatures: "Caricatures multiply by the hundreds," a contemporary journal wrote, "and the groups of curious spectators grow in proportion, crowding quais and boulevards."[2]

Caricatures were indeed among the most visible and popular forms of graphic art: they could be bought for a few sous at printshops or from street hawkers roaming towns and villages; and they could be seen for free pinned on the walls of homes, shops and inns, or exhibited on printshop windows. There, rain or shine, crowds of passers-by would eagerly scan the displays for new arrivals: "Despite pouring rain, Martinet's printshop was besieged by a host of curious spectators who huddled in front of two new caricatures," we read in 1814.[3] And again, in 1820, "The crowds gather in front of Martinet's in order to see a charged portrait of [the actor] Potier in the role of Père Sournois [Father Sneaky]. This caricature, which is especially biting in its perfect resemblance, is by the author of the drawings of the *Observateur des modes*."[4]

The story of caricature, a comic genre developed in the late sixteenth century and used polemically to unmask or combat by ridicule personal, social and political ills, has been told many times. In France, political caricature had its heyday during the Revolution. Despite the establishment of a print censor in 1789, and the reaffirmation of state control of printed images in 1794, in the exhilarating and turbulent atmosphere of these years an avalanche of caricatures serving the interests of conflicting factions circulated unhindered. The revolutionary government itself resorted to cartooning, and commissioned propagandistic anti-English prints.[5] Napoleon's draconian administration, between

1799 and 1814, exerted severe control over political prints. Even so, the verve of satire was not entirely stifled. But the few satirical drawings which braved the imperial police were harshly punished. In general, caricature under the Empire was confined to harmless *scènes de moeurs* and anti-British cartoons, which the administration encouraged in retaliation for the flood of anti-Napoleonic caricatures produced in England by such great masters of the pencil as Gillray and Rowlandson.[6]

With respect to the Empire, the Bourbon Restoration announced itself, at first, as an era of relative freedom for political caricature. The period was one of instability, rapid political shifts, ideological diversity and social restratification, an ideal setting for the emergence of satirical polemic. A brief list of landmark events would include, for example, the first abdication of Napoleon, in April 1814, and the first restoration, in May, of the Bourbon monarchy under Louis XVIII; Napoleon's return to power in the wake of the fleeing Bourbons, in March 1815; the truncated One Hundred Day revival of the Empire and its conclusion in the débâcle of Waterloo, in June 1815; and the second Bourbon restoration in July of that same year. A constitutional charter provided for an elective government and a bicameral parliamentary system. Political passions were channeled into loosely structured factions, right (Ultra), center (Doctrinaire) and left (Liberal and Bonapartists). Although freedom of the press, proclaimed by article 8 of the Charter, was restored in 1814 and reaffirmed during the Second Restoration in 1815, these same years also saw the establishment of the first restrictive press measures, such as preliminary censorship of newspapers. Some of these restrictions affected printed caricatures as well, especially laws passed in October 1817 and May 1819, which stipulated obligatory deposit with the state of all satirical prints, and imposed penalties on the production and sale of "seditious" images.[7]

Despite such sanctions, political satire flourished. Formulated in caricature's elliptic idiom, opposing ideologies competed for the eye and the allegiances of the passer-by. In 1819, a newspaper observed that:

> The war of caricatures has not slowed down. It could make the subject of a special issue. The Ultras have attempted to pay back the Liberals by awarding them some of the features which the latter used in order to attack them; but for this they [the Ultras] must strain their imagination enormously, whereas it suffices for their adversaries to capture the resemblance.[8]

The shop of the engraver, publisher and printseller Aaron Martinet, in the narrow rue du Coq-Saint-Honoré (now rue Marengo) on the Right Bank, behind the Louvre, was an institution when it came to political caricature.[9] This family printing business with adjoining public reading room (*cabinet de lecture*) had been founded in the eighteenth century. Its specialties were colored etchings and aquatints, but the printshop was also one of the first to embrace lithography as early as 1804 (Fig. 2). In 1804 a descriptive guidebook of Paris singled Martinet's out as one of the best-appointed reading rooms in town, famous, in addition, for

> its ingenious caricatures which are exhibited there and which are, so to speak, periodical. . . Caricatures are present everywhere, but the biggest office is that

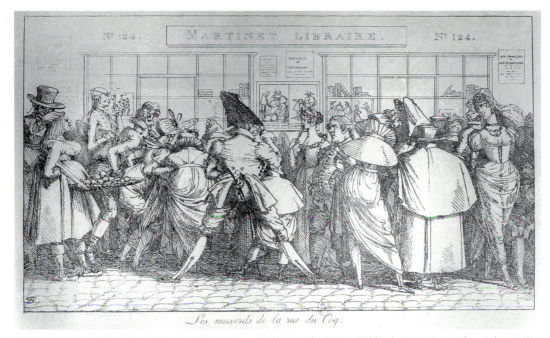

2. Bergeret, *Les Musards de la rue du Coq*, 1805. Lithograph, Paris, Bibliothèque Nationale, Cabinet des Estampes.

of Martinet, rue du Coq. They are issued periodically, every fifteen days; some are pleasant, others moralizing, others bawdy. In general, they are very well drawn and have a great deal of truth.[10]

During the revolutionary outbreak, Aaron Martinet, a progressive follower of the *philosophes* under the Ancien Régime, lashed at aristocracy and clergy with his caricatures. During Napoleon's rule he carefully avoided visual comment on actual events and concentrated, instead, on fashion scenes and anti-British caricatures, the latter in response to the imperial government's wishes. Although he dutifully greeted the Restoration with prints in praise of the Bourbons and their European allies, Martinet's loyalties remained with Bonaparte and the Liberal faction. The majority of his satirical output after 1815 thus poked fun at royalty, Ultras, émigrés and the foreign occupation forces of France, after Waterloo. Prefiguring Charles Philipon and the Maison Aubert's future patronage, Martinet surrounded himself with talented draughtsmen among them Grandville, Carle and Horace Vernet and the young Daumier. Between 1815 and 1817, the shop also published several of Delacroix's caricatures.

Instrumental in the flood of cartoons during the early Restoration was the growing popularity, about the same time, of the developing lithographic medium. Invented in Germany only a few years earlier, in 1799, and introduced into France in the early years of the nineteenth century by Charles-Philibert de Lasteyrie and the Alsatian Godefroy Engelmann, lithography revolutionized the printing trade with its ability to reproduce a design in a virtually unlimited number of copies at low cost. It soon surpassed other current commercial printing techniques – etching, aquatint and mezzotint – eventually causing an unprecedented flood of commercially produced images.[11] Between 1817

and 1825 the number of lithographic printshops in Paris grew spectacularly. Delacroix, whose first experiments in lithography included two orientalizing prints (*The Persian Ambassador* and *The Favorite Slave of the Persian Ambassador*), produced his first lithographic cartoon in 1819. This, along with all but one of his other satirical lithographs, was issued by Charles Motte, the lithographic publisher who was to become the father-in-law of Delacroix's friend, the painter and graphic artist Achille Devéria.

Government tolerance, paired with this eminently fertile and accessible new medium – artists, in fact, needed no special skills in order to work in it – mostly account for the proliferation and broad diffusion of political caricature during these years. From the start, lithography, with its affordability and potential for wide distribution, was enlisted by the Liberal opposition as the vehicle best suited to spread its propagandistic mottos down to the lower strata of the urban and rural masses throughout France.[12] Sentimental evocations of the Napoleonic epic – one of the ideological pillars of Liberal creed – by Géricault, Charlet, Bellangé and Horace Vernet flooded printsellers' windows and stalls. Writing from Paris in 1817 to a friend in Geneva, the Swiss Frédéric-Jacob Lullin de Châteauvieux contrasted the poverty and decay prevailing in post-Napoleonic France with the glorious memory of the imperial age to which a multitude of lithographic evocations – the products of astute Liberal-Bonapartist propaganda – stood as the eloquently silent witnesses:

> The Bonapartists have only lithography on their side but they are using it beautifully. The walls are covered with prints of six sous representing the Old Guard under all its guises. Those among them which are colored feature the tricolor flag; the amounts that sell are unbelievable. Bonaparte is featured in several of them. This party is the only one that has some dignity and knows how to manage its business. The others are just words.[13]

The majority of subversive political prints after 1817 were, indeed, lithographs. This triggered the conservatives' suspicion of the medium, which they voiced in the guise of aesthetic repudiation. In 1819, for example, the royalist *Gazette de France* dubbed lithographic depictions of Napoleonic feats tedious "hyperboles lithographiées."[14] *La Quotidienne*, likewise a monarchist, affirmed her preference for the "art of the burin," and openly declared its contempt for lithography: "Our opinion on this kind of print-making has not changed; we continue to consider it fatal to the art of the burin and we persist in blaming its abusive use in the last two years."[15] To this, the Liberal *Le Constitutionnel* replied:

> A certain political party has such a hatred for anything new, that we would not be surprised to hear out political Tartuffes [hypocrites] exclaim, in an inspired tone, on the subject of lithography: "The end of the world is near; the well of the abyss is gaping; the beast of the Apocalypse is loose. Even the stones speak, and recount to the eyes of the entire world the triumphs of the French armies. Lithography, discovered by a Protestant [i.e. Engelmann], deals the ultimate blow to religion and good morals: it is a real invention of Satan."[16]

The claim for radical lithography, in opposition to conservative-royalist engraving, was supported by the themes of the majority of lithographic prints.

These primarily addressed the concerns of the two social strongholds of Bourbon malcontents: discharged soldiers and officers of Napoleon's Grande-Armée who loitered about in cities and manned the rural countryside, and members of the educated urban and provincial bourgeoisie, a mix of civil servants, merchants, industrialists, doctors, lawyers, shopkeepers and students.

On 16 July 1815 a royal ordinance had disbanded the imperial army which had lent its support to the "Usurper" over the Hundred Days. In the following year, the government proceeded to pare down, reorganize and purify the armed forces by initiating extensive purges of its dissident elements. By 1816 the army, which in its heyday comprised about 500,000, was reduced to a minimum of 150,000 men. More than 300,000 soldiers were sent home and restituted to their previous existence, primarily as peasants in rural regions. At the same time thousands of officers were forced to retire or placed on inactive duty at half-pay (demi-solde). In their stead stepped royal favorites, the sons of the aristocracy or elderly returned émigrés who claimed the highest positions. Although in 1818, under a new military law proposed by War Minister Marshal Gouvion-Saint-Cyr and passed by Parliament, attempts were made, first, to prevent favoritism by strictly regulating promotion, and second to reintegrate Napoleonic veterans by establishing a trained reserve, by 1819 such democratic measures were deliberately ignored. Consequently, discontent ran high both within and without the ranks. On the outside, embittered veterans and idle demi-soldes led a marginal existence as urban paupers or as farmers returned to poorly paid agricultural toil (Delacroix's elder brother Charles was, as we saw, such a half-pay officer wasting away in his land at Le Louroux, near Tours). Within the army, officers experienced the double frustration of peacetime inactivity and slow advancement, the latter further intensified by persisting favoritism on behalf of enrolled members of the nobility. By comparison, the bygone revolutionary and Napoleonic eras of glorious and unlimited opportunity seemed especially alluring. Between 1820 and 1822, veterans, demi-soldes and discontented NCOs were the driving force behind the many conspiracies that attempted, unsuccessfully, to overthrow the monarchy.[17]

These military rejects had their civilian counterparts. The main beneficiaries of the Revolution and former administrative and economic buttresses of the Empire, the bourgeoisie, also saw itself largely upstaged, during the Restoration, by a favored aristocracy. Here the process was a gradual one, however. Conservative, as a rule, the established middle class at first welcomed a constitutional monarchy that guaranteed material prosperity and peace. Under the conciliatory policies of the royal government, the majority of bourgeois civil servants remained in their posts. Given, in addition, the special franchise that made electoral status for an individual conditional upon the amount of yearly taxes he paid, the bourgeois owners of landed property also constituted the larger portion of the electorate.

But these early certainties were promptly eroded by mounting anxiety. First, although previous appointments were, indeed, being honored, virtually no new nominations to civil positions of privilege, the monopoly of the middle classes under the Empire, were made from the bourgeoisie. For example, all Restoration diplomatic appointments went to nobles, and 70 per cent of the new prefectoral nominations were made from the ranks of the aristocracy.[18] Second,

and most alarmingly, at the same time as military purges the Second Restoration undertook a political purification of the bureaucratic establishment as well. The more than 50,000 officials ousted were replaced by members of the nobility. The feeling was strong, therefore, that bourgeois "notables" were quietly but steadily being "phased out." (Delacroix, whose father had been an imperial prefect until his death, may have watched the situation with particular resentment.)[19] To such realizations were added bourgeois worries over the returned aristocracy's property claims. As the main body of *acquéreurs de biens nationaux*, buyers of the nobility's estates that had been confiscated and sold during the Revolution, the wealthy middle class saw with apprehension the incoming émigrés' demands, pressed in Parliament and at court, for a restitution of their pre-revolutionary lands. Fears of impending displacement were compounded, finally, by the confrontation with the social "otherness" of the old nobility. This brought about a sharpening of the bourgeoisie's self-consciousness as a group with a separate social identity manifested in a separate set of values. Thus, to the nobility's belief in monarchy, church, social hierarchy and inherited social and financial privilege, the middle class opposed its egalitarianism, its anti-clericalism and its faith in work, personal merit and individual talent – values reminiscent of the Empire and Napoleon's famous phrase, "careers open to talent."[20] It was therefore mainly discontented members of the middle class who joined the veterans and half-pay officers in the underground of secret societies and plots. Their alliance was the beginning of the solidarity that was to bond Bourgeois and People in the revolutionary days of 1830, and again in 1848.

Especially vulnerable under the new regime was the group of younger middle-class men constituting a highly educated and ambitious *jeunesse bourgeoise*, which historians such as, most recently, Alan Spitzer, have identified as a "cohort" apart, a "Generation of 1820."[21] Their situation, on the threshold of both the bourgeois and the aristocratic establishment, was especially frustrating. Brimming with professional and civic eagerness, they saw themselves as kept out of the professional scene by an older generation already in place, and excluded from the political sector by their youth and their poverty (aside from the necessity of a minimum tax franchise, the minimum voting age was forty). Such discontents found expression in James Fazy's *La Gérontocratie* (1828), a pamphlet indicting the political rule of an elderly oligarchy over France. Fazy argued that under the political and economic leadership of the older generation, these "seven thousand or eight thousand asthmatic, gouty, paralytic eligible candidates with enfeebled faculties," the country's growth was bound to stop. While experience was a valuable contribution of old age, Fazy continued, progress and productivity were the domain of youth.

> But production is only represented by youth that wants to enjoy the leisures of life by offering in exchange its labor. Old age, instead, stubbornly rejects the surge toward productivity, thinking that they would lose their hardwon capital. I am therefore not afraid to maintain that we must attribute all the ills of our time to the absence of youth from political deliberations.[22]

A member of this special cohort, bourgeois, young and poor, Delacroix must have shared the feeling of near impossibility of breaking through the strata above

him. His family ties with Revolution and Empire, moreover, must have made prospects for success under the new royalist regime even dimmer.[23]

Although the old age/youth conflict was experienced by both conservative and liberal *jeunesse bourgeoise*, as a theme it dovetailed with Liberal propaganda claims for an ideology of youth, novelty and modernity that was advantageously opposed to the conservatives' alleged attachment to the ideals and values of the past. Thus the poet Pierre-Jean Béranger, the bard of the Liberal Bonapartist faction, conjured up a futuristic vision of France as a Lilliputian kingdom whose growth had been stunted by its reactionary elderly rulers, the "barbons" – bearded old men but also a pun for "Bourbons" – in his poem "Les Infiniment petits, ou La Gérontocratie" (late 1820s):

> La France est l'ombre du fantôme
> De la France de mes beaux-jours.
> Ce n'est qu'un tout petit royaume;
> Mais les barbons règnent toujours.[24]

In the satirical mythology of the time, a young and fashionably dressed exponent of the bourgeoisie or a sprightly Napoleonic officer became the symbols of the Liberal faction; in turn, the dominant conservative ideology reminiscent of the last century's sociopolitical system was represented by an old aristocrat sporting outdated Ancien Régime fashions. An anonymous caricature of 1819 provides a schematic illustration of these political, generational and sociological dichotomies (Fig. 3).[25] In diptych fashion, it shows, on the right, a *demi-solde* officer pointing out lithographs of Napoleonic military scenes (some done by Vernet and Charlet) to Monsieur Fla-Fla, whose decrepit figure, eighteenth-century dress and wig signal him as an exponent of the aristocratic and Ultra gerontocracy. On the left, the same crochety noble meets with a mischievously smiling young bourgeois who arouses his indignation by asking him if he has read the *Homme gris*, a radical satirical magazine illustrated with caricatures of Monsieur Fla-Fla and his like.

Illustrated satirical journals, such as the *Homme gris*, were, indeed, another outlet for Restoration cartoonists. Delacroix was no exception, in that respect, creating, as we saw, the larger number of his caricatures for one such publication. A pioneer in this genre was *Le Nain jaune*, a left-wing political magazine disguised as a cultural publication. Issued for the first time on 15 December 1814, and reissued every five days thereafter, it assumed the format of a 24-page bound book in octavo that once a month included, in the guise of a frontispiece, a large fold-out caricature, etched and hand-colored. The *Nain jaune*'s irreverent attacks on monarchy, aristocracy and clergy eventually brought about its closure by royal decree, on 15 July 1815. Undaunted, its editor, Louis-Auguste-François Cauchois-Lemaire, took refuge in Brussels from where he published a sequel to his magazine, entitled *Le Nain jaune réfugié*. Smuggled over the border into France, the new *Nain* continued to provoke the government which eventually, using diplomatic channels, contrived its second and final demise, in December 1816. During its brief existence the magazine had published a total of nine colored caricatures whose themes spanned the spectrum of dissident protest, from satire of the conservative press and contemporary theater to exposure of political opportunism and Ultra ineptitude.[26]

7

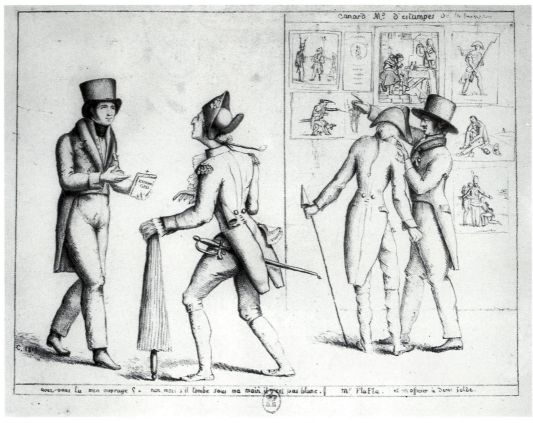

3. Anonymous, *Monsieur Fla-Fla*, 1819. Lithograph, Paris, Bibliothèque Nationale, Cabinet des Estampes.

The idea of a caricature insert launched by the *Nain jaune* was continued in later satirical magazines of both left- and right-wing persuasions. Foremost among the former were the *Homme gris* (1817–18), published by Amédée Féret and Creton, and its successor, the *Nouvel Homme gris* (1818–19), published by the journalist Cugnet de Montarlot (the title was a reference to Napoleon's legendary "redingote grise"). In almost every one of its thirty-six issues, the *Homme gris* offered crude engravings ridiculing aristocracy and clergy. Among the royalist emulations of the *Nain*, *Le Nain couleur de rose* (1815–16) also adopted the practice of periodical caricatural inserts, which it now directed against the Liberals.

The reluctant freedom allowed to political cartooning came to an abrupt end in 1820. That year, the conservative backlash caused by the murder of the duc de Berry by a Bonapartist extremist gave grounds, along with other repressive measures, for a bill establishing censorship for caricatures. Despite vigorous Liberal resistance, the bill was passed by the Chamber of Deputies on 30 March 1820, and was reconfirmed and promulgated as part of the press law of 17 March 1822. In accordance with the new law, "no engraved or lithographed drawings can be published, sold or exhibited without prior authorization from the government, under penalty, for ignoring this provision, of a jail sentence of three to six

months and a fine of 10 to 500 francs, plus possible prosecution resulting from the subject of the drawing.''[27]

The apprehension of the conservative Right regarding the dangerous potential of political caricature is echoed in an essay on the state of the fine arts in France, published in 1820, in Chateaubriand's royalist and clerical *Le Conservateur littéraire*:

> While political parties are actively at war with each other through the newspapers in the reading rooms, bitter fights are taking place on the quais and on the boulevards by means of caricatures. . . Thanks to lithography, the pencil has now become for our polemicists a weapon as swift and as redoubtable as the pen. The only difference is that we can attend these open air skirmishes for free, while we must pay in order to immerse ourselves in the quarrels [that take place] in closed quarters. Caricatures have yet another advantage, they address, so to speak, our instinct, while the newspapers address themselves only to our intelligence. Any illiterate dawdler [*musard*] can grasp perfectly well the intention of these grotesque scenes, and recognizes right away the representatives of every faction that are depicted. But given that he [the dawdler] is not always as well versed in the knowledge of allegories, he is often prey to cruel misunderstandings. By being always confronted with men in priests' cassocks armed with daggers and torches, he is made to think of all the clergy as murderers and arsonists.[28]

Considering the severity of the press laws and the newly voted restrictions on printed images after 1820, it is especially remarkable that yet one more satirical publication, which also issued cartoons, would dare emerge in 1821. This was, however, the case of the *Miroir des spectacles, des lettres, des moeurs et des arts*, the left-wing newspaper to which Delacroix contributed the majority of his lithographic caricatures. The *Miroir* was the brainchild of Cauchois-Lemaire, the former editor of the *Nain jaune*, who had returned from his Belgian exile in 1819 benefiting from the general amnesty proclaimed by the Decazes ministry. On its editorial board sat notorious Bonapartists, such as the playwrights A. V. Arnault, E. Gosse and E. Mercier-Dupaty, and the writers and critics Antoine Jal and Étienne Jouy. Its first issue circulated on 15 February 1821. Just like the *Nain* and other similar publications, the *Miroir* attempted to elude the severe post-publication sanctions that had replaced censorship after 1821, by posting a deceptive literary and cultural front, and by making profuse use of fables, allegories, insinuations and "*allusions*. . . through which it managed to convey to its readers political news or ideas."[29]

A daily, the *Miroir* took on the large quarto format of newspapers. Its caricatures, lithographs on separate single sheets measuring roughly 8″ × 11″, were sent to subscribers or sold individually from the *Miroir*'s editorial offices. They were accompanied by an explanatory notice in the paper's columns. Caution was taken to avoid the print censor: the subjects of the prints varied unpredictably and could just as well be innocent portrayals of popular actors and operatic singers of the day, such as Talma or Nourrit, as charged images attacking the conservative administration and its representatives. And their explanatory texts read, most of the time, like impossible riddles.

Although mindful of government reprisals, the *Miroir* nevertheless bravely

called for outspoken caricatures on political and social themes. In November 1821, for example, it issued an *Appel aux lithographes* in which it invited artists to choose their models from the corrupt and reactionary aristocracy: "What are you thinking of, you artists, who could so usefully employ your pencils? What, no more caricatures? Martinet is calling out to you, the models are willing, and the dawdlers of the rue du Coq do not know where to look for hope. . . ."[30] Elsewhere, again, it called attention to the deeper layers of meaning underlying caricature's intricate symbolism, allusive abbreviations and superficial levity:

Oh! how stupid! We hear this exclamation frequently in society, at the theater, and in front of the shops of printsellers. . . The attentive observer judges, however, with less frivolity, and knowing that we are not allowed to say everything, takes good notice of what is said. There are times when we must read between the lines. Just imagine, for a minute, some *evil geniuses*, which, armed constantly with a sharp steel come to deprive you of half or more of the thoughts you set down on paper. Should you not, then, agree to leave your work unfinished, and should not the intelligence of the reader be made to supplement what is missing? What we have just said must also be applied to caricature; their authors must often resort to bad taste in order to tell a good joke; even more often, they are so compelled to hide their thoughts that these end up eluding the attention of the majority of the strollers stopped in front of Martinet's [printshop]. Therefore, may God help us if we think that, because the number of caricatures is smaller now compared to other, different times, it is the models that are missing; on the contrary, the models are everywhere, they proliferate, they surround us, they stifle us. Far from hiding, they present themselves to our eyes in all kinds of dress: in tails, in embroidered suit, or in uniform. We must, if not admire them, at least endure their presence.[31]

The *Miroir*'s political taunts eventually caused its downfall. Between May 1821 and May 1823 it was summoned to court nine times. Of these, it was acquitted four and condemned five. In June 1823 a court decision pronounced the *Miroir* a political, as opposed to a cultural, publication, and faulted it for not obtaining the preliminary authorization required from political dailies by the current press law. That same year, and as penalty for the same offence, the newspaper was suppressed by ministerial decree. Its end came nearly a year after Delacroix had published his last caricature.

CHAPTER 2
Our Friends, the Enemies

Viv' nos amis,
Nos amis les enn'mis!

P. J. Béranger, *L'Opinion de ces demoiselles* (1815)

IN APRIL 1814, DEFEATED BY the allied forces of Britain, Russia, Prussia and Austria, Napoleon abdicated his throne at Fontainebleau and took the road to Elba, his first place of exile. As the victorious troops streamed into French territory, Louis XVIII – the legitimate Bourbon king – his family and his court entered Paris. In his wake came representatives of the European Powers who had engineered the restoration of the toppled monarchy, as well as members of the old aristocracy who had weathered the Revolution and the Empire in exile. That same year, on the copper bottom of a kitchen-pan, Delacroix, sixteen years old and a *lycée* student, tried his hand at his first print, an etching (Fig. 4).[1] The print also represented his first attempt at caricature.

Makeshift in origin and crude in execution, the etching looks like a notebook page filled with random sketches of apparently unrelated figures. These appear to fall into three distinct groups: in the center is the profile bust of Napoleon wearing the uniform of the *chasseurs* of the imperial guard – the decoration of the Légion d'honneur pinned to his chest – and identified by the inscription "Buonaparte," on the upper right. The Emperor faces toward the right, in the direction of an officer of the imperial cavalry who charges diagonally into the distance. A third group of sketches is located on the left, behind Napoleon's back: we have two caricatural figures, of which the dominant one is that of a hunchback ape in human clothes identified as "Le Bossu."

At first, these humble drawings done on a likewise humble surface seem hardly to deserve attention. Nevertheless, they do represent specific themes, including an accurate portrait of Napoleon, which in 1814 would have carried precise historical and political significance. By the same token, the order and placement of the drawings with relation to one another (center: Emperor; behind him: the ape; in front of him: the galloping horseman) may not be entirely random, and may be governed instead by a loose kind of program, although perhaps not an entirely conscious one. Considering the print, therefore, as more than mere technical experiment and seeking some meaning in its composition and imagery may be in order.

Indeed, if we accept the possibility of a consistent iconographic and compositional thought at work, the disparate sketches acquire inner coherence and seem to collaborate toward a single overall meaning for the picture, much in the

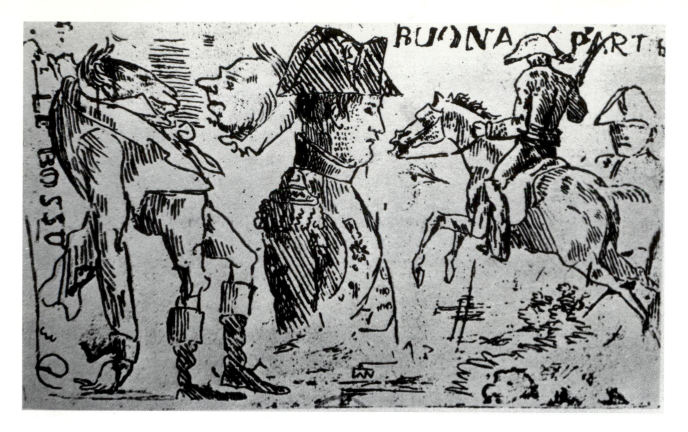

manner of a rebus. In elliptic, emblematic fashion, they may refer to the critical events of 1814: the fall and revilement of the Emperor, the dashed glory of the Grande-Armée, and the advent of a new social order dominated by political speculators.

We enter the scene with the prominently centered bust of Napoleon. Napoleon's gloomy, downcast expression implies distress and, by extension, defeat and failure. The abrupt shift of scale and viewpoint between the imperial bust and its two flanking sets of drawings surrounds the effigy with a sense of isolation which enforces the impression of the fallen Emperor as an outcast, a tragic hero and secular Man of Sorrows.[2] An additional touch of inflicted revilement is represented by the apposition of the Italian version, "Buonaparte," of Napoleon's name. After 1814 the term, which stressed his alien origin, was pointedly used by Napoleon's opponents as a means of invalidating the legitimacy of his claims to the French throne and of denouncing his reign as an aberration in French history. Chateaubriand, at the time Napoleon's implacable foe and most vocal supporter of the Bourbons, used it to this end in his pamphlet *De Buonaparte et des Bourbons* (1814), in which he asked, for example: "Absurd as an administrator, criminal as a politician, what did this foreigner do to seduce the French?"[3] Contrary to Chateaubriand, however, Delacroix's evocation of the Emperor is nostalgic and empathetic, and his use of the denigrating surname adds a poignant note of transient worldly glory to the deposed ruler's effigy.

Napoleon's profile leads to the figure of the galloping officer vanishing into the distant right, perhaps a visionary evocation of the demise of imperial military glory (analogous to Géricault's images of imperial officers on the battlefield).

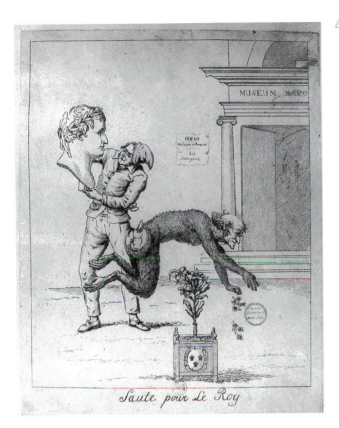

Saute pour Le Roy

4. Delacroix, *Buonaparte* and other sketches, 1814. Etching, Paris, Bibliothèque Nationale, Cabinet des Estampes.

5. Anonymous, *Saute pour le roy*, *c*. 1814. Etching, Paris, Bibliothèque Nationale, Cabinet des Estampes.

This figure too, therefore, would underscore the mood of defeat emanating from the imperial portrait.

Behind Napoleon's bust, the principal figure is that of a slouching humanoid ape in civilian dress. Ape-like caricatures of men, an age-old satirical device, became one of the Restoration opposition's prime symbols for shameless political opportunism. They particularly targeted those disloyal imperial officials who, no sooner had the Emperor relinquished power, hastened – with monkeying agility and fauning – to pledge their troth to the Bourbons. Contemporary cartoons awarded a simian look, for example, to baron Dominique-Vivant Denon, former director of the Musée Napoléon appointed director of the Royal Museums in 1814 (Fig. 5). "M. Dominique-Vivant Denon," a contemporary publication commented ironically, "has conceived such affection for the museum that he has never been able to separate himself from it, not even for an instant."[4] Denon, his profile portrait attached to the lithe body of a monkey, performs a somersault over a potted fleur-de-lis against the background of the museum while – in an emblematic arrangement evocative of Delacroix's etching – the gigantic bust of Napoleon is held up (or taken down from an unseen podium) by a sadly respectful latter-day *sans-culotte* whose presence here may suggest Denon's revolutionary and imperial past. "Jump for the king [Saute pour le roy]," the caption commands, in allusion to Denon's political (and physical) antics.

Delacroix's ape is, in addition, a cripple, a hunchback who seems to walk with difficulty supported by one outsized arm in the guise of a cane.[5] Another obvious candidate for simian identity was Talleyrand, Napoleon's Foreign Minister who was promoted virtually overnight, in 1814, to Prime Minister

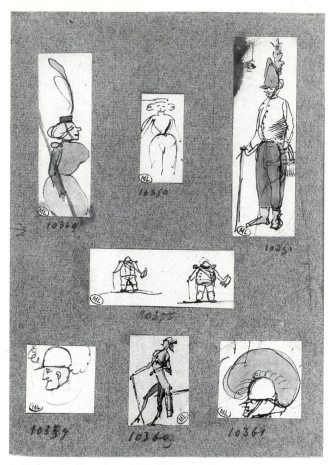

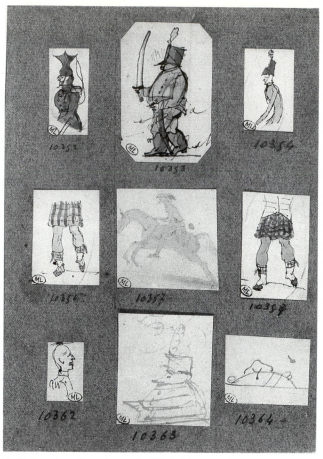

6. Delacroix, *Drawings of Allied Troops and Louis XVIII* (10355). Paris, Musée du Louvre, Cabinet des Dessins (RF 10349–RF 10361).

7. Delacroix, *Drawings of Allied Troops, the comte d'Artois* (10362) *and Louis XVIII* (10364). Paris, Musée du Louvre, Cabinet des Dessins (RF 10352–RF 10364).

8. Anonymous, *Louis XVIII le Désiré, c.* 1814. Lithograph, Paris, Bibliothèque Nationale, Cabinet des Estampes.

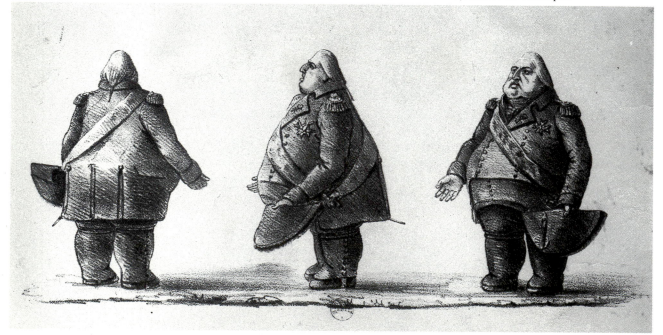

of Louis XVIII. Although not a hunchback, Talleyrand was crippled in one foot and walked with a limp (and a cane), a fact that won him the nickname "Clopineau" (Gimpy). In cartoons, such as *La Grande Consultation* (Fig. 17), which we shall examine later in this chapter, he was often portrayed as a smartly grinning monkey. Apart from alluding to faithless imperial defectors in general, therefore, Delacroix's hunchback ape may be a specific reference to Talleyrand, the crowning genius of his shifty kind, whose diplomatic machinations had partly engineered Napoleon's downfall. If this is indeed so, the ape would not only be a statement of rejection of the crafty politician, but one of disavowal of the man as well, whom biographers have at times designated as, possibly, Delacroix's natural father and later unacknowledged benefactor.[6]

Numerous satirical drawings of 1818–20 bear witness to the young Delacroix's Liberal Bonapartist sympathies and, conversely, to his distaste for royalty, aristocracy and clergy. Thus amidst sketches of figures in extravagantly fashionable clothes and humorous profiles of contemporaries, we have, less innocuously, insolent references to the two mighty Bourbon institutions, the monarchy and the church. The portly and gout-ridden Louis XVIII appears as a faceless and obese stuffed mannequin (Fig. 6), a favorite theme of contemporary anti-royalist caricature (Fig. 8). His brother and leader of the Ultra royalist faction, the comte d'Artois, grins vapidly baring a set of grid-like teeth (Fig. 7). A nobleman in breeches, tails and wig arrogantly arches his lithe silhouette (Fig. 6). About the same time, around 1815–16, Delacroix was setting down his distaste for court and aristocracy in a short novel, the product of his early aspirations toward a career in literature, rather than painting. Titled *Les Dangers de la cour*, it was a Rousseauesque tale of the tribulations of a young Swiss, a child of nature grown in the region of the Alps, employed as a secretary at the court of Sardinia where he is ruthlessly and cruelly exploited by scheming nobles, including a royal prince. The novel gave a grim view of court ethics:

> The Court is one of the most despicable inventions of man. The Court is a nest of intrigues, of ambitions, of lowliness, where the most detestable projects are being continuously concocted, where conspiracies, plots and factions are fomented all the time. . . Seeing the courtiers carefully watch one another and pretend toward the appearance of a virtue that everyone knows they do not possess, one could be deceived for a while by such externals. But a closer look reveals the falseness and the contrivance. Vice shows through everything.[7]

But it was mostly the church, in its heyday during the Restoration when Catholicism was declared the official state religion by the Charter, that became the butt of his most fierce verve. In yet another youthful novel, *Alfred* (c. 1814), Delacroix had constructed an ominous plot of love, loyalty, abduction, murder and suicide revolving around an "evil genius," a priest described as "homme vif et adroit" who does not hesitate to resort to lies and crime in order to achieve his somber goals.[8] Priests appear in no better light in his satirical drawings. They are turned into grim and scowling figures reminiscent of Goya (Figs 9, 10) and reflecting contemporary anti-clerical evocations of the Catholic priesthood (Fig.

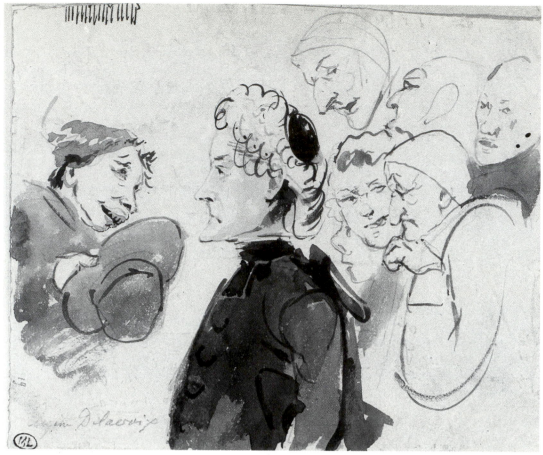

9. Delacroix, *Priests and Monks*. Drawing, Paris, Musée du Louvre, Cabinet des Dessins (RF 10207).

10. Delacroix, *Priest*. Drawing, Paris, Musée du Louvre, Cabinet des Dessins (RF 10258).

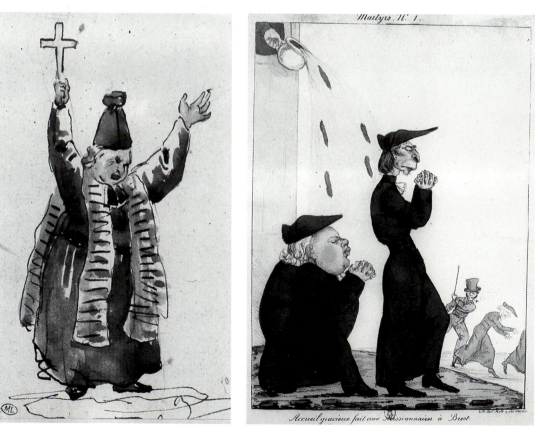

11. Anonymous, *Accueil gracieux fait aux missionnaires à Brest*. Aquatint, Paris, Bibliothèque Nationale, Cabinet des Estampes.

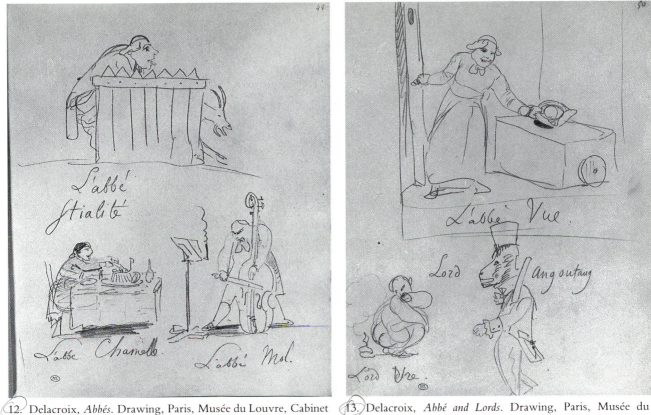

12. Delacroix, *Abbés*. Drawing, Paris, Musée du Louvre, Cabinet des Dessins (RF 9140 folio 48).

13. Delacroix, *Abbé and Lords*. Drawing, Paris, Musée du Louvre, Cabinet des Dessins (RF 9140 folio 50).

11). In witty visual puns and rebuses, *abbés* and monks are dubbed with derisive names or made to perform humiliating tasks that underscore their stupid and vicious nature. In one drawing, a cello-playing priest is called *L'abbé Mol*, an allusion to musical terminology (*La bémol* = the note A Flat), but also to the disparaging *mol*, soft, spineless (Fig. 12 right); in another, inscribed *L'abbé Vue*, a priest is caught red-handed commiting a blunder (*bévue*) (Fig. 13 top); in yet another, an indictment of clerical material greed, *L'abbé Chamelle* spoons into an enormous dish of béchamel sauce (Fig. 12 left), while the lewd *L'abbé Stialité* (Father Bestiality) sexually assaults a goat behind the near-privacy of a fence (Fig. 12 top).[9] These drawings echoed specific anti-clerical themes, especially accusations of priestly voracity and perversion, diffused by the Liberal opposition. Thus in his satirical "chansons," Béranger sang of Jesuit missionaries coveting women and delicacies ("Glous! glous! glous! glous!/ De truffes parfumez Ignace");[10] of a pope frolicking in bed with his maid ("Ce pontife à sa chambrière disait:/ quel bon lit d'édredon! Ma dondon,/ Riez donc,/ Sautez donc");[11] and of priests' alleged homosexual practices ("C'est nous qui fessons,/ Et qui refessons/ Les jolis petits garçons.")[12] In the same vein, Paul-Louis Courier, a classical scholar and confirmed republican turned into the Restoration's greatest pamphletist, writing his virulent denunciations from his rural retreat in the Touraine, dwelled on scandalous *faits-divers* aimed to illustrate the corruption and hypocrisy of the church. One such story involved a boarding-school priest who first seduced and then killed innocent schoolgirls; the other, a village priest who also seduced and murdered his female parishioners: "Were he

17

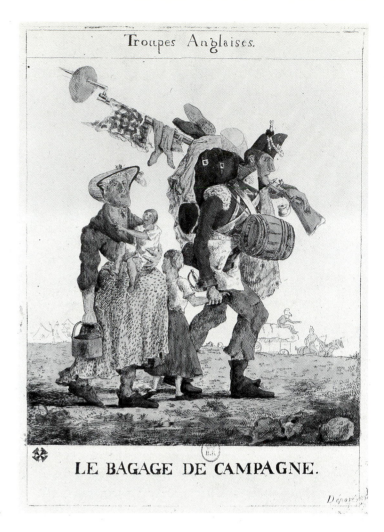

14. Delacroix, *Troupes anglaises.*
Le bagage de campagne, 1815.
Etching, Paris, Bibliothèque
Nationale, Cabinet des Estampes.

to confess another one, young and pretty, and were she to resist him, he will treat her like the others, without losing, for this, the promise of salvation."[13]

Delacroix also shared the Left's conviction that the Bourbon monarchy had been reinstated against the wishes of the French people by the foreign victors of France. Ridiculing the foreign Allies, therefore, was yet another way to indict the monarchy. This is the subject of Delacroix's first published cartoon, *Troupes anglaises. Le bagage de campagne* (Fig. 14), a hand-colored etching issued by Martinet in October 1815.[14] In its anti-British theme, the print falls within the tradition of similar caricatures produced by Martinet under the Empire. This is, however, no mere lighthearted satire of English habits and fashions. Under its humorous surface Delacroix's caricature conceals a layer of mordant poignancy that alludes to the tragic situation of the motherland, humbled, occupied and depleted.

A lanky British soldier straggles ahead laden with his expeditionary equipment, to which the burden of an ambulant household that includes his pregnant wife and two children has been added. The children whimper and pull in all directions. The wife, all jaws and bones, chatters on, an unbearable nag. The soldier's haversack overflows with clothing, shoes and bedlinen. His rifle serves as combined clothes–hanger and food reserve, with socks and a plaid kilt drying

18

on it and a loaf of bread nailed to its bayonet. Suspended from his neck is a barrel of wine. In the distance, more soldiers pull up tents and ride on covered wagons as the troops strike camp.

This was the second time in little more than a year that France knew foreign invasion. Napoleon's return from Elba and his attempt to restore the Empire during the Hundred Days had come to a brutal end at Waterloo, in June 1815. Only days after the defeat, France and its capital were once again occupied by the victorious enemy. As the last debris of the battered Grande-Armée retreated behind the Loire, and Louis XVIII hurriedly returned to Paris from his hideaway in Ghent, Russians passed the Rhine into Alsace, Austrians marched into the Savoie and, in the south, emboldened Spaniards crossed the Pyrenees into French territory. In Paris, Wellington's men camped in the Bois de Boulogne, and Blücher's and Saacken's Prussians and Austrians bivouacked amidst the flowerbeds of the Luxembourg gardens.

French patriotic pride smarted at such sights. Nationalist feeling soared. "The image [of Louis XVIII's second entrance into Paris]," Count Hyde de Neuville remembered, "was sinister, for it was framed by hordes of foreigners who bivouacked on our quais and on our public squares."[15] In his memoirs, Louis Véron recalled "that entry of foreign armies which steeped my family into great sadness and deep terror." He ached at the sight of cossack regiments: "To encounter one of these barbarians in the streets of Paris produced in me a very powerful emotion."[16] In an elegiac *messénienne*, Casimir Delavigne lamented:

> Des soldats de la Germanie
> J'ai vu les coursiers vagabonds
> Dans nos jardins pompeux errer sur les gazons,
> Parmi ces demi-dieux qu'enfanta le génie.
> J'ai vu des bataillons, des tentes, des chars,
> Et l'appareil d'un camp dans le temple des arts.
> Faut-il, muets témoins, dévorer tant d'outrages?[17]

For the Liberals, the blame was all to be put on the monarchy. Napoleon, they argued, had stood for a strong and respected France. Louis XVIII turned her into a despised province of the European Powers. Venality and prostitution became common metaphors for a weakly yielding monarchy and an eagerly consenting nobility. Béranger, for example, cast the occupation of 1815 into a scene of prostitution in which Parisian *cocottes* rejoice at the prospect of a reunion, the second after 1814, with their foreign "clients" (including foreign army commanders Blücher and Saacken), their "friends, the enemies":

> Comme l'argent pleuvait quand les Russes
> F'saient hausser d' prix
> Tout's les filles de Paris!
> . . .
> Mais, puisqu'ils revienn't, faut les attendre.
> Je r'verrons Bulof, Titchakof,
> Et Platof;
> L'bon Saken, dont l'coeur est si tendre,
> Et puis ce cher. . .

19

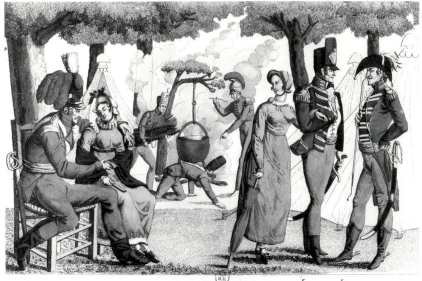

BIVOUAC ANGLAIS AU CHAMPS ÉLISÉES.

Les Meringues du Perron ou Milord la gobe

15. Anonymous, *Bivouac anglais au [sic] Champs Élysées*. Etching, Paris, Bibliothèque Nationale, Cabinet des Estampes.

16. Anonymous, *Les Meringues du perron ou Milord la gobe*. Etching, Paris, Bibliothèque Nationale, Cabinet des Estampes.

> Ce cher monsieur Blücher:
> Ils nous donn'ront tout c'qu'ils vont prendre.
> Viv'nos amis
> Nos amis les enn'mis![18]

The theme became popular with graphic satirists as well. Caricatures showed camping foreign troops consorting with French women whose little virtue was denoted by the prominent exposure of their breasts, revealingly molded in semi-transparent, clinging blouses (Fig. 15).[19] In one such print, entitled *Les Meringues du perron ou Milord la gobe* (Fig. 16), a British officer in the company of a buxom *cocotte* devours meringues – whose shape and frothy sweetness is a confectioner's alternative for the lady's bosom – in front of a pastry shop. The caption includes wordplay (Perron = balcony = bosom, and "Milord la gobe" = Lord Devouring) alluding to the English invader's appetite for both culinary and sexual French specialties, and, by extension, territorial possessions as well.

Negotiations for peace with the allied monarchs, the kings of England and Prussia and the emperors of Austria and Russia, were in the hands of the diligent but faithless Talleyrand, the new Restoration Prime Minister. In November 1815 an agreement was reached. Known as the *Treaty of Paris*, it called for severe sanctions on the defeated, which included cession of vast territories, payment of a heavy monetary indemnity and, worse, a five-year-long military occupation of France. In the following years, more than 150,000 foreign soldiers, English, Russian, Prussian and Austrian, were distributed all over the country.

The arrangement, endorsed by the Bourbon monarchy in agreement with the aristocracy and the church, was greeted with contempt and anger by French patriots, especially those loyal to the proud imperial ideal. Pamphlets described

20

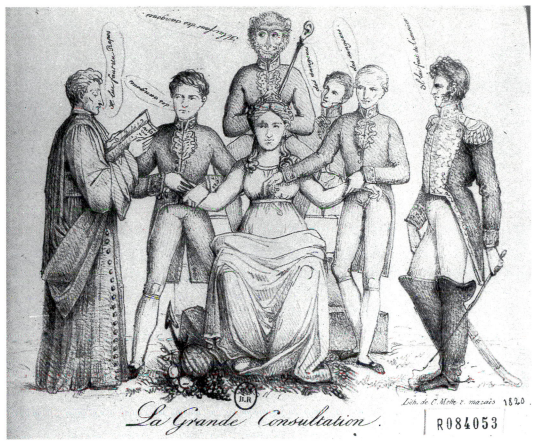

17. Anonymous, *La Grande Consultation*, *c.* 1820. Lithograph, Paris, Bibliothèque Nationale, Cabinet des Estampes.

Napoleonic veterans covered with wounds and medals attempting to stir placid civilians into an avenging war: "But above all, *morbleu*, we must make an honorable peace for France. The king has but to say the word, and he can instantly have four hundred thousand soldiers [at his command]. . ."[20] Likewise, an anonymous poet from Rouen warned:

> Mais si jamais l'heure de la vengeance,
> Vient à sonner, magnanimes soldats,
> Ralliez-vous à ce cri de vaillance:
> "La garde meurt, elle ne se rend pas."[21]

The plight of France – exploited by her victors, betrayed by her politicians, and ravaged by inner factional dissent – was allegorically represented as a medical consultation in an anonymous lithograph published by Motte (Fig. 17). France is the draped figure in the center, and around her stand her "doctors": a clergyman representing the Church prescribes rest ("il lui faut du repos"), another term for the Bourbon government's proclaimed return to peace; a Grande-Armée officer, a symbol for the Bonapartist opposition, calls instead for exercise or war ("il lui faut de l'exercice"). The three men in embroidered court dress represent France's allied victors, the great European Powers. Their medical

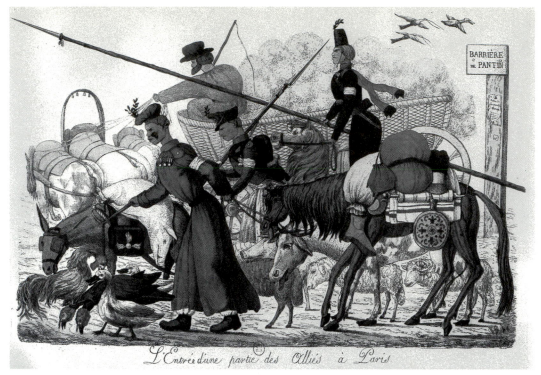

18. Anonymous, *L'Entrée d'une partie des alliés à Paris.* Etching, Paris, Bibliothèque Nationale, Cabinet des Estampes.

verdict is, in turn, that France should be bled with leeches ("il lui faut des sangsues"). From above France's head, Talleyrand, as a costumed ape but still bearing an unmistakable resemblance to his true-to-life portraits, coordinates the transactions. Talleyrand's betrayal is signified by his agreement with the foreign monarchs rather than his countrymen, and his request for bleeding of the patient as well. (In 1874 Champfleury was to refer to Talleyrand as "this old doctor who does not want to attend the agony of the patient under his care.")[22] In its insistent repetitiveness, the call for bleeding hinted at the harsh terms of the 1815 peace treaty.

In principle, the treaty was to be carried out as a civilized affair. The Allied occupation forces pledged not to interfere with the local administration, and to respect public and private property. General Carnot, the provisional Minister of the Interior, assured the French that although "the outcome of the war has put the French capital at the mercy of its enemies, the latter have, nevertheless, *solemnly* promised to respect the people, public and private property, our institutions, our authorities, and our national colors."[23]

But reality was soon to belie this. During three years, between 1815 and 1818, when the Congress of Aix-la-Chapelle finally put an end to the occupation, France was literally "bled with leeches." Looting, confiscating and indulging in all sorts of violence, including rape and murder, foreign soldiers ravaged the land, especially the countryside and provincial towns where the terms of the treaty were only loosely observed.

One of the treaty's most harrowing stipulations was that the French nation was to assume responsibility for housing, feeding and clothing the foreign

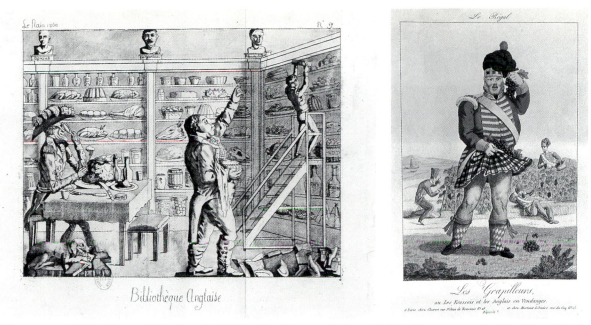

19. Anonymous, *Bibliothèque anglaise*, from *Le Nain couleur de rose*, vol. 2, no. 4 (December 1815) bet. pp. 96–7, Paris, Bibliothèque Nationale, Imprimés.

20. Anonymous, *Les Grapilleurs*. Etching, Paris, Bibliothèque Nationale, Cabinet des Estampes.

occupation forces. It was estimated that this assignment alone cost the French economy, already a shambles after the long years of Napoleonic wars, the exorbitant sum of 1.75 million francs a day.[24] And the Allies proved to be particularly demanding. Meat, fish and fowl had to comply with exact freshness and quality specifications. Clothes had to be sewn from choice fabrics. According to calculations, the British forces, a total of approximately 57,000 men, required as many as 88,629 pairs of trousers, 177,261 shirts and an equal amount of shoes every year. Wine, the prized French product, was abusively consumed. In one single month, the troops stationed around Paris drank, allegedly, 704,731 liters of wine, of which as much as two-thirds were consumed by the British regiments alone.[25]

Financially, most of this expense was borne by the middle class and the peasantry, those who had the most to lose. In fact ultra-royalist administrators would often see in such exactions laid on the bourgeois a means of avenging themselves on the loathed *acquéreurs de biens nationaux*.[26] Anger and resentment at such expenditure, when the French themselves suffered extreme deprivation, added to the Liberals' rejection of the monarchy. "Our friends, the enemies" became the target of patriotic spite, and foreign greed draining the motherland – represented in the guise of looting or gargantuanly feasting foreigners – one of the favorite themes of French caricature before 1820. Thus in an anonymous print the entry of the Allies in Paris takes on, ironically, the look of market day, as Russian officers ride into the city amidst, and as an inextricable part of, herds of cattle and cartloads of confiscated farm goods (Fig. 18). The caption, *L'Entrée d'une partie des alliés à Paris*, wickedly groups humans and animals under the common label "Alliés."

The British in particular, France's perennial rivals, again became the butt of caricatures and anecdotes. Waterloo had opened the borders of France to British

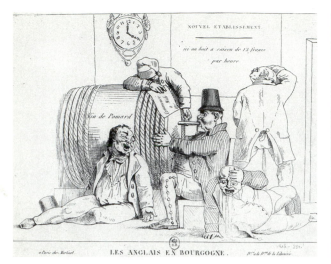

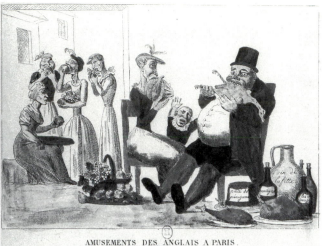

21. Anonymous, *Les Anglais en Bourgogne*. Etching, Paris, Bibliothèque Nationale, Cabinet des Estampes.

22. Anonymous, *Amusements des anglais à Paris*. Etching, Paris, Bibliothèque Nationale, Cabinet des Estampes.

tourism, so that along with British military occupants, French satirists were also provided with a continuous and abundant flow of British civilians on whom to pick. By 1816 the number of migrating Britons had reached the thousands, giving tourist travel to France the disquieting look of a population drain depleting Britain of its wealthiest citizens: "We some time since stated that the number of English visitors at Paris was 29,000, and it seems they are still augmenting," *The Times* nervously observed on 15 July 1816; and a few days later, on 20 July, "The emigration from England to France continues to be indeed alarming...They [the tourists] take the bread from the mouth of the slaving workman in England and lavish it on French luxuries and French amusements...The words *national bankruptcy* begin to be familiar to our ears." French royalists, however, were delighted and flattered by this new kind of invasion. On 10 July 1816 *The Times* quoted the monarchist *Gazette de France* bragging that "many English of distinction arrive in Paris. A great number take apartments in Paris, or country houses, for the whole of the fine season...They now come to study our manners, our customs, our language, our urbanity, and our arts, and do so like good neighbours, sincerely reconciled."[27]

What the Ultras welcomed, the Liberals loathed. British voracity for French products, from food to culture, became a widespread metaphor for the rapacious insular invaders, military and civilian. A cartoon of 1815 imagined the library of an English officer in which the owner, surrounded with shelves laden with food instead of books, sits at his desk as if at a dinner table, carefully perusing not a manuscript, but a forkload of roast (Fig. 19). "Roast beef in hand, this is how a real thinker looks," was the magazine's ironic comment.[28] Among Martinet's many prints on the subject, one etching represented English and Scottish soldiers raiding a vineyard. Allusions to drunkenness are combined with explicit sexual symbols referring, perhaps, to foreign soldiers' rapes of local women (Fig. 20). Another print showed English civilians sprawled drunk in the "caves-à-vin" of Burgundy (Fig. 21).

24

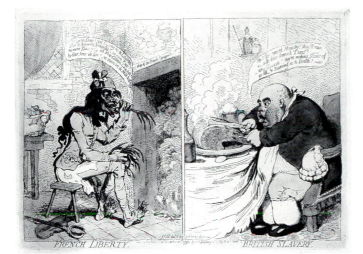

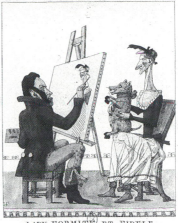

23. Gillray, *French Liberty, British Slavery*. Etching, London, British Library.

24. Anonymous, *Lady-Formité et Fidèle en séance chez Mr. Croûton*. Etching, Paris, Bibliothèque Nationale, Cabinet des Estampes.

Not even British women were spared. A humorous article in the *Miroir* entitled "Le Menu d'une dame anglaise" listed as the lady's daily fare:

> *For breakfast*: A whole filet of beef, a four-pound loaf of bread, a cake with fruit, four bottles of stout beer. *For dinner*: A slice of salted beef, a slice of roast beef, some stew from the king's kitchen [the lady was purportedly a member of the English court from a past century], a four-pound loaf of bread, four and half bottles of stout beer. *For a snack*: One brioche, two and half bottles of stout beer...

and the enumeration went on as the lady's meals and snacks multiplied throughout the day.[29] In illustration of British greed, female and male, a caricature of around 1815 set forth John Bull, the archetypal middle-class Englishman here seen during a visit to France, as he plunges his teeth into a whole goose, while his spouse attacks a whole pumpkin (Fig. 22). On the floor, select château wines and choice *pâté du Périgord* await their turn. The couple's child screams for its share. In the background, more English ladies gobble handfuls of fruit from the tray of a sad and sober French peasant woman, who may be an image of France. The scene of the obese feasting Englishman sitting across from his skinny wife undoubtedly recalls the English cartoonist Gillray's juxtaposition of scrawny, famished French revolutionary to *bon-vivant*, paunchy John Bull in his *French Liberty, British Slavery* (Fig. 23).[30] But in the French caricature the irony is appropriately reversed, as it is the feasting Britons, not the French, who are raised as exemplars of human perversity.

Equally voracious was the conquerors' appetite for French culture. This subject, paired with the stock theme of the unappealing British female, is illustrated in an anonymous cartoon of 1815 representing a scrawny English lady, bony, angular and flat-chested, appropriately matched to Monsieur Croûton, the archetypal clumsy artist popularized by vaudeville plays of the time (Fig. 24).[31] An ugly model, the print suggests, deserves a bad painter. The caption dubbed

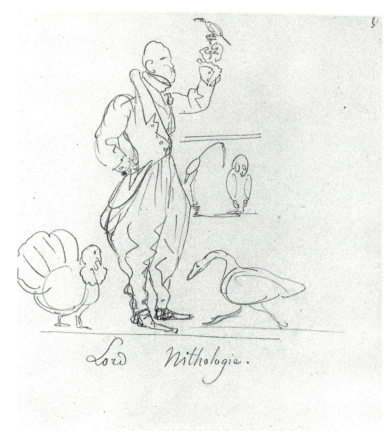

25. Delacroix, *Lord Nithologie*. Drawing, Paris, Musée du Louvre, Cabinet des Dessins (RF 9140 folio 51r).

the lady "Lady-Formité" (la difformité, Lady Difformity). Witty sallies, word-play and puns often make up the captions of these cartoons. Names such as "Milord La Gobe" (Lord Devouring), "Milord Richepanse (Lord Ample Paunch)," "Lady Constipée" (Lady Constipated) and "Milady Gloutonne" (Lady Glutton) cleverly suggested both Englishness and the draining effects on national resources of the English presence on French soil.[32]

British and alien ridicule also permeates Delacroix's sketches of foreigners in Paris. Thumbnail-size drawings depict arrogant Prussian officers with puffed-up torsos and pot bellies crowned with extraordinary feathered helmets and towering shakos (Figs 6, 8). The Scottish regiments follow with their minimal kilts and tasseled leggings (Fig. 8). In the *Album de la Saint-Sylvestre*, an album filled with drawings done for fun by Delacroix during the New Year's Eve parties he and his friends celebrated together, he portrayed Englishmen as part of visual and verbal puns whose humor ranges from light wit to scatology. Thus, next to the elegantly erudite "Lord Nithologie" (l'ornithologie) in his exaggeratedly dandyish attire (Fig. 25), we have the brutish "Lord Angoutang" (l'orangoutang) in the guise of a threatening ape holding a club and, next to him, the coarse "Lord Ure" (l'ordure = the dirt, crap) who defecates publicly with a grin (Fig. 13, bottom).[33] Delacroix's Lord Ure, in fact, directly reflects

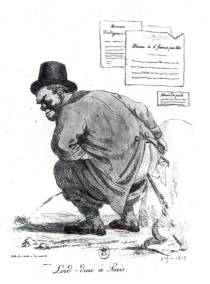

Lord-Dure à Paris.

(26) Anonymous, *Lord-Dure à Paris*, 1819. Etching, Paris, Bibliothèque Nationale, Cabinet des Estampes.

the imagery and sentiment of contemporary anti-British caricatures such as the one, dated 1819, representing an Englishman in Paris relieving himself on the sidewalk beneath posted notices whose headings, "Bureau d'indigence" (welfare office), "Mont-de-piété" (pawn shop), and "Dîner à 6 francs par tête" (an expensive dinner), allude to both the indigent French and, in contrast, their feasting foes (Fig. 26).[34]

Likewise, Delacroix's *Le Bagage de campagne* (Fig. 14), completed within months after the second foreign invasion, mocks the unwelcome British occupants of France and denounces their destructive greed by reiterating current satirical themes and types, such as the ravenous Englishman and his ungainly spouse. The barrel of wine tied to the soldier's neck, while associating his image, demeaningly, with that of a Saint Bernard dog also refers to the uncontrolled drinking of the British troops. The soldier's military haversack, stuffed with clothing and food, along with his laden rifle suggest the drain of local goods. As for the soldier's wife, with her angular limbs and lopsided jawbone, she is but a plebeian version of the art loving Lady-Formité.[35]

For there is no doubt that Delacroix echoed the Liberal faction's call for a repudiation of the foreigners. Punning once again, this time – as was his habit – on his own last name, he signed the lower left-hand corner with two superimposed military crosses (*deux croix*).[36] Their combined shapes recreate the cross of the Légion d'honneur, the decoration instituted by Napoleon to reward civic and military achievement, and an ideological emblem cherished by Restoration Bonapartists.

For Delacroix, the patriot, time did not wipe out the stinging memory of defeat either. Nearly fifty years later, in his 1862 essay on Charlet, he reminisced on the dire occupation years in lines still vibrant with feeling: "It was in 1816 or 1817," he wrote, "when the humiliations inflicted upon France as a result of our misfortunes had excited national sentiment to the highest degree."[37]

27

CHAPTER 3
Voltigeurs and Weathervanes, Crayfish and Candle-extinguishers

Voyez ce vieux marquis
Nous traiter en peuple conquis;
Son coursier décharné
De loin chez nous l'a ramené
. . .
C'est moi, dit-il, c'est moi
Qui seul ai rétabli mon roi.
Mais s'il ne me rends
Les droits de mon rang
Avec moi, corbleu!
Il verra beau jeu.
Chapeau bas! chapeau bas!
Gloire au marquis de Carabas!

P. J. Béranger, *Le Marquis de Carabas* (1816)

DELACROIX'S PATRIOTIC CONCERN for the ailing motherland, evident in his sarcastic portrayals of the foreign occupants of France, also underlies the meaning of his print *La Consultation* (Fig. 27), published by Motte in March 1820, a scene of doctors deliberating while a patient lies dying, and Death is on the watch.[1] Here, however, the focus appears to be the country's domestic troubles and the factional split that threatened interior peace and stability at the onset of the Bourbon regime.

Depicting the helplessness or incompetence of medical men in the face of superior powers was, of course, an old standby of religious moralizing and social satire. Examples closer to Delacroix would include, among others, Thomas Rowlandson's *A Consultation* (Fig. 28), a drawing of three repulsive and conceited doctors debating, presumably on obscure scientific matters, while their neglected patient is being tended by a humble old woman,[2] and Goya's socially charged Capricho 40, *De qué mal morirá?* (Of what illness will he die?), a reference to the suffering Spanish people governed by an inept aristocracy.[3]

In 1815 the theme of a medical consultation became a common metaphor for the alarming condition of France in the aftermath of defeat. In the anonymous caricature *La Grande Consultation* (Fig. 17) it served, as we saw, to deplore France's plight in the hands of greedy allies, ruthless political speculators and warring factions. The allegory was not the prerogative of a specific political ideology. A royalist like Chateaubriand used it to refer to France saved by the monarchy, and to the Bourbons as "the only doctors who can heal our wounds. Their moderation, their paternal sentiments and their own adversities are suited to a kingdom exhausted, overwhelmed by convulsions and suffering."[4] From the opposite side of the political spectrum, a satirical piece in the anti-royalist *Le Miroir* entitled "Consultation des médecins. Écrite pour la gouverne d'une garde-malade" warned of the dangers threatening France's frail constitutional regime through, once again, the parable of a medical council:

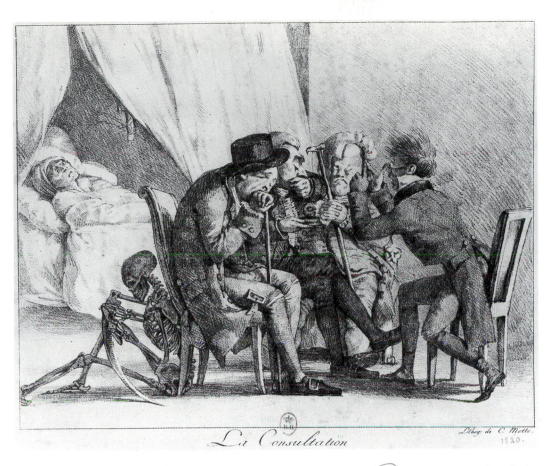

La Consultation

Lithog: de C. Motte.
1820.

27. Delacroix, *La Consultation*, 1820. Lithograph, Paris, Bibliothèque Nationale, Cabinet des Estampes.

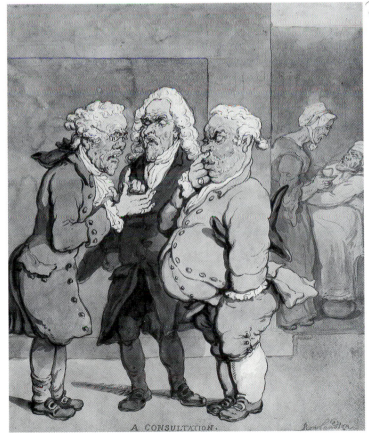

A CONSULTATION. Rowlandson.

28. Rowlandson, *A Consultation*. Drawing, Yale Center for British Art.

29. Boilly, *Le Libéral. L' Ultra*, 1820. Lithographs, Paris, Bibliothèque Nationale, Cabinet des Estampes.

A man, very well-known in the world, is sick right now...A counsel of doctors was convened in order to prescribe a treatment. The able doctor who presided over this assembly, after a rather animated dispute with one of his colleagues who was not a partisan of natural medicine, has finally managed to impose this cure...This is what he said to the nurse: "The illness of the patient is serious; it is what our authors call a constitutional illness..."[5]

During the early Restoration, opposing ideologies inherited from France's troubled past tore political life asunder. By 1820, however, any nuances that had previously existed between factions – such as extreme royalists (Ultras), constitutional royalists, center (Doctrinaires), Bonapartists, Liberal constitutionals and extreme republican left – were consolidated into or rather subsumed under two partisan extremes, the Ultras and the Liberals (an alliance of Bonapartists, Liberals and Republicans). The Ultras, proponents of monarchy and church, wished for a return to Ancien Régime absolutism and aristocratic privilege. The Liberals supported the constitutionalism established by the Charter and a democratic egalitarianism based on individual talent and merit. Two satirical lithographs of 1820, by the painter and printmaker Louis-Léopold Boilly, illustrate in emblematic fashion the polarities of contemporary political opinion (Fig. 29). The archetypal Ultra is an old man in eighteenth-century outfit, a match to his outdated beliefs, grieving over the loss of a long-concluded past; the quintessential Liberal, on the other hand, is a young, jovial and fashionably dressed individual – a man of the present – poking fun at his ageing

30. Boilly, *La Partie de dames au café Lemblin*. Chantilly, Musée Condé.

companion.[6] The Liberal's laughter will be the subject of our last chapter. For the moment, it is his youthful and fashionable looks, the symbols of the Liberals' belief in the new era and progress, that will retain our attention.

In yet another work of the same period, his painting *La Partie de dames au café Lemblin* (Fig. 30), Boilly imparted a real existence to his emblematic types by incorporating them into a genre scene. In the dark, smoke-filled interior of the café Lemblin, one of the popular Restoration haunts located in the Palais-Royal area,[7] two men bend attentively over a game of draughts. The older one, on the right, is clearly an Ancien Régime aristocrat and, presumably, Restoration Ultra, complete with powdered hair, lace *jabot*, breeches, silk stockings and patent leather shoes adorned with a silver buckle. Across from him sits his young Liberal opponent, smartly up to date in his short dark hair and whiskers, cravat and trousers. Here, as in Boilly's pendant prints, the Liberal seems to be in control: he is obviously winning the game, as the chips – white like the Bourbon flag – "captured" from his opponent pile up on his side of the board. By infusing his image with discreet yet unambiguous political overtones, Boilly, who maintained his republican beliefs during the Restoration, not only illustrated the political divisions of his time, but also indicated where his own preferences rested.

Boilly explored the allegorical potential of the medical consultation in a print entitled *Consultation de médecins. 1760*, published in July 1823 as part of his series *Les Grimaces*, of 1823–8 (Fig. 31).[8] A tightly knit cluster of old and impotent physicians wearing elaborate powdered wigs shouts (to overcome deafness) and quarrels fiercely in a confused and ineffective *dialogue de sourds*. The eighteenth-

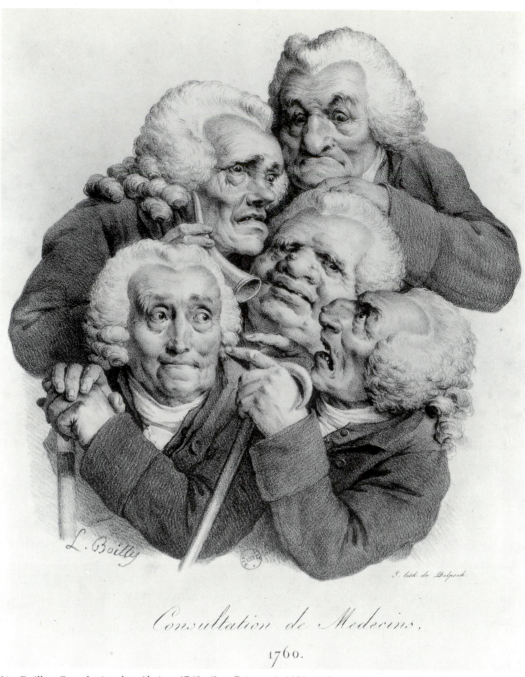

Consultation de Médecins.

1760.

31. Boilly, *Consultation de médecins. 1760. (Les Grimaces)*, 1823. Lithograph, Paris, Bibliothèque Nationale, Cabinet des Estampes.

century date in the caption and the eighteenth-century look of the figures suggest that this is an evocation, unflattering and chaotic, of the Ancien Régime. Done in the heart of the Restoration, the caricature reveals the Liberal Boilly's contemptuous outlook on a past cherished by the Ultras, the present-day heirs of his grotesque warring doctors.

Just like Boilly in his *Café Lemblin*, in *La Consultation* (Fig. 27) Delacroix

32

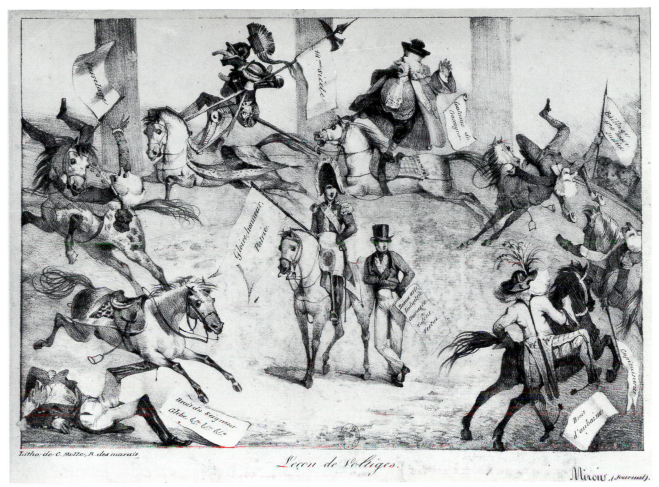

Litho: de C. Motte, R. des marais.

Leçon de Voltiges.

Miroir (Journal).

32. Delacroix, *Leçon de voltiges* (*Manège de voltigeurs*), 1822. Lithograph, Paris, Bibliothèque Nationale, Cabinet des Estampes.

opposed three old and old-fashioned men seated on one side, and a younger and modern one placed across from them. With their eighteenth-century attire enhanced by voluminous wigs, Delacroix's ageing doctors, like Boilly's, refer to the old order and to the Ultra faction; their stylish young colleague stands for the progressive Liberals. The wigged doctors doze indifferently or sniff tobacco in a state of stupor, and seem indeed in close alliance with Death. Their young counterpart alone seems concerned with the patient – France – and gesticulates in an energetic fashion as he proposes various cures. Set in the interior of a room, the confrontational scene suggests the atmosphere prevailing in the parliamentary chambers where, in heated debates, Ultra and Liberal opinion collided head on. For Delacroix, as for Boilly, the exhausted and regressive Ultra faction was incapable of saving the moribund motherland. The future lay with the Liberals, hardworking, progressive and involved.

Mocking the inept Ultras while, conversely, extolling the efficiency of their Liberal Bonapartist opponents is also the subject of Delacroix's caricature *Leçon de voltiges* (or *Manège de voltigeurs*) for the *Miroir* of 8 March 1822 (Fig. 32).[9] In a riding ring or *manège*, old men in medieval armor, clerical robes and Ancien Régime court dress are seen as the awkward students of a riding school or apprentice circus acrobats rehearsing the art of airborne convolutions or *voltiges*.

33

But the inexperienced riders, the exponents of Ultra ideology and values, have lost control of their mounts and are being tossed around in a wild cavalcade that lands a great many of them on the ground. Inscriptions on the banners they hold or drop, such as "vasselage" (vassalage), "baillage" (land leasing), "droit du seigneur" (lords' rights), "droit d'aubaine" (estate repossession) and "14e siècle" (fourteenth century), evoke feudalism and point to Ultra absolutism. The print exposes Ultra ideology and practice as a bankrupt and ineffectual system that could only breed disaster and chaos.

The clumsy riders are, however, not alone in the arena. In the center of their infernal merry-go-round, two young men – one a soldier on horseback, the other a civilian in bourgeois frock-coat and hat, on foot beside him – act as riding instructors. Their dignified calm contrasts with the riders' disarray. The cavalry-man wears the uniform of a Napoleonic officer and carries a banner inscribed with the Grande-Armée motto: "Gloire, honneur, patrie." His companion is a representative of the French middle classes whose democratic and progressive ethic, founded on probity, industry, merit and education, the banner in his hand proclaims: "Beaux-arts, industrie, commerce, talens, vertus." The officer's name, the *Miroir*'s commentary explained, was *Senatus Constitutionnel*; that of his pedestrian companion was *Populus*.[10]

As in his *Consultation*, Delacroix here juxtaposed old and young, past and present, Ultras and Liberals, aristocracy and the middle class, perpetrators of the old and proponents of the new. Against Ultra privilege, incompetence and disarray, he posited Liberal-Bonapartist merit, welfare and order. In the words of the *Miroir*:

> Time which brings good fruit to maturity also brings back to life the parasites. The old feudal order, which for many years now had been receiving the invalids and was no more than a shadow banished by the new laws, suddenly conceived the idea to reappear on the stage of the world, to push the century back, and to seize again the old privileges that it had lost. . . However, this gothic cavalry had forgotten how to sit on a saddle. It was resolved, therefore, that before appearing as a spectacle in the eyes of the villains of the capital, a most contemptuous and hissing species, the knights who represented the institutions of the past would take a few riding and acrobatics lessons.[11]

There is, however, more in Delacroix's print than just upholding a Liberal social and political ideal. For in the satirical vocabulary of Restoration Liberals, *voltiges* and *voltigeurs* – the latter originally the name for light infantry regiments – were heavily loaded terms that alluded to a special category of Ultras, those repatriated émigrés who demanded, and received, military office.[12]

The reinstatement of the Bourbons had signaled a massive return from abroad of émigrés, old regime aristocrats who had fled France in fear of the Revolution. Throughout their long years of exile, these men had remained true to the royal cause. Several of them had even served in the so-called "army of the Princes" or "army of Condé," the royalist forces assembled in 1792 in the German town of Koblenz by the prince of Condé to fight on the side of Austria and Prussia against the French Republic. The claims of returned émigrés took essentially two courses (neither of which especially endeared them to the Liberal bourgeois): they claimed back their lands and estates now in the ownership of mostly

33. Anonymous, *Voltigeur de Louis XIV/Madame de La Jobardière*. Etching, Paris, Bibliothèque Nationale, Cabinet des Estampes.

bourgeois *acquéreurs de biens nationaux*; and they demanded to be reinstated in, or be awarded anew, high-ranking positions in the army.[13]

As far as the latter went and much to Liberal outrage, the royal administration hastened to comply with Ultra demands, appointing, promoting and even creating new, prestigious regiments for the sons of the nobility. At the same time officers and soldiers of the Napoleonic army were being discharged or put on half-pay by the hundreds. General de Rumigny recalled: "While the few nominations made at Fontainebleau [that is, during the Hundred Days] in favor of officers covered with the dust of battle whose achievements the Emperor had wished to reward were being contested, they [the royal government] were creating more than two hundred superior officers."[14] It was calculated that by 1818, the year when marshal Saint-Cyr's army reforms attempted, in vain, to put an end to such scandalous appointments, nearly 1,500 regular army officers had been dismissed and replaced by émigrés, most of them too old and out of practice. Of the estimated 387 reappointed émigré generals, for example, a great many had not been on active duty since the time of Louis XV.[15] De Chaumareys, the captain responsible for wrecking the frigate the *Méduse* in 1817 – the subject of Géricault's subversive painting at the Salon of 1819 – was one such case. Another was the duc de Havré who, at the age of seventy-four and back from his Spanish exile, was named captain of the Scottish guard and, later, lieutenant-general.[16]

Liberal wit could not wish for a better theme: "All of a sudden there was a flood of pamphlets and caricatures against the émigrés," Louis Véron recalled.[17] A comical character was born. Dubbed Monsieur de La Jobardière (from *jobard*, slang for fool) he typified the *voltigeur* and, through him, the misplaced ambitions of a pathetic and decadent nobility.[18] Journals concocted spoof stories of La

34. Anonymous, *Vision de M. de La Jobardière*, 1814. Etching, Paris, Bibliothèque Nationale, Cabinet des Estampes.

Jobardière's exploits,[19] and plays such as Eugène Scribe's *Marie Jobard* brought him to the popular stage.[20]

La Jobardière's appearance reflected his class and beliefs. Contemporary descriptions showed him as an old man clad in "a short culotte and woolen stockings, soft boots made in 1788..." the whole complemented by a wig which, when not in use, "was replaced on his head...by a cotton bonnet held

35. Charlet, *J'Attends de l'activité* (*c.* 1820). Lithograph, Paris, Bibliothèque Nationale, Cabinet des Estampes.

36. Charlet, *J'Obtiens de l'activité* (*c.* 1820). Lithograph, Paris, Bibliothèque Nationale, Cabinet des Estampes.

together by a beautiful violet ribbon."[21] In a caricature of 1815 (Fig. 33), Monsieur de La Jobardière features in bust, his refined gauntness sandwiched between fluffy, powdered wig and lace *jabot* (flipped upside down, the print cleverly turns into the émigré's worthy companion, Madame de La Jobardière, ensconced in eighteenth-century beribonned bonnet and fur collar). In an explicit allusion to émigré demands for social, financial and military reinstatement, a satirical etching of 1814 issued by Martinet depicted a slumbering La Jobardière – Madame faithfully in attendance beside him – dreaming of honors, money and mansions (Fig. 34).

Monsieur de La Jobardière's martial alias was "Voltigeur de Louis XV" (as well as "Voltigeur de Coblentz," "Voltigeur de Louis XIV" and "Voltigeur de Louis XVIII"), a term directly hinting at La Jobardière's military presumptions (as well as at his royalism, ancient beliefs and age). As a *voltigeur*, La Jobardière was represented in old regime military uniform complete with wig, feathered hat and soft leather boots. Such an outfit ridiculed the anachronistic military attire of real-life émigrés, whose appearance was frequently the butt of Liberal wit. Louis Véron told, for example, of a prank played by three former Grande-Armée officers who, one day, strolled down the Paris boulevards dressed up in (fake) *voltigeur* costume. The pranksters were arrested and thrown into jail, but once free again and encountering a real *voltigeur* they "warned" the old man with feigned concern against a uniform which could cost him a jail term![22]

The military claims of émigré nobility form the subject of Charlet's two lithographs, of around 1820, entitled *J'Attends de l'activité* (Fig. 35) and *J'Obtiens de l'activité* (Fig. 36).[23] In *J'Attends de l'activité*, the nobleman in his luxurious Rococo interior comfortably and confidently awaits his call to the ranks. He studies a book containing his family's coat of arms, a hint that he will secure his appointment through his noble birth. Symbolic references to his reactionary beliefs abound: a servant, in the background, prepares an enema; the old man's

37. Charlet, *La Manie des armes*. Lithograph, Paris, Bibliothèque Nationale, Cabinet des Estampes.

slippered foot suggests that, like King Louis XVIII, he suffers from gout, a disease of the old and wealthy.[24] *J'Obtiens de l'activité* tells the conclusion of the story. His wishes gratified by an order of enrolment, the aged nobleman dons a preposterous seventeenth-century military uniform and, helped by his feudal-looking pageboy, struggles to his aching feet. He is now the perfect (and crumbling) image of a "voltigeur de Louis XIV."

A third print by Charlet, *La Manie des armes* (Fig. 37), underscores émigré military obsolescence by showing an old aristocrat and his servant emerging laden with rusty medieval weaponry and armor from a second-hand shop, under the contemptuous eyes of an invalid Grande-Armée officer.[25]

Satirical publications echoed such themes in witty tongue-in-cheek anecdotes. Here, too, as in the prints, a level-headed, democratic bourgeois was frequently set against a conceited exponent of the old aristocracy. Such was the *Miroir*'s "true story," in 1822, of the salesman, employed at a *marchand d'habits*, who was called upon, one day, to wait on "an old gentleman in horseshoe-shaped wig, a

38

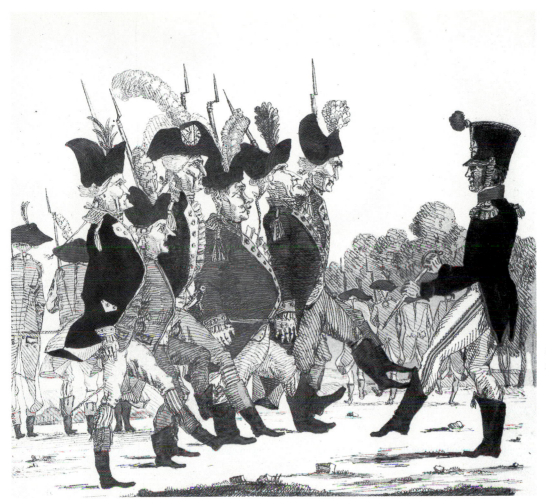

38. Anonymous, *Les Aspirants au service ou Les Militaires impromptus*, 1815. Etching, Paris, Bibliothèque Nationale, Cabinet des Estampes.

sword at his side, an umbrella in hand." Presented with the right garments for his age, the old man burst out angrily:

"Go to hell, idiot. . . I am asking you for a military uniform." – "A military uniform for Monsieur?" – "And an officer's uniform, too." – "An officer's uniform!" "Certainly," added my bourgeois. . . "and I am going to show Monsieur le Chevalier a magnificent uniform of a lieutenant general which will fit him as if it had been made for him; it is the one that general G. wore on the last battlefield where he fell;" I was careful to point out to him the mended hole on the spot where the bullet entered the chest of that hero taking away his life; "But it will be easy to erase every trace of it." – "Not at all, I beg you, I was wounded exactly at the very same place in the assault of Sainte-Lucie, during the American war, and I will not be displeased to wear on my uniform the scar of my wound."

We showed him the uniform; he tried it on. Never before have I seen such a grotesque figure; and I had to muster all my sang-froid in order to withhold the laughter which choked me as I looked upon this good man, disguised as a hero, admiring himself in front of the mirror. . . [26]

39

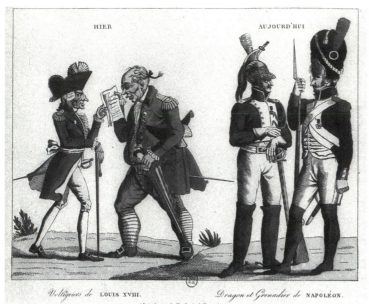

HIER AUJOURD'HUI

Voltigeurs de LOUIS XVIII. *Dragon et Grenadier de* NAPOLÉON.

La Jobardière had struck again!

Voltigeur ridicule was further enhanced by juxtapositions of comically old and old-fashioned émigré officers with youthful, vigorous and dignified Napoleonic soldiers. In a caricature of 1815, grotesque *voltigeur* multiples of Monsieur de La Jobardière march to the orders of a smart Grande-Armée officer (Fig. 38); more emblematically, another print entitled *Hier. Aujourd'hui* created a parallel between the past (obsolescence, reaction) seen as two *voltigeurs*, one armed with an umbrella – a symbol of stupidity and reaction with additional overtones of émigré anglophilia[27] – and the present (modernity, progress) represented by two sturdy Napoleonic officers (Fig. 39).[28] A more explicit reference to émigré military privilege at the expense of wronged Napoleonic soldiers was made in the lithograph *Je le porte sur mes épaules* (Fig. 40), a clever adaptation of Goya's class-related allegory of exploiting asinine aristocrats riding on peasants' backs from his Capricho 42, *Tu que non puédes* (Thou who canst not).

For his *Leçon de voltiges* (Fig. 32), Delacroix obviously drew upon such satirical inventions. By using the symbolic juxtapositions of ramshackle uniformed nobles (here dressed as medieval knights) and sprightly Napoleonic officers, he thus managed to introduce references to yet another hot topic of Liberal concern – unfair army appointments – into his image poking fun at Ultra reaction. The idea of a *manège* as a metaphorical arena for displaying and ridiculing social ills was also a current satirical conceit. In 1816, the *Nain jaune réfugié* had published a spoof announcement for a so-called "Manège des voltigeurs de Louis XIV," an imaginary riding school frequented, according to the *Nain*, by a most exclusive clientèle:

One cannot be admitted to it as a student before being at least sixty years old

40

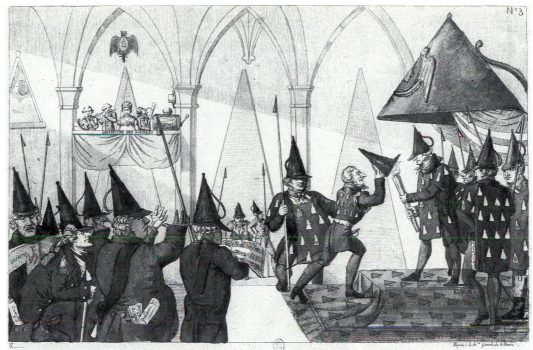

RÉCEPTION DUN CHEVALIER DE L'ÉTEIGNOIR

41. Anonymous, *Réception d'un chevalier de l'éteignoir*. Etching, from *Le Nain jaune*, 1815. Paris, Bibliothèque Nationale, Imprimés.

. . . Once installed on the saddle, the *voltigeurs* perform maneuvers at a walking pace and kicking-strap for a few weeks, then they are to attempt a jog-trot flanked by two riding masters attentive to their every movement and prompt to restore their balance which they are likely to lose. . . Within the next two years, MM. Franconi intend to form two squads of *voltigeurs* of this kind which will replace the elite cavalry corps that we lost at Waterloo.[29]

The inexhaustible sources of radical mischief, the *Nain jaune* and its heir, the *Miroir*, were responsible for coining the period's most original humorous devices in their attempt to fight conservatism by ridicule. To allude to political opportunism and Ultra reaction, for example, they invented three fictitious "secret societies," the Order of the Weathervane, the Order of the Crayfish and the Order of the Candle-extinguisher, and published lists of prominent Ultras, barely disguised by ridiculous nicknames, as the orders' "honorary" members. Each order had its charter, ritual, dress and special emblem.

The Order of the Weathervane, symbolized by a diminutive pinwheel-shaped weathervane or a windmill, stipulated in its charter that: "No one will be eligible to become a member of the Order of the Weathervane if he has not provided prior proof to have changed his convictions at least three consecutive times, and to have served at least three different governments."[30] Talleyrand and Police Minister Fouché were among the order's most illustrious members.

The Order of the Crayfish was intended to suggest a parallel between the crayfish's backward gait and Ultra retrograde ideas. According to their rank and seniority, which themselves depended on the individual's greater or lesser profession of reactionary beliefs, members of the order were awarded crustacean emblems of different magnitude, from the puny shrimp to the medium crayfish

42. Devéria, *Famille d'éteignoirs*, 1819. Lithograph, Paris, Bibliothèque Nationale, Cabinet des Estampes.

43. Anonymous, *Grand combat entre les Libéraux et les Ultras*, 1819. Etching, Paris, Bibliothèque Nationale, Cabinet des Estampes.

44. Anonymous, *Les deux extrêmes se touchent*. Etching, Paris, Bibliothèque Nationale, Cabinet des Estampes.

45. Anonymous, *Justice rendue au courage*. Etching, Paris, Bibliothèque Nationale, Cabinet des Estampes.

to, most honorably, the sizeable lobster. Not surprisingly, the order's motto was "Backtrack to take a better leap [*Faut reculer pour mieux sauter*]."[31]

By far the most popular of the three orders was that of the Knights of the Candle-extinguisher (*Chevaliers de l'éteignoir*) launched by the *Nain jaune* in its issue of 15 December 1814. A conical candle-snuffer looking more like a fool's cap was the order's symbol (the symbol derived from British caricature where, ironically, it had been used to deride Bonaparte). Intellectual obscurantism and hatred of truth, reason and progress were required qualifications for candidacy. Initiation ceremonies, presided over by King Misophanes (Hater of Light/ Truth), the order's Grand Master, were held at night, under dimly lit Gothic vaults (Fig. 41). Members pledged to "fight hand in hand all truth which would be counter to the Order's best interest, and not to back away from any absurdity, no matter how grotesque and obvious, if it is as profitable to forward it as it is shameful to support it"; they also vouched to "hate *philosophy*, *liberal* ideas, the *constitutional charter*."[32] The names of the Ultra members composing the society were accompanied by a minuscule cone "the perfect image of the gloomy obscurity of his [the member's] brain."[33]

The Order of the Candle-extinguisher became an instant symbol of political

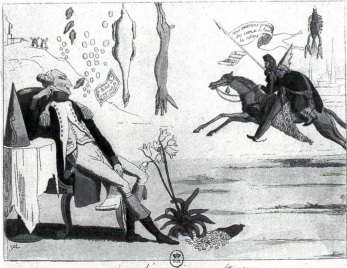

rêve d'un franc voltigeur

46. Anonymous, *Rêve d'un franc voltigeur*. Etching, Paris, Bibliothèque Nationale, Cabinet des Estampes.

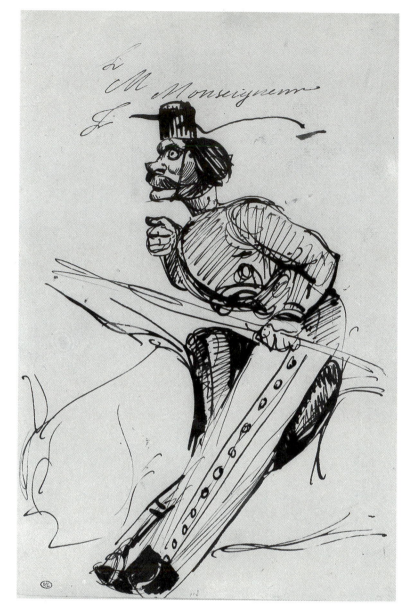

47. Delacroix, *M. Monseigneur*, 1818–24. Drawing, Paris, Musée du Louvre, Cabinet des Dessins (RF 10571).

subversion and, like the *voltigeur* craze, even inspired some daring pranks. For example, on 2 February 1822 police in the town of Dreux reported a "seditious masquerade" held at nightfall: two men, one dressed all in black and wearing, allegedly, a three-foot-tall bonnet "which imitated in its shape a huge candle-extinguisher," the other holding lighted candles in his hand, pranced about the streets putting out the candle flames with a candle-snuffer as they chanted "no more light! no more light!"[34]

No sooner had the three emblems been coined than they became an integral part of the visual vocabulary of contemporary graphic satire. In a caricature of 1819 attacking the clergy, for example, Achille Devéria showed a row of priests (holding, significantly, Chateaubriand's *Le Conservateur*) as a family of conical

candle-extinguishers of decreasing height (Fig. 42).[35] In another cartoon of 1819, the *éteignoir* became a lethal weapon against Ultra assault in the hands of the Liberal supporters of constitutionalism (Fig. 43). It also crowned a *voltigeur* caught in emblematic fist-fight with a *sans-culotte* (Fig. 44), and was solemnly awarded to another *voltigeur* by an allegorical figure of France as Minerva, simultaneously with the laurel wreath bestowed upon a Napoleonic officer (Fig. 45).

In curtain-call fashion, all three symbols – candle-extinguisher, crayfish and weathervane-windmill – feature in *Rêve d'un franc voltigeur* (Fig. 46), an image of a slumbering *voltigeur* lost in a royalist's Land of Cocaigne. On the right, Louis XVIII – capped with an *éteignoir* under a looming *écrevisse* – rides into France on the back of a Russian cossack.

Undoubtedly Delacroix knew such prints. One of his drawings, dated between 1818 and 1824 (Fig. 47), represents a briskly riding cossack, strikingly similar to the galloping Russian of *Rêve d'un franc voltigeur*.[36] Although Delacroix's drawing omits the backriding king, its inscription, "M. Monseigneur", still suggests the royal presence. As in the anonymous print, Delacroix's use of a Russian soldier in conjunction with a reference to the royal house of France literally illustrated the Liberal dictum that the Bourbons had been brought back in the bandwagons of the foreigners. Cossacks, in particular, presented as the latter-day incarnations of Attila and his Huns, were made to embody all the barbarism and destruction associated with the foreign invasion. Thus Béranger, in his "Chant du cosaque," a bitter allusion to the plight of war, showed a cossack, responding to an invitation from kings and priests, riding fiercely through Europe and urging his horse to trample over the monuments of civilization:

> Hennis d'orgueil, o mon coursier fidèle!
> Et foule aux pieds les peuples et les rois.
>
> . . .
>
> Tout cet éclat dont l'Europe est si fière,
> Tout ce savoir qui ne la défend pas,
> S'engloutira dans les flots de poussière
> Qu'autour de moi vont soulever tes pas.
> Efface, efface, en ta course nouvelle,
> Temples, palais, moeurs, souvenirs et lois.[37]

By the early 1820s, indeed, the young Delacroix was initiated into the cryptic symbols used by the dissenting underground. In the remainder of his cartoons for the *Miroir*, the subject of the forthcoming chapters, candle-extinguishers, weathervanes and crayfish hold full sway.

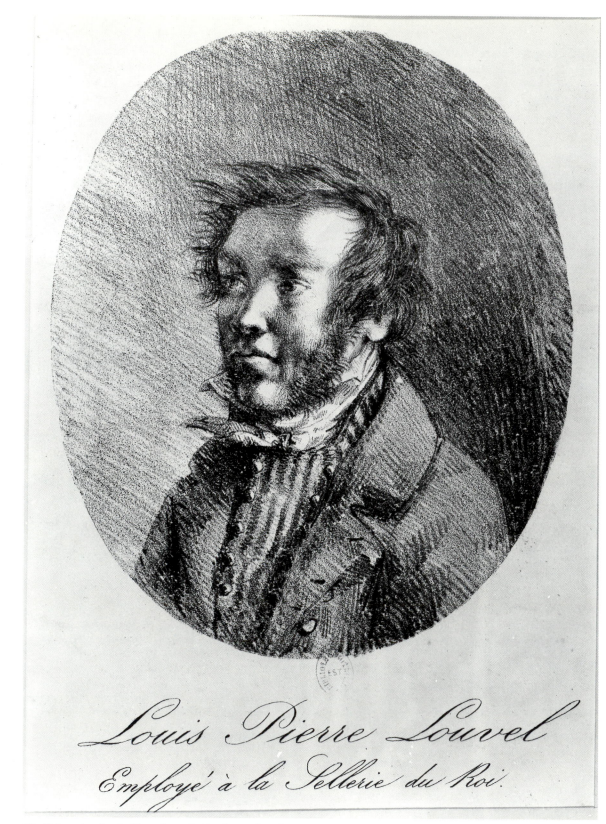

Louis Pierre Louvel

Employé à la Sellerie du Roi.

48. Delacroix, *Louis Pierre Louvel. Employé à la sellerie du roi*, 1820. Lithograph, Paris, Bibliothèque Nationale, Cabinet des Estampes.

CHAPTER 4
Louvel, the Murderer

Louvel (Louis-Pierre), assassin français.

Firmin-Didot (ed.) *Nouvelle Biographie générale*, Paris, 1865

In one instance, Delacroix's political prints forsake caricature for the immediacy of naturalistic portraiture. This is the lithograph representing the convicted murderer Louis-Pierre Louvel, formerly a saddler in the royal stables, which the printer Langlumé published in a few independent sheets on 25 February 1820 (Fig. 48).[1]

Like the cartoons a record of political actuality, albeit unmediated by the symbolisms of satire, Delacroix's lithographic portrait of a murderer followed an age-old tradition of depicting sensational criminals, from ordinary killers to political outlaws. Apart from popular broadsides (*canards*) and Épinal prints, the tradition also accounted for paintings such as Hogarth's portrait of Sarah Malcolm (1733) and Goya's depiction of the capture of the bandit El Maragato (1806). While in Rome, in 1816–17, Géricault had also made drawings of public executions, and in London, in 1820, he recorded a public hanging.

What gave Delacroix's print special significance for its time, however, was that his model was not the undistinguished villain of an ordinary *fait-divers*, but instead a "royal assassin," a man who had made history by murdering, just two weeks earlier, the heir to the Bourbon throne, Charles Ferdinand, duc de Berry, son to the comte d'Artois and nephew to Louis XVIII.[2] When Delacroix's print was issued, Louvel was in prison awaiting trial, but his crime and his person had already acquired the power of ideological emblems that sent passions flaring and polarized political differences. Louvel indeed became a national figure and a symbol potent enough to justify, several decades later, an entry in Firmin-Didot's authoritative biographical dictionary, which provides the epigraph to this chapter, under the proud title of "assassin Français."

In the Fall of 1818, the representatives of the great European Powers gathered at Aix-la-Chapelle had voted to withdraw the occupation forces from French territory and to offer France admittance to their political alliance. This double decision, which coincided with the end of the duc de Richelieu's conservative ministry, meant the beginning of both national and international rehabilitation for France. The nation's internal political system, too, showed signs of greater liberalization: in elections held in October, the Ultra party was defeated. In December, a new ministry came to office. It was presided over by General Dessoles in collaboration with the Minister of the Interior, the duc Decazes, and mostly consisted of moderate conservatives. Not only were restrictions

including press censorship relaxed, but former revolutionaries such as the abbé Grégoire, a regicide, were elected to Parliament. The immediate effect of these changes was a political strengthening of the Liberal party and a weakening of Ultra power. Ultra resentment soared. An Ultra press campaign attempted to stir up fears of imminent return to revolutionary chaos which it blamed on Decazes, "that vile slave of the Liberal Jacobins."[3] It is against this backdrop that the assassination of the duc de Berry took place.

The circumstances of the crime, told over and over in the contemporary press and in an avalanche of hastily printed pamphlets and "eyewitness accounts," became instantly known throughout the country. On the evening of 13 February 1820 the duke and his wife, Marie-Caroline de Bourbon-Siciles, were attending a performance at the Opéra, located, at the time, on the rue de Richelieu, by today's Square Louvois. The princely carriage had been ordered for eleven o'clock, before the end of the performance. At the appointed time, and as the duke helped the duchess into the carriage standing in front of the side-entrance to the building, in rue Rameau, a man, his hat lowered over his eyes, his coat buttoned to the chin, broke through the ring of bodyguards and thrust himself on the prince, striking him in the side with a dagger.

Mortally wounded but conscious, Berry was laid up in one of the back rooms of the theater. There, and as the performance went on, the duc's family and an assortment of doctors, ministers and senior army officers were summoned in haste. The king himself arrived only in time to listen to his nephew's last wishes, and to close his eyes. France had lost its dauphin. The Bourbon dynasty seemed extinct.[4]

The man who had stabbed the prince was caught that same night in a nearby alley, by the Passage Choiseul. He turned out to be one Louis-Pierre Louvel, a thirty-seven-year-old army veteran employed as a saddler in the royal stables. Louvel confessed to his crime which, he declared, he had conceived and executed alone. Despite such assertions, fear of a possible anti-Bourbon conspiracy spread. In the following months France was combed for accomplices and fellow conspirators. More than 1,200 individuals were arrested and questioned. Meanwhile, Louvel's imprisonment, his trial by a specially convened court of Peers, his defense, and, ultimately, his execution, on 8 June at the guillotine of the place de Grève, riveted the nation's attention.

More than just a sensational event, the murder of the royal heir telescoped the current discontents in French internal politics. The thwarted Ultras pounced on this unexpected opportunity to discredit, with one blow, both the Decazes ministry, on whose laxity they blamed the crime, and the Liberal party, whose agent they openly accused Louvel of being. "Yes, M. Decazes, it is you who killed the duc de Berry," wrote the Ultra *Gazette de France*.[5] From the pages of *Le Conservateur*, Chateaubriand thundered:

> The hand that struck the fatal blow is not the most guilty. The men who have murdered the duc de Berry are those who. . .institute democratic laws within the monarchy. . .those who have thought it their duty to call back the murderers of Louis XVI [i.e. Grégoire]. . .those who have given employment to the enemies of the Bourbons and to the creatures of Buonaparte. . .These are the true murderers of the duc de Berry.[6]

49. Anonymous, *Louvel dans son écurie*. Lithograph, Paris, Bibliothèque Nationale, Cabinet des Estampes.

The *Journal des débats*, which embraced Chateaubriand's views, pointed the finger at a Liberal conspiracy: "No, Louvel's atrocity is not an isolated atrocity; it is the atrocity of an abominable faction, to which a demented individual served as a docile instrument."[7] Parallels were drawn between the revolutionaries of the 1790s and the Liberals of 1820: "An unholy race known, in 1790, by the nickname of Jacobins and, in 1815, under the label of Liberals, has prepared, by means of dark maneuvers, the extinction of the family of the Bourbons and the fall of the kings of Europe."[8] Louvel, dubbed a "monster with human face"[9] who revived the memory of Ravaillac, murderer of Henri IV, and Clément, assassin of Henri III,[10] was presented as the unwitting victim of the fallacious doctrines of radical fanatics, including the abbé Grégoire and Napoleon: "It is not a private hatred, but rather your doctrines [i.e. the Liberals'] that have armed the assassin," an anonymous pamphlet accused.[11] "Who has put the homicidal flame in the hands of the saddleboy Louvel?" another asked. "The virtuous Grégoire... Who has turned his head? The man on the island of Elba."[12] Such views were reflected in a contemporary lithograph which represented Louvel lost in thought in his stable, presumably plotting his crime (Fig. 49). On the walls are prints portraying Grégoire and Napoleon, Louvel's alleged mentors according to the Ultras. The caption denounces the Liberals as "sophistic corruptors," and Louvel as the man "who drank the poison that dripped from your [the Liberals'] mouth."

To Louvel, the Liberal terrorist, was opposed Berry, the quintessential emblem of Ultra Throne and Altar. Praised as an exemplar of bravery and

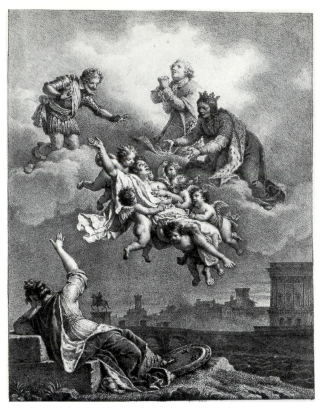 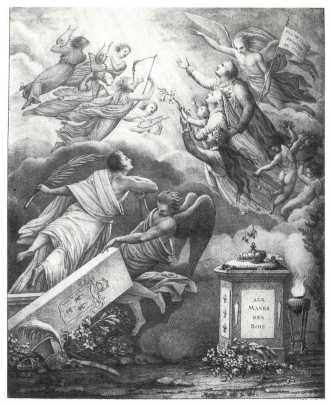

50. Anonymous, *L'Apothéose du duc de Berry*. Lithograph, Paris, Bibliothèque Nationale, Cabinet des Estampes.

51. Ravault, *L'Apothéose*. Lithograph, Paris, Bibliothèque Nationale, Cabinet des Estampes.

generosity "beloved by military men, cherished by the poor,"[13] the duke was mourned as the latter-day heir to earlier royal victims of radical violence including Henri IV and, more recently, Louis XVI.[14] A print issued by Langlumé showed him lifted to the skies by a team of Correggiesque putti into the welcoming arms of Henri IV (Fig. 50). Another issued by Motte, entitled *L'Apothéose*, depicted his shrouded body resurrected to an apotheosis of more recent Bourbon martyrs such as Louis XVI, Marie-Antoinette and the child dauphin, Louis XVII (Fig. 51). A contemporary, allegedly present during the last moments of Berry, described similar visionary experiences: "In that last and cruel moment I thought that I saw [above Berry's deathbed]. . .the busts of Louis XVI and of Marie-Antoinette. I have, since, not been able to verify whether they were indeed there or whether it was my troubled imagination that associated them with that scene of pain."[15] Berry's murder – the same eyewitness contended – was a patriotic sacrifice confirmed by Berry's own last words, "France" and "Patrie."[16]

Religious overtones added a mystic dimension to Berry's death. Pamphlets extolled the prince's past life of devotion marked by uncanny forebodings of his martyrdom. At the sight of a crucifix, it was said, the duke

was not merely content with applying his lips just to the feet and hands of his Saviour, but would next apply them with a tender affection to the wound at His side: as if he could foresee that, wounded one day in the same spot, he would be able to find in the loving heart of Jesus the gift of repentance and the grace of those who are predestined.[17]

50

52. Menjaud, *Derniers moments du duc de Berry*. Versailles, Musée du Château.

Likewise, the last moments of the royal heir were said to be filled with piety, humility and magnanimity. The conservative press lingered on Berry's request for forgiveness from God and bystanders alike, his confession and last communion, and, above all, his plea to the king for mercy on behalf of his assassin.[18] In modest prints just as in official paintings, Berry's death was cast into the format of a Lamentation, with Berry as the dead Christ, his wife as Mary Magdalen and King Louis XVIII as God the Father (Fig. 52).

For the Liberals these were difficult moments. The murder of Berry had certainly revived anti-royalist hope. But to embrace Louvel would mean confirming Ultra allegations of Liberal terrorism and thus falling into the trap set by their opponents. In the end, therefore, the official Left publicly repudiated murder and murderer, and joined the Right in bereavement. For weeks following the event, newspapers and pamphlets of Liberal tendencies denounced Ultra "calumnies" of collective Liberal culpability by stressing, primarily, the solitary nature of Louvel's crime: "The atrocious crime of Louvel is an isolated crime, nothing is more certain than that," wrote the *Constitutionnel*. "Every good citizen has shuddered with horror. How guilty, therefore, are these men who insult public grief and the mourning of France, by means of cowardly calumnies and untruthful accusations."[19] The same daily also published open letters of condolence to the king and royal family by, for example, groups of "Liberal authors,"[20] or military regiments such as the National Guard of Metz (a unit notorious, incidentally, for seditious unrest within its ranks) which expressed the "indignation they felt when they heard that it had been thought that the

monster who killed him [the duc de Berry] could have come from their ranks."[21]

Under the pretense of the official party line, however, jubilant radical sentiment could hardly be contained and the press observed with annoyance that, despite nationwide consternation, it was sadly evident that Louvel's gesture was far from being unanimously reproved. Lucas-Dubreton described swelling unrest in popular Paris neighborhoods, including the working-class Faubourg Saint-Antoine, fueled by crude anti-royalist jokes, disparaging anecdotes about the dead prince, and revived hopes of an imminent Napoleonic return. "Seditious and infamous" posters made their appearance in the main boulevards, in the provinces as well as in the capital, some right on the walls of the Louvre.[22] In a language evocatively and disquietingly peppered with revolutionary vocabulary, broadsides extolled Louvel as a heroic tyrannicide, a defender of liberty and of the rights of man:

> A hero guided by the arm of liberty has just dealt a mortal blow to one of the branches of the tyranny...The friend of the people [*l'ami du peuple*], the immortal and fearless Louvel, this disciple of the Rights of Man, by generously dedicating himself to the motherland permits his able supporters to set a trap which the tyrant and his detestable followers will be unable to escape. Friends of liberty and equality, everything has been foreseen for the destruction of this dynasty. Sharpen your daggers...Then the cry of Death to the Tyrants and to all nobles of the world will be our cherished motto, the distribution of their possessions will be our deserved reward, and fanaticism burnt alive will be expelled from the temple of reason and truth.[23]

More generally, other broadsides were leveled at church and nobility: "Well then, scoundrels whom we call nobility; you pedlars of *oremuses* [prayers], of indulgences and of masses...and other idiots, supporters of slavery; why such sorrow, why such noise? You are the only ones to shed tears, what's so sad about it? Except that yet one more real swine...has ceased to live."[24]

According to such radical lore, Berry was a conglomerate of moral and physical blemishes. He was denounced as a traitor who had, during his years in exile, joined Condé's émigré army to fight with the foreign powers against his own country. He was a *voltigeur* (albeit younger in years) whose title and rank secured his appointment as a colonel under the Restoration. His brutal, humiliating manner (and his British uniform) had won him the hatred of his men.

But even shadier facets (true or false) of Berry's life were unveiled. He was given to drink and lecherous love affairs. When bivouacking with the émigré forces in Germany, he shamelessly chased village girls; during his exile years in England, he chose his many mistresses among women of little virtue, before contracting a more permanent liaison – some said a secret marriage – with an opera singer named Amy Brown. Later, in Paris, and even when he was married to the duchess, his official wife, he continued to see his English mistress, brought over from London, and the two daughters he had had with her. An anonymous brochure summed up Liberal opinion:

> The bottle and the skirt are, they say, the favorite pastimes of the duc de Berry; he drinks copiously, they say...twelve to fifteen bottles of delicious

and very strong wines a day; for a young prince, this is enough to establish a well-founded reputation of drunkenness; after that, he always has two or three mistresses who take turns near him, in this way he spends the better moments of his life between Bacchus and Eros...[25]

In contrast with the duke, Louvel elicited near veneration among Bonapartist and republican sympathizers. Accounts were circulated not only of his sober and industrious present life but also of his model youth as one of the eleven orphaned children of a humble shopkeeper from Versailles, educated as an "enfant de la patrie" at the expense of the revolutionary government. His first readings were, appropriately, the Constitution of 1791 and the Declaration of the Rights of Man and the Citizen. He had fought in the republican army and in the Grande-Armée. He was at Austerlitz, Marengo, and at Waterloo. Napoleon became his hero. Louvel continued to support him in defeat in Elba, and, in 1815, joined him again at La Rochelle from where the Emperor sailed to Saint Helena. His bedside readings – at the time of the murder – were said to include the Constitution of 1791, Voltaire's *Essai sur les moeurs*, and the series *Victoires et revers des armées françaises...depuis le commencement de la Révolution jusqu'en 1815*, which contained accounts of revolutionary and imperial battles.[26] In his answers to police questioning and during his defense, which he wrote and read himself to the court of Peers, Louvel denounced the Bourbons as "tyrants, and the cruelest enemies of France,"[27] responsible for France's humiliating foreign occupation, Louvel's principal motive for his crime:

> When finally the foreign troops entered Paris, France had not been informed in time about the crimes, the treasons, and the secret committee which favored the allied armies to the detriment of our country. It is then that I conceived my plan. I could see that the nation was going to be ruled by its greatest enemies. As far as I was concerned, she was more miserable and more dishonored than being governed by one single conqueror.[28]

Indeed, for Liberal Bonapartists, the antithesis Louvel/Berry only fleshed out the more general *demi-solde/voltigeur* contest to which it brought, in fact, a promising denouement with the final victory of the dispossessed sons of the people over the detested privileged few. And it is in that vein that Louvel was hailed by his supporters as a "modern Brutus" (and even called himself so in his trial), entrusted with the mission of ridding France from tyranny, a patriotic martyr "determined to sacrifice himself in order to destroy the greatest enemies of his country."[29]

What was Louvel like in real life? His military record, published in contemporary newspapers, described him as "one meter and sixty one centimeters tall [five foot two], hair blond, eyebrows the same, short forehead; eyes blue, nose small, mouth small, chin round, face oval...."[30]

Such overall unremarkable, even peaceable, exterior was bound to disappoint contemporary imagination, which had been fired by the horror-filled reports of Louvel's crime and shaped, in addition, by popular versions of the physiognomic and phrenological theories of Lavater and Gall, then much in vogue.[31] Louvel's appearance was, consequently, refashioned to fit his crime, and a darker and more sinister individual emerged, matched to his dark and sinister deed.

Louis Pierre Louvel, agé de 36 ans
assassin de Monseigneur le Duc de Berry le 13 février 1820.

Dessiné d'après nature a son arrivé à la Conciergerie.

Dépose à la Direction.

Louis Pierre Louvel

Dessiné dans la nuit du 13 au 14 dans l'antichambre de l'administration de l'Opera
pendant le 1er interrogatoire

chez Martinet.

Litho. de l'Motte.

Louvel's eyes, for example, were recolored as black or, at best, steely grey. They were "somewhat deep-set in their sockets due to the somber inclination of his character."[32] Louvel's features were seen as bearing "the imprint of a profound and somber meditation."[33] As if this were not enough gloom already, on the day of his trial Louvel was said to have worn "a black coat, buttoned all the way up to a tie of the same color."[34] Somber exterior reflected abysmal interior, of course. Louvel was dubbed a "fierce character" and "an anti-social individual,"[35] who "lived away from human society. Sullen, anxious, silent, he avoided public sites."[36] With wondrous confidence, one brochure asserted that he resembled Cain.[37]

Printed portraits of Louvel, even those done, purportedly, from life, echoed similar fictions.[38] In one print Louvel's ominous bust, dark-eyed, dark-haired and clad in black, looms over his similarly black dagger (Fig. 53). Immediately reflecting the impact of physiognomic treatises, prints (Figs 54 and 55) awarded Louvel the harsh features, menacingly knit eyebrows, and thin-lipped mouth of Lavater's malignant type (Fig. 56); a ring hanging from Louvel's ear (Fig. 54) added associations with Revolution and republicanism. Horace Vernet's lithograph of Louvel (Fig. 57), done allegedly from life during the trial, nevertheless repeats the same horrific formula.[39]

Commercial in purpose, it is evident that these prints were intended to respond, primarily, to a broader public's expectations. The artists's or printers's

54

LOUIS PIERRE LOUVEL.
*Déssiné sur la place de Grève, en montant
à l'Échaffaud.
le 8 Juin. 1820.*

53. Anonymous, *Louis Pierre Louvel.* Lithograph, Paris, Bibliothèque Nationale, Cabinet des Estampes.

54. Anonymous, *Louis Pierre Louvel.* Lithograph, Paris, Bibliothèque Nationale, Cabinet des Estampes.

55. Henriquel-Dupont, *Louis Pierre Louvel*, 1820. Lithograph, Paris, Bibliothèque Nationale, Cabinet des Estampes.

56. Anonymous, *Malignant type.* Engraving, from J. C. Lavater, *Essays on Physiognomy*, 1804, vol. 3, part II, p. 317.

57. Vernet, *Louis Pierre Louvel*, 1820. Lithograph, Paris, Bibliothèque Nationale, Cabinet des Estampes.

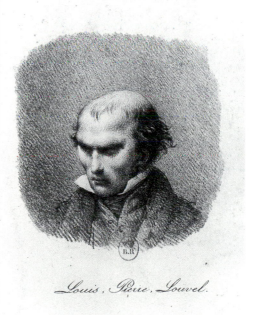

Louis . Pierre . Louvel.

58. *Voltaire*. Engraving, from J. C. Lavater, *Essays on Physiognomy*, 1792, vol. 2, part I, p. 90.

59. Delacroix, *Louis XVIII, the comte d'Artois and the duc de Berry*. Drawing, Paris, Musée du Louvre, Cabinet des Dessins (RF 10241).

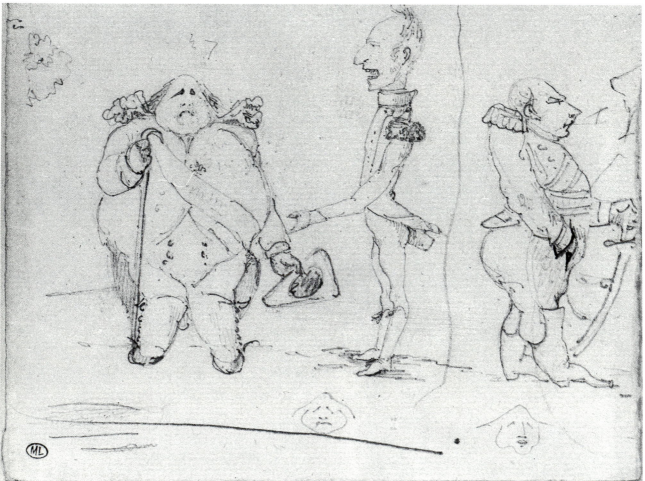

private political allegiances clearly interfered very little with such exploitation of a profitable market. Langlumé, Martinet and Motte, for example, who were responsible for the bulk of anti-government caricatures during the Restoration, also published prints exalting Berry and condemning Louvel. Horace Vernet's Liberal Bonapartism did not prevent him from creating a sinister image of Louvel, just as, one year earlier, it had not stopped him from accepting a commission for two military pictures (albeit with Napoleonic themes) for the duc de Berry.

Delacroix, too, was not exempt from a dose of opportunism in these matters. Like his fellow Liberals Vernet and Géricault, he eagerly pursued official recognition and official commissions in the 1820s. But in the case of Louvel (Fig. 48), he seems to have remained true to the allegiances expressed in his anti-royalist cartoons.[40] Indeed, this is hardly the face of a ruthless killer and seems even less so in comparison with the gloomy and menacing portraits just examined. For, apart from restituting the murderer to his original fair complexion and soft features (a fact that can only be fully appreciated when looking at the original lithograph), Delacroix also gave him the confidently happy expression of an idealist – or a divinely inspired madman – imbued with faith in his mission and with a calm confidence in the ultimate equity of providence. Louvel's eyes glow, his lips are parted in a faint smile and his whole face radiates as if with inner light. A soft breeze blows his hair and tie forward, adding a touch of exalted spirituality to his countenance (a typical romantic symbol alluding to genius as portraits of Byron or Chateaubriand – such as the well-known one of the French author in Rome painted by Girodet – remind us). Among Lavater's illustrations of human types, in fact, Louvel's serene, inspired expression conforms to images of superior human nature (Fig. 58). And although we cannot be entirely sure of Delacroix's precise intentions, visually at least this seems to be a benevolent image, one that reflected Louvel's supporters' ennobling vision of him as a patriot and a martyr of liberty who did not, in Louvel's own words, "hesitate to sacrifice [himself] for [his] country."[41] Such positive overtones may also explain why Delacroix's print was issued in only a few, preciously rare, copies destined, we have to assume, not for the large, popular market, but only for a handful of like-minded initiates.

That the perception of such Bonapartist extremists could have coincided with his own private sentiment on the event is borne out by one of Delacroix's contemporary satirical drawings (Fig. 59).[42] In it, lined up to reflect the order of dynastic succession, we have, from the left, Louis XVIII, corpulent, puffy and crippled by gout; in the middle, his brother the comte d'Artois, father of the murdered heir, a hideously hydrocephalic figure; and to the right, the duc de Berry himself as a monstrous and obese hunchback whose hand, pointedly slipped into his open fly (note also the telltale position of the sword), suggests (much like the disparaging pamphlets quoted earlier) the prince's lecherous nature.

For Delacroix as for Restoration radicals, therefore, Berry's murder must have represented the felicitous end to the threat of a concatenation of decadent and impotent rulers governing France. And it is possible that in his benign portrayal of the murderer the artist subtly introduced some of this hopeful vision.

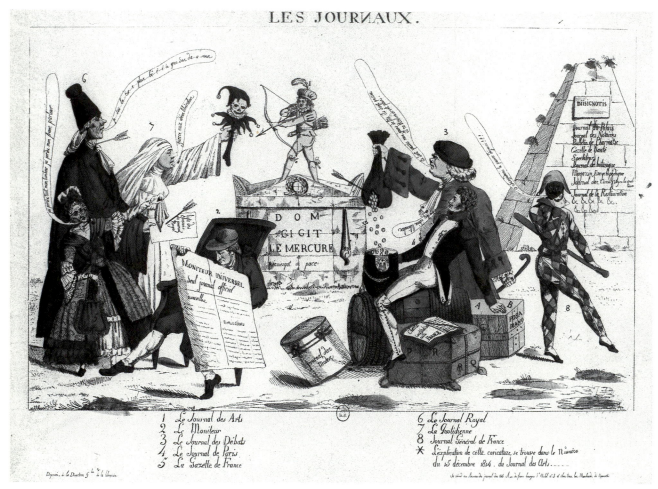

60. Anonymous, *Les Journaux*. Etching, from *Le Nain jaune*, 1814, Paris, Bibliothèque Nationale, Imprimés.

Censorship is Dead! Long Live Censorship!

Censorship, when it is in the hands of the government, can become the weapon of one political party. This is undoubtedly true. But this party will at least be that of the Monarchy, of France, of the Charter, of the house of Bourbon, of liberty. And this party must triumph at all costs.

Le Moniteur, 4 March 1820

FIVE OF DELACROIX's satirical prints, four lithographs published by the *Miroir* and one hand-colored etching issued by Martinet, comment on the artist's contemporary journalistic scene. They testify to the tribulations of the press in its relation with the Bourbon administration between 1815 and 1822, while also revealing the tensions immanent in the densely populated and competitive world of Restoration newspapers and journals. That the *Miroir*, which was in permanent conflict with the censoring authorities, would commission cartoons commenting on the situation of the press seems normal. What gives these images additional bite, however, is that at a time of right-wing control of public opinion they also served as allegorized vehicles for the oppositional views nurtured by the liberal middle class.

Under Napoleon, the French press, controlled to near extinction, had been reduced to a handful of newspapers of which even fewer were still in circulation in 1814. Of the four authorized papers for the Parisian region – the *Gazette de France*, the *Journal de l'Empire* (formerly *Journal des débats*), the *Journal de Paris*, and the *Quotidienne* – the first three alone were still in print at the advent of the Bourbons; the *Quotidienne* was suppressed in 1797.

Into this journalistic deadlock, the First Restoration breathed new life. On 4 June 1814, the royal administration proclaimed the freedom of the press warranted by article 8 of the Charter in these terms: "The French have the right to publish and to print their opinions, while abiding by the laws intended to check the abuses of such freedom."[1] No matter how circumspectly formulated, the provision had an invigorating effect on the press: a host of new dailies and journals sprouted virtually overnight, while previously extinct publications, including *La Quotidienne*, resurfaced. By 1815, there were at least twenty newcomers on the journalistic scene.[2] With long repressed energy, the press launched itself in the political arena, taking sides for Right or Left, applauding the Bourbon government or attacking it, extolling the benefits of constitutionalism or pointing out its dangers, rooting for the Emperor or denouncing the "Usurper," admonishing, debating, approving or reproving, in short acting as the multiple echo of the reawakened public spirit. Alphonse de Lamartine was later to recall:

The confrontation of opinions, of antipathies, of essays, of sarcasms, of hatreds, of provocations, of invectives which infused the passionate exchanges and the scandals of political debate in the Chambers were continued outside in the daily newspapers which the new freedom of the press had made more numerous and more aggressive. All the great literary talents of the time armed themselves for the fight with a permanently polemical tone that transformed any intercourse into a controversy. Public spirit, which had been quelled for so long by the military and by despotism, surged anew with a thousand voices. Everywhere, one could feel the explosive emergence of a new century in men's souls. France was seething with ideas, with ardor, with zeal, with passions . . .[3]

Varieties of political views matched by varieties of journalistic writing gave each newspaper individual character, its own distinct personality. Seizing on this diversified profile of the press, the satirical imagination of the time was quick to give it bodily form. Personified newspapers, each awarded special features, dress and temperament, were made to incarnate varieties of public opinion. The inventor of this device was once again the indefatigable *Nain jaune*. A hand-colored caricature entitled *Les Journaux*, included in its first issue of 15 December 1814, is a burlesque of conservative newspapers which also ingeniously charts the complex physiology of the Restoration press (Fig. 60).[4] Personified papers are assembled around the gravestone of the *Mercure de France*, a magazine of Liberal tendencies which had temporarily stopped publication. Perched on the stele, the Liberal *Nain jaune* (or *Journal des arts* as its subtitle went) (no. 1), posing as the heir and avenger of the *Mercure*, is a minuscule yellow-clad Jester-cum-Cupid who aims his poisonous darts against the bizarre assortment of men and women in the foreground, the representatives of the conservative press. On the left stands the royalist and religious *Quotidienne* (no. 7), which a contemporary described as "the official gazette of the aristocracy, of privilege and, primarily, of the clergy. Among the men who dwell in her offices one encounters only abbés and marquis."[5] Dressed like a nun, the *Quotidienne* calls for "War to Liberal ideas." Next to her, the *Journal royal* (no. 6) takes on the appearance of Bridoison, Beaumarchais's foolish and complacent judge from the *Marriage of Figaro*.[6] The *Gazette de France* (no. 5), nicknamed "la voltigeuse," is a desiccated spinster whose rococo hooped dress harks back to her Ancien Régime loyalties.[7] The conformistic *Moniteur universel* (no. 2), the official government daily, is shown in the hands of a reader who dozes, overwhelmed by "the feeling of dignity which pervades its lines throughout; it never deigns to stoop to jokes or epigrams."[8] To the right, we have the *Journal des débats* (no. 3), whose bulky figure evokes its portly editor, Louis-François Bertin (also known from Ingres's famous later portrait at the Louvre). The *Débats* weeps bitter tears, the *Nain jaune* told its readers, because its rival, the *Journal de Paris* had recently won over 1,300 new subscribers in a single day, and the *Journal général*, 300 subscribers.[9] The *Journal de Paris* (no. 4), in the uniform of a Napoleonic officer who holds out his *bonnet de poil* to collect the *Débats*'s diverted profits, is, in turn, described as a spineless individual who voiced a mixture of constitutional and Bonapartist views. As to the *Journal général* (no. 8), it dons the diamond-patterned suit of Harlequin to suggest the shifty "diversity of its opinions"[10] and the instability of

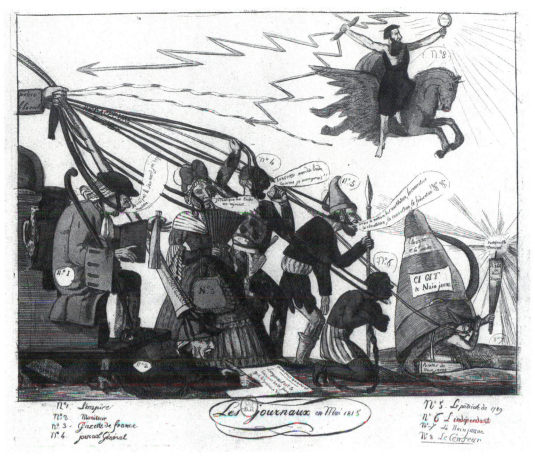

61. Anonymous, *Les Journaux en mai 1815*. Etching, Paris, Bibliothèque Nationale, Cabinet des Estampes.

its allegiances, for "it floated for a long time uncertain as to which party to devote itself."[11]

No sooner had the restored Bourbon government announced the freedom of the press, however, than it proceeded to restrict it. A press law passed in October 1814 required that, prior to publication, all new dailies obtain governmental authorization, and that all writings of less than twenty pages be submitted to preliminary censorship. The editors of Parisian newspapers were to apply to the Director-General of the police for authorization, and a list of censors was posted. In the first years of the Second Restoration, dominated by the White Terror, the situation evolved toward even greater rigor. To the requirements for advance authorization and preliminary censorship, a new press bill, passed in November 1815, added the provision that writings deemed potentially damaging to the monarchy, the constitution, and the preservation of domestic and international peace were to be refused the right to be printed. Newspaper owners and authors were to be fined and imprisoned, and the guilty publication suspended.[12]

Among the first victims of the new law was, predictably, the *Nain jaune*. Ordered to silence by royal decree, the journal appeared for the last time on 15

LES TROIS NAINS LITTÉRAIRES,
Ou les bâtards du Nain Jaune.
Se Disputant ses Dépouilles.
A Paris chez Martinet Libraire Rue du Coq St Honoré.
Déposé à la Direction G^{le}

62. Delacroix, *Les Trois Nains littéraires ou Les Bâtards du Nain jaune se disputant ses dépouilles*, 1815. Etching, Paris, Bibliothèque Nationale, Cabinet des Estampes.

July 1815, before taking the road to exile in Belgium. An anonymous caricature of May 1815 forecast the *Nain*'s impending doom while also commenting on the new bondage of the press (Fig. 61).[13] Using the satirical vocabulary invented by the *Nain* itself, it represented a group of personified newspapers and journals like hounds on leashes held firmly by the hand of an invisible "Police" labeled, ironically, "libérale." At the head of the captive cohort crouches the *Nain jaune* looking like a giant hermit crab. He is about to be buried in the eternal darkness of his candle-extinguisher shell, an allusion not only to governmental obscurantism, but also to the journal's insolent pranks which had triggered official ire. Though nearly in his grave, the indomitable *Nain* still holds out a blazing torch, a statement of his commitment till death to enlightenment, truth and reason.

The *Nain jaune*'s demise gave rise to its journalistic nemesis in the form of three shortlived satirical magazines with pointedly similar names, but with diametrically different, right-wing, sympathies. From the outset, the three journals – the *Nain vert* (1815), the *Nain couleur de rose* (1815–16), and the *Nain blanc* (1815–16) – posed as the avengers of the *Nain jaune*'s conservative victims and as the detractors of its Liberal supporters.[14] To make their counter-attack more effective they imitated the *Nain*'s format, writing style, cartoon inserts and humorous devices, including the infamous *éteignoir* which, of course, they awarded to their Liberal foes.

The conservative emulators of the *Nain jaune* are the subject of Delacroix's caricature *Les Trois Nains littéraires ou Les Bâtards du Nain jaune se disputant ses dépouilles*, a colored etching published by Martinet in September 1815 (Fig.

62

62).[15] The three new *Nains* are portrayed like monkeys (the crafty opportunist's symbol, it will be recalled), a green, a pink and a white one, an allusion to their imitative as well as opportunistic nature. They are busy plundering the *Nain jaune*'s open grave, that is stealing the journal's ideas and inventions. With deliberate irreverence, Delacroix gave his image the compositional format of well-known religious scenes, such as the division of Christ's garments or the Resurrection. The *Nain* is thus by implication a martyred Christ of state press control.[16] The print reveals Delacroix's sympathetic response to the *Nain jaune*'s plight, his contempt for the journal's conservative parodists, and, above all, his rejection of the government's severe sanctioning of public opinion.

The hostile climate surrounding the press at the beginning of the Second Restoration abated with the advent of the tolerant Dessoles-Decazes ministry, late in 1818. In 1819, the "Serre laws," drafted by Justice Minister, comte Hercule de Serre, ended police control of newspapers and signaled a period of relative freedom for the press. But one year later, the murder of the duc de Berry brought censorship back in full force. A new press law, voted on 31 March 1820, reinstated preliminary authorization and preliminary censorship. A Commission de la Censure was appointed with headquarters in the capital, and branches in the chief towns of the departments. On 3 April 1820, the Paris censorship committee, constituted of prominent members of the journalistic and literary establishments, held its first meeting at its premises, 13, rue des Saints-Pères. The next day all Parisian newspapers appeared censored.[17]

The law of March 1820 triggered angry responses from left- and right-wing dailies alike (the latter's vehemence was deemed equally harmful as the subversive comments of the left-wing press). Several newspapers chose to close down rather than write under the supervision of censors. Both Chateaubriand's royalist *Le Conservateur* and Benjamin Constant's Liberal *La Minerve française*, for example, ceased publication. In protest, censored articles were published with large blank or dotted spaces in place of their cancelled texts. In the hope of deceiving the censors, some political dailies, including the *Miroir*, took on titles that suggested literary and artistic, rather than political, contents. Allusions, allegories, insinuations and oblique hints proliferated. Mockery, wit and satire replaced direct political criticism.[18]

In this climate of concealment, the familiar metaphor of a society of personified newspapers became a convenient and safe vehicle of displaced political discourse. Liberal newspapers, especially, thrived in seemingly innocuous fables of humanoid dailies engaging in political debate. Taking its cue from the *Nain*, its forebear, the *Miroir* imagined a group of newspapers in a morning stroll in the Luxembourg gardens. The dailies' stature suggested their circulation volume; their course – center, left, right – indicated their political alignments:

> The *Moniteur*, boasting of its tall stature of a drum-major, was pacing along with a solemn and measured step in the center alley. *L'Étoile*, which reached barely to his hips, dragged herself near the ground, by his side; she had embroidered her collar in order to achieve a more official look...Dame *Quotidienne* in hooped dress, demoiselle *Gazette* in a hood, Messire *Drapeau blanc*...trotted and hopped on the right...The *Constitutionnel* and the *Courrier* followed with a steady step a straight alley, on the left. The *Miroir* walked in the same direction...[19]

Combat entre la Quotidienne et le journal du Commerce.

63. Anonymous, *Combat entre la Quotidienne et le Journal du commerce*, 1818. Lithograph, Paris, Bibliothèque Nationale, Cabinet des Estampes.

Another similar story told of Parisian newspapers gathered to celebrate New Year's Day at the home of the *Gazette de France*, described as a venerable old lady. After the customary polite exchanges, the conversation turned, inevitably, to politics:

> Politics which is present everywhere, no matter how much one agrees not to talk about it, was brought up by the *Drapeau blanc*. They spoke calmly at first, soon however the tone became sharper, everyone started sounding like their newspapers. The *Quotidienne* turned crimson; the *Drapeau blanc* had already his hand on the hilt of his sword, and the gentleman of the *Débats* was yelling like a blind man, at which point the wise *Moniteur*, seeing that one never agrees on political issues, brought back the conversation on literature...[20]

In real life, squabbling newspapers of opposing political views suggested the seething tensions of quelled public opinion. A famous such feud opposed the Ultra and devout *Quotidienne* to the Bonapartist, Liberal and free-thinking *Constitutionnel*. Already in 1817, a contemporary reporting on the state of the press noted that "*La Quotidienne* and *Le Constitutionnel* tear each other to pieces three hundred and sixty-five times a year and three hundred and sixty-six times in a leap year," and remarked on the *Quotidienne*'s "hateful, taunting, bitter" temperament and on the violence of its attacks.[21] The conflict between the two newspapers even inspired a caricature in 1818 entitled *Combat entre la Quotidienne*

64

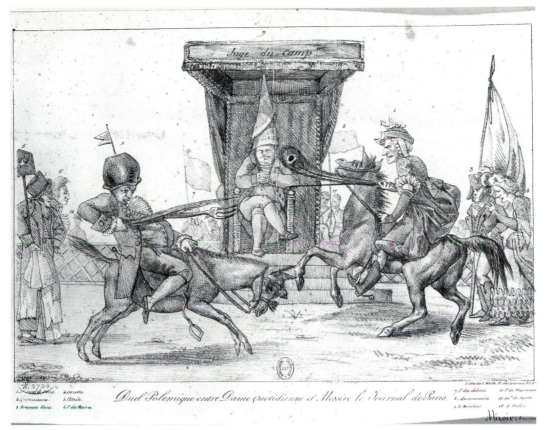

Juge du Camp

Duel Polémique entre Dame Quotidienne et Messire le Journal de Paris.

64. Delacroix, *Duel polémique entre Dame Quotidienne et Messire Le Journal de Paris*, 1821. Lithograph, Paris, Bibliothèque Nationale, Cabinet des Estampes.

et le Journal du commerce (the *Constitutionnel*'s alternative name between 1817 and 1819) (Fig. 63). Armed with the symbolic mirror of truth and Montesquieu's *Esprit des lois*, the youthful *Constitutionnel*, in the pose of Romulus from David's *Battle of the Romans and the Sabines* (1799), rises as the defender of reason, progress and democracy. Across from him, the ageing *Quotidienne*, wearing a mask and wielding a fan and a parasol – accessories alluding to both Ancien Régime and concealment – stands as the emissary of reaction and deceit.

The spite of the belligerent *Quotidienne* would sometimes be aimed at dailies of its own persuasion as well. In 1821, the target of its wrath became the wobbling *Journal de Paris*, the irresolute speaker for liberal conservatism. From the Liberal lines and with unbridled glee, the *Miroir* reported such hostile exchanges between the two papers as the *Quotidienne*'s accusations of the *Journal* as "somniferous" and "vulgar," and the *Journal*'s indictments of its opponent as "base informer" and "atheist."[22]

Delacroix's caricature for the *Miroir*, *Duel polémique entre Dame Quotidienne et Messire Le Journal de Paris*, of 29 September 1821, like *Le Nain jaune*'s print before it, mocks the conservative press through its two warring representatives, which it depicts engaged in a ridiculous joust and echoing the common, at the time, pairing of aristocratic reaction with feudalism (Fig. 64).[23] The two contenders assume the appearance of Cervantes' protagonists: the lanky *Quotidienne* on its bony nag is Don Quixote; the pot-bellied *Journal de Paris* on an ass is his sidekick,

65. Anonymous, *Convoi de la Quotidienne*. Etching, Paris, Bibliothèque Nationale, Cabinet des Estampes.

66. Anonymous, *L'Enterrement de la censure*. Etching, Paris, Bibliothèque Nationale, Cabinet des Estampes.

Sancho Panza.[24] A tiny weathervane on top of the *Journal*'s chamber-pot head-gear and a barometer attached to his chest allude to his shifty opportunism.[25] Hinting at her unpatriotic flattery of the Russian occupants of France, in 1815, the *Quotidienne* sports boots "à la Suwarow," named after the Russian General Aleksandr Suvorov who had defeated the French republican armies in Italy, in 1799. Presiding over the combat is a sleepy *Moniteur*, majestically enthroned under a dais to refer to his capacity as the government's official paper. The *Moniteur*'s telltale conical bonnet, made out of one of his printed pages, also identifies him as a member of the Order of the Candle-extinguisher, perhaps even as the Grand Master Misophanes himself. The *Moniteur* is flanked by groups of anxious representatives of the conservative press: the *Drapeau blanc*, the *Gazette*, the *Étoile* and the *Journal des maires*. As opposed to the conservative press symbolized by ageing and decrepit personifications, the Liberal press is associated with youth and modern fashions. The Liberal newspapers, among them the *Miroir* itself, are shown as smartly dressed young men peering at the grotesque sight from behind the canopied platform with evident signs of hilarity.

The *Quotidienne*'s belligerence did not gain it much popularity, however. Late in 1821 its readership declined to such a degree that closure became imminent.[26] Delighted, the Liberal press hastened to announce its funeral. The *Miroir* described the *Quotidienne*'s last moments and its funerary cortège attended by its right-wing companions such as the *Drapeau blanc*, the *Étoile*, the *Gazette* and the *Moniteur*. The latter "did not shed any tears, considering that they hoped to inherit the small number of subscribers that the defunct was leaving behind . . ."[27] In the same vein, an anonymous cartoon envisioned a burial procession in which the dead *Quotidienne*, carried by *éteignoir*-capped and donkey-eared pall-bearers, is accompanied to her last abode by bereaved colleagues (Fig. 65).

Late in 1821, Villèle's Ultra ministry, which had succeeded Decazes, once again altered press control procedures. Censorship and censorship committees were ostensibly abolished, but the press law was redrafted to include restrictive measures of a subtler type such as the "tendencies" bill. This stated that news-papers, journals and writings whose overall tendency could be perceived as potentially damaging to the crown or the church, as well as to public peace and morality, were to be brought to trial. Such an amendment was dangerously undefined and open to abuse. Despite vigorous protest in Parliament, it was passed in March 1822. During the next year lawsuits against newspapers and journals multiplied.[28] *Le Miroir* alone was the subject of no less than nine in two years. In December 1822, a few months after it published Delacroix's last cartoon, its editor was condemned to prison and a heavy fine. It was suppressed altogether on 24 June 1823.[29]

But in the meantime, and although hounded from all sides, the *Miroir* still mustered the wit to celebrate the abolition of censorship with a satirical piece entitled "Funeral Home. The last moments of Censure, her death, her testa-ment, her funerary procession, her obituary and her apotheosis," published in its issue of 18 February 1822:

No sooner had the defunct surrendered the little mind that she possessed, than the two notaries who acted as executors of her will proceeded to fulfill it.

Le Déménagement.

N°1. Maison à louer.
 2. Pain-de-Sucre.
 3. Une Mazure.
 4. La Chaise.
 5. d'Outre-zèle.

6. Cadet-Roussel.
7. un Vieillard.
8. une Lourde-Oye.
9. un Anonyme.

Miroir (Journal).
Devéria

67. Delacroix, *Le Déménagement*, 1822. Lithograph, Paris, Bibliothèque Nationale, Cabinet des Estampes.

Announcements of her passing were dispatched to all "obscurantists." The entire corps of *voltigeurs* in mourning arrived instantly, and the *Quotidienne* in mourning veils . . . In order not to deprive the eyes of her admirers of the sight of the modern Gorgon, . . . she was to be suspended by means of a rope inside a huge glass jar containing red ink . . . The undertaking was istantly carried out, so much had Censorship become insignificant ever since she died.[30]

As in the case of the *Quotidienne*'s death, an anonymous cartoonist recreated the funerary procession of Censure, in which giant scissors – censorship's traditional emblem – were raised high, and personified newspapers carrying banners openly expressed their satisfaction (Fig. 66). The death of the Lady Censure, the *Miroir* contended, came as a result of spleen due to her disgrace with the administration: "Having to move house she was reduced to vagrancy, and having no more leaves to suck, the unfortunate caterpillar died of exhaustion . . . after making her will."[31]

Delacroix's *Le Déménagement*, published by the *Miroir* on 11 February 1822, alludes to the abolition of censorship by showing the censors as a strange bunch of symbolic figures piled up in a cart that drives, led by the devil, away from their abandoned and boarded-up headquarters at rue des Saints-Pères (Fig. 67).[32]

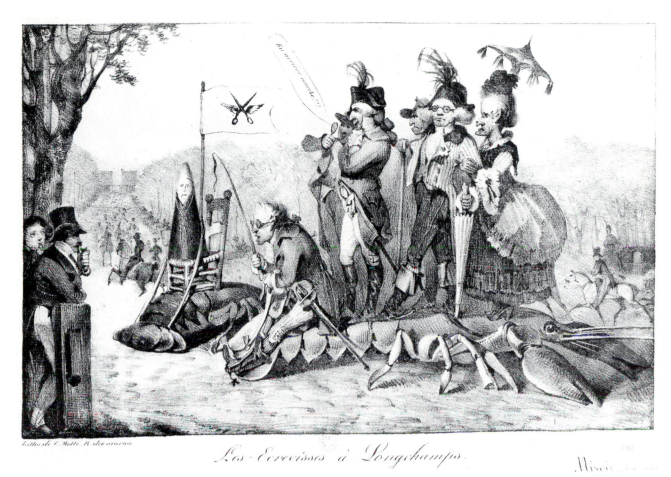

Les Écrevisses à Longchamps.

68. Delacroix, *Les Écrevisses à Longchamps*, 1822. Lithograph, Paris, Bibliothèque Nationale, Cabinet des Estampes.

Delacroix used visual puns to suggest, without naming them, the identities of the dreaded censors. I have been able to identify the following: in the conical form of an *éteignoir*-like sugar-loaf, or "pain de sucre," Marie-Joseph Pain, writer of popular vaudeville and theatrical censor of the commission (no. 2);[33] as a ruined shack or "masure" (no. 3), censor F. A. J. Mazure, the author of education manuals;[34] as the chair, "la chaise" (no. 4), on which Pain sits, Lachaize, a censor appointed to the commission in 1821;[35] as the sulky "d'Outre-zèle" (excessive zeal), Abbé Bathélemy-Philibert Picon d'Andrezel, a former émigré bishop who also held the post of Inspector-General of the University (no. 5);[36] as "Cadet-Roussel" (no. 6), the Academician Rousselle who joined the committee in 1821;[37] as the old man in a cap and dark glasses labeled "un Vieillard" (no. 7), the poet P. A. Vieillard who served as literary censor.[38] The plump goose (no. 8), designated as "Lourde-Oye" (heavy goose) and perched on the back of the craven donkey, or "âne" for "an-onyme" (no. 9), is Jacques-Honoré de Lourdoueix, the Ultra journalist of the *Gazette de France* and president of the Paris censorship bureau.[39] Once again Delacroix brings together smartly dressed bourgeois and grotesque protagonists in order to highlight the ridiculous nature of the latter by opposing it to the smart common sense of the former. A group of fashionably dressed men, in the distant left, seem to be

69

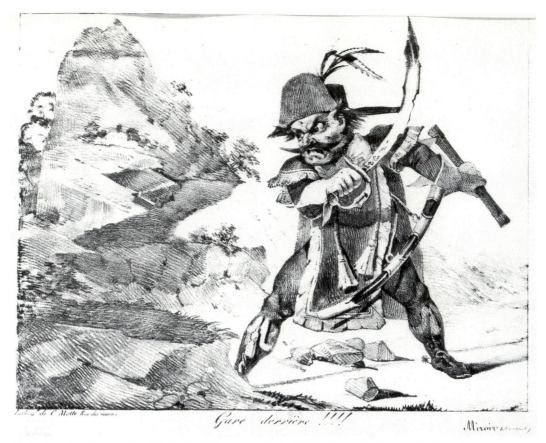

69. Delacroix, *Gare derrière !!!!*, 1822. Lithograph, Paris, Bibliothèque Nationale, Cabinet des Estampes.

asking about the ultimate destination of the convoy. From the top of the heap, censor Rousselle points toward the flying devil as if to respond: "Au diable [To Hell]." In the wake of the bizarre cohort rises a flock of black, menacing-looking, winged scissors, the censors' tools and attributes.

Censors, scissors and crayfish meet once more in Delacroix's caricature *Les Écrevisses à Longchamps* issued by the *Miroir* on 4 April 1822 (Fig. 68).[40] In the elegant Longchamps promenade, on the outskirts of the Bois de Boulogne, smartly dressed men on horses and in plush carriages are seen riding along the avenue of the Champs-Elysées in the direction of the unfinished stumps of the Étoile arch, a symbol of the Empire and an allusion, here, to Liberal Bonapartist ideology. Two bizarre carriages in which gigantic retreating crayfish hold the place of horses have deviated from this course. Their riders, grotesque old men and women in outdated dress, succinctly allude to the two powerful pillars of Ultra opinion: censorship and the royalist press. On the one, which flies the be-scissored banner of the censor, rides Pain's ubiquitous sugar-loaf figure enthroned on Lachaize's chair. On the other, we see *La Quotidienne*, the dowager leaf in rococo outfit, in the company of several wigged and monocled *voltigeurs* identified by the *Miroir* as press censors and Academicians (the Ultra and "voltigeuse" *Quotidienne* had obviously nothing to fear from them). The choice of crayfish for mounts, the *Miroir* wrote, "was perfectly suited to these men who never rose to any heights and usually walked backwards."[41] Confirming such

70

allusions to intellectual and political reaction, one of the *voltigeurs* shouts the motto of the Order of the Crayfish: "En arrière, marche [Backwards, go!]."

The crustacean convoys are met, on the left, by two young men (one of them held to be Delacroix himself), the familiar, by now, bourgeois denigrators of the old order. The youthful observers laugh and blow whistles at the crayfish and their mounts, both in mockery and in a vain effort to alert them to their mistaken course. The meaning of such imagery is clear: adhering to Liberal Bonapartism, as the riders and carriages in the distance seem to do, was bound to lead to a future of progress and prosperity; straying from that road could only lead to delusion and ridicule. Symbolic references to Ultra rejection of modernity and progress in favor of the past and reaction borrowed, at the time, a similar allegorical language. Thus an anti-government pamphlet of 1820:

> Our political crayfish will not let go, they insist on walking backwards. It is in vain that people from all sides are shouting to them: "Go forward on the grounds of the Charter with an honest and loyal gait; fear nothing, not even your own ineptitude! The French nation will correct your blunders, and by constantly whistling at you will end up turning you into tolerable actors."[42]

Delacroix's last caricature for the *Miroir*, *Gare derrière!!!!* (Watch your rear!), published on 30 May 1822,[43] also attacks censorship and, beyond it, Ultra ideology as well (Fig. 69). A grotesque policeman or National Guard is seen fiercely thrashing at an outcrop of land, while, in the rear, fearful-looking men take refuge behind a conical mound. Its *éteignoir/pain de sucre* shape identifies it as the symbol of censorship. (In his poem "Le Censeur" (1822). Béranger used a similar image when he evoked "la censure, à son rocher funeste.") The frightened men are surely the members of the (disbanded) censorship committee. The giant swordsman is an emissary of the police authorities who executed the censors's verdicts. The policeman, the *Miroir* told its readers, was called "De Monts-Coupés" (Cut Mountains), a name that closely evoked "De mots coupés" (cut words). The name of the invisible "mountain" at which he brandished his sword was, on the other hand, "Fantôme" (ghost), a reference to the censors's excessive, often imaginary, fears.[44] The caption of the print with its warning "Watch your rear!" implied that the real threat lay not in the ghostly, non-existent mountain in front of the policeman, but instead in his rear, where the members of the censorship committee lurked.

In its commentary on *Gare derrière,* the *Miroir* directly linked censorship and the Ultra faction. Given that censorship committees had been officially abolished – the newspaper mused – the valorous "De Monts-Coupés," now out of work, was appointed meat carver to "Prince Galaor" – an Ancien Régime nickname for the comte d'Artois, the king's brother and leader of the Ultra party.[45] Seen through such allusions, Delacroix's caricature takes on the character of a gloomy prophecy: for, in its depiction of a ferocious sword-wielding monster, it hinted at the inexorable rise of repressive Ultra power which, ushered in by the conservative reaction of 1820, was to be sanctioned in 1824 with the ascent of "Galaor" to the throne as Charles X, and to culminate in the latter's increasing absolutism during the final years of the Restoration.

CHAPTER 6
"Rossinisme" as Modernism

> Rossini addresses our intelligence better and has a more intimate grasp
> of the secret of our tastes and of our impressions. In the music of
> Rossini there is something indefinably alive and actual which is
> lacking in Mozart's magnificence.
>
> (Stendhal), "Théâtre italien," *Le Miroir*, 5 August 1821, p. 2

IN ITS ISSUE OF 6 December 1822, the *Miroir* published a satirical piece entitled "Les Ciseaux," an "open letter," allegedly by one Eustache from Châtellerault who claimed the joint identities of "homme de lettres" and "coutelier" (cutler). Under the humorous pretense of an historical investigation into the origins and usages of scissors – the product of his trade, but also the tool and emblem of censorship – Eustache cynically argued that owning a pair of scissors (i.e. being a censor) was the surest road to a successful literary career: "I am not afraid to maintain that in literature, for example, a pair of scissors is more useful these days than a penknife, and a man who wants to prosper and, like everybody else, make the Academy should arm himself with one..." Conservatism, the Academy and classicism went hand in hand, Eustache further suggested. "In Praise of Scissors" should, therefore, be the Academy's proposed topic for its next poetic contest and the winning piece should be in verse, preferably an ode. In fact, Eustache promised to "present the winner with the most beautiful pair of scissors to be found in my shop, and to this I will also add a corset if the piece is in verse, especially if it is an ode: an ode definitely deserves that [the corset]."[1] Thus, with feigned naivety, Eustache's letter exposed the hidden ties between politics and art, conservative government and official cultural institutions, intellectual establishment and aesthetic choice. More particularly, it hinted at the role of the Academy as the officially appointed sentry of artistic orthodoxy during the Restoration.

Abolished in 1793, the Academy had re-emerged two years later as the Institut National des Sciences et des Arts. It grouped the various scholarly disciplines under three umbrella categories called Classes. Literature and the Fine Arts (including music) formed the Third Class until 1803, when the Fine Arts, severed from Literature, were granted independent status as the Institut's Fourth Class. Shortly after the advent of the Bourbons, in March 1816, the Institut, now also referred to as Académie Royale, was restored by royal decree to its Ancien Régime status as directly under the king's protection: its four classes, rebaptized with the pre-revolutionary *académies*, were comprised of the Académie Française (for French language and literature), the Académie des Sciences (mathematics, physics, chemistry, medicine), the Académie des In-

scriptions et Belles-Lettres (ancient languages, archaeology), and the Académie des Beaux-Arts (painting, sculpture, architecture, music).

The Restoration also undertook a political overhaul of the Academy's administration and membership. Thus in the Académie Française, extensive purges replaced Academicians known for their left-wing sympathies with others, mostly non-elected government appointees, loyal to the monarchy. By the early years of the new regime the academic body was composed of an aristocratic and bourgeois majority whose common ground was its loyalty to the crown and to the classical tradition.[2]

Restructured and "purified," the Académie Française became the bastion of the ideological and aesthetic status quo. The works of past and present French authors were carefully scrutinized for conformity of content and form. Books were put on index, or ordered to be seized and destroyed. Among the first to be banned were the writings of the eighteenth-century *philosophes*, especially Voltaire and Rousseau.[3]

In its censoring task, the French Academy was assisted by the Société des Bonnes Lettres, a right-wing association of Academicians, authors, journalists, nobles and upper clergymen, founded in January 1821 in response to the conservatives' demand for a program of educational and literary reform in the spirit of the monarchy and Christianity. The Société also collaborated closely with the almighty Congrégation, a religious society composed of Jesuits, which controlled state education and launched nationwide proselytizing campaigns. In the words of its advertizing brochure, the Société's ultimate goal was to "turn all the Muses into royalists and into the advocates of monarchist France."[4] Among its founding members were Academicians and Ultra supporters such as Chateaubriand, Bonald and Campenon, as well as important journalists of the conservative press such as Bertin de Vaux (*Journal des débats*) and Michaud (*La Quotidienne*). The marquis de Fontanes, poet, politician and "grand maître" of the University, served as its president until March 1821, when Chateaubriand succeeded him.

As Eustache's spoof letter with its demand for odes and verses implied, classicism – with its connotations of *grand siècle* absolutism and of a quintessentially French tradition – was, indeed, the sanctioned academic manner. New editions in progress of the Academy's official *Grammaire* and *Dictionnaire* attempted a codification and "purification" of the French language according to the rules and conventions of the grand classical tradition. "These so-to-speak reformers," Stendhal was to comment in 1823, "pretend to be able to restore literature to that moral and classical dignity which it had under Louis XIV."[5]

Classicism also governed the Académie des Beaux-Arts. Apart from David's students and followers, including Gros (who had reverted to a most Davidian manner after 1815), Gérard and Delacroix's own teacher Guérin, who formed part of the academic body, it was enforced by Quatremère de Quincy, a renegade revolutionary now allied to the Bourbons and the Académie's perpetual secretary since March 1816. Like his peers of the Language and Literature section, Quatremère was actively at work, as member of a specially named committee, at the Academy's official *Dictionnaire des Beaux-Arts*, which was meant to establish permanently the canons of correct and good (i.e. classical) art.[6]

Despite such activity and despite Eustache's confidence in the superiority of

the classical manner, academic classicism was under fire both from within and from without its institutional precincts. Within the Academy and the Société, members as prestigious as Chateaubriand, Lamartine, the three Hugo brothers (Victor, Abel and Eugène), Nodier, Guiraud and Soumet rejected classicism as outdated and embraced, instead, a royalist brand of romanticism which, they believed, best expressed the new era and its new society. Monarchist and Christian in spirit, their works were begrudgingly tolerated by their fellow Academicians and "sociétaires,"[7] although the most conservative among them, such as Louis-Simon Auger, Lacretelle Jeune or Denis-Luc Frayssinous, bishop of Hermopolis, did not hide their disapproval. Société member Duvicquet even went so far as to publicly deny the very existence of the "genre romantique."[8]

Liberal romanticism represented the outside foe. Although classicism had its adherents in the Liberal camp as well – men, for example, like the critic Delécluze, and the poets Delavigne and Viennet, who saw in it the progeny of eighteenth-century rationalism – the movement was largely considered obsolete by the younger generation in search, much like their conservative counterparts, of novelty and modernity in the arts (in fact, after 1824, romantics from both political camps were to join forces, first against classicism, and later against political reaction as well).[9] Barred from its ranks because of their political sympathies, these progressive romantics despised the Academy, which they considered the bastion of conservatism and classicism. As Stendhal, who was one of their most vocal defenders, was to write in 1823: "The French Academy . . . has always been attached to the old order of things," and "the protection that the aristocracy of letters (i.e. the Academy) lends to the classical genre will very soon heal the French public of this effeminate taste."[10]

Speaking the mind of middle-class liberalism, the *Miroir* was one of the dailies that aimed its poisonous jabs against the reactionary supporters of the aesthetic status quo. The Académie Française and the Société des Bonnes Lettres were dubbed "Académie des Ignorants," "Société des Bonshommes," and "Confrérie des Bonnes Lettres" and granted instant membership to both the orders of the Candle-extinguisher and the Crayfish.[11] Spoof reception ceremonies of new "Société des Bonshommes" members, conceived as parodies of the academic ritual, described candidates, dressed in black (the color of intellectual obscurantism) and coiffed with a wig (the symbol of reaction) being asked to define the words "ignorance," "prejudice," and "extinguish," to break a plaster bust of Voltaire, and to blow out twelve candles which symbolized the extinct intellects of the twelve official censors.[12] Alluding to the Academy's dual mission, literary and political, the *Miroir* imagined an association of Academicians-censors at work on the *Dictionnaire de l'Académie française* suspiciously prying into every word in the French language for potential political allusiveness. In the process,

> they proscribed the usage of a host of words and expressions with double meaning, thanks to which truth could slip unheeded inside the most apparently innocuous sentences. He [the Censor-Academician] explained that ambiguity was an unassailable bastion behind which the ideas of justice, philosophy and natural right would always manage to show themselves without danger. . .[13]

Regarded with a blend of hostility and raillery, the portentous members of the French Academy and the Société des Bonnes Lettres were nicknamed *bonshommes de lettres* or *bonshommes*, slang for naive stupidity,[14] or, in the *Miroir's* own definition wittily conceived as a dictionary entry, "Bon Homme, Bons Hommes: Ever since goodness has been transformed into stupidity, the characterization 'bon' mostly indicates the absence of all malice, or, to be more precise, of all intelligence."[15] The *bonshommes'* special emblem was the cotton bonnet, a nightcap whose conical shape evoked a candle-snuffer, a fool's cap and the Inquisition's *sanbenito*.[16] A satirical poem entitled the "Ten Commandments of the *Bonshommes de lettres*," published by the *Miroir*, spelled out the *bonhomme's* moral and intellectual mandate, which included destruction of the works of eighteenth-century *philosophes* and worship of those of contemporary Academicians, such as Chateaubriand and Bonald:

1. You will thoroughly forsake common-sense
 and wit.
2. Under the candle-extinguisher
 You will contain all light.
3. You will speak ill of the *philosophes*,
 And of the Liberals, as well.
4. You will condemn Jean-Jacques [Rousseau] to the pyre
 And Voltaire, too.
5. For ever, you will talk against them
 In verse and in prose.
6. What you do not understand
 You will constantly praise.
7. You will admire Chateaubriand
 And Bonald exclusively.
8. Once a year you will reread them
 Only as a penance.
9. You will be true to honor,
 Very conscientiously.
10. And you will not change your colors
 Unless it is in your interest.[17]

This is the setting for Delacroix's lithograph *Un Bonhomme de lettres en méditation*, published by the *Miroir* in 1821 (Fig. 70a and b).[18] In the figure of an old and grim *bonhomme de lettres* ensconced in an academic *fauteuil*, Delacroix denounced the reaction and bigotry reigning over France's premier intellectual institutions. Heavy curtains seal the Academician's study from exterior light and air, an allusion to his stuffy, old-fashioned thinking. His nightgown, slippers and *éteignoir* nightcap refer to intellectual lethargy. A candle capped with a candle-snuffer echoes the shape of his bonneted head and alludes to its sparkless contents. Under his feet are the books he despises most, including Voltaire's *Dictionnaire philosophique* and Rousseau's *Émile*.

The print teems with clever symbols, which the *Miroir's* commentary undertook to decipher for its readers. The *bonhomme*, for one, was a composite of well-known Academicians and Société members, such as the vicomte de Bonald, represented by his book *Législation primitive*,[19] Bishop Frayssinous represented

Un bon homme de lettres en méditation

Dans quel siècle sommes nous !!!

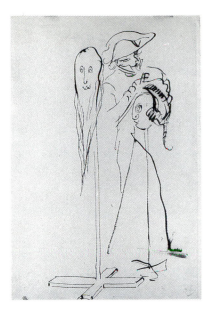

70a and b. (*top*) Delacroix, *Un Bonhomme de lettres en méditation*, 1821. Lithograph, Paris, Bibliothèque Nationale, Cabinet des Estampes. (*below*) Delacroix, *Un Bonhomme de lettres en méditation* (second version), 1821. Lithograph, Paris, Bibliothèque Nationale, Cabinet des Estampes.

71. Delacroix, *Academician and wigstands*, early 1820s. Drawing, Paris, Musée du Louvre, Cabinet des Dessins (RF 23006).

by an *Histoire des jésuites* (he was responsible for recalling the Jesuits from exile), and Chateaubriand, represented by a vial labeled "eau du Jourdain" for his pilgrimage-like travelogue to Jerusalem. On the wall, a picture of an *auto-da-fé* points out the parallel between the public book-burnings staged by Restoration Catholic missionaries and Congrégation emissaries and those staged by the Spanish Inquisition.[20]

Intellectual mediocrity and bigotry are associated with extreme political conservatism in the image of Delacroix's *bonhomme*. Opulent furnishings with touches of rococo decorativeness evoke an old regime, eighteenth-century atmosphere which the subtitle of the print ("In what century are we!!!") underscores. The old Academician is an Ultra whose noble descent is illustrated by the escutcheon-studded family tree displayed behind his chair. He is also a *voltigeur* whose treacherous association with the British enemies of his country is suggested by the portrait, on the wall, of the Duke of Marlborough, the British general remembered for a humiliating defeat he inflicted on the French.[21]

Nobility and academicism are jointly symbolized by the wig (on a wigstand) and the sword, the distinguishing accessories of both a nobleman's and an Academician's official attire.[22] This may imply that the *bonhomme*'s academic position was the result more of his noble birth and Ultra sympathies than of his personal merit. The print thus hinted at Liberal accusations regarding the political character of academic nominations, the cause of a great deal of animosity among opposition intellectuals. The pamphletist Paul-Louis Courier who was, as we saw, a classical scholar by training, was one of them. In 1818, Courier had submitted his candidacy for one of three vacant seats at the Académie des Inscriptions et Belles-Lettres, and had been declined. In a pamphlet addressed to "Messieurs de l'Académie," Courier ironically declared that to become a member of the Academy, just as to become an officer in the army, nobility of birth was the only requirement:

Nothing is more simple: a nobleman of name and sword . . . becomes a member of the military without fighting at war, [becomes] a member of the

Academy without knowing how to read. "The custom of France does not require," Molière says, "a nobleman to know how to do anything at all," and the same custom dictates that any position be granted him, even in the Academy.

And further, bitterly: "Being part of the nobility, gentlemen, is not a chimera, but something very real, very solid, very good, of which we know the exact price. . .For, you see what happens, and the different treatment each, a nobleman and a plebeian, receives within the very land of equality, within the republic of letters."[23]

The near-impossible dream of entering the Academy for a younger member of the middle class also seems to be the subject of one of Delacroix's drawings, of the early 1820s (Fig. 71). This represents two wigstands side by side, one supporting the head of a gaunt old man with an extremely long, white beard, the other, a head wearing a rococo powdered and curly wig on which a young man in academic uniform is busying himself with a comb. The disembodied heads are similar to the one in Delacroix's *Bonhomme de lettres* and may be seen as allusions to the aristocratic *vieilles perruques* of the academic establishment (or, in the case of the bearded head, to the *barbons* of Béranger's song "La Gérontocratie," cited on page 7).

As to the combing young man in academic uniform, his presence is ambiguous. Definitely he seems to perform his task with a mocking sneer. Perhaps he stands for the progressive intellectuals aspiring to academic rank. If so, his bizarre activity could be read as an allusion to the demeaning exertions, servile flattery included, that younger men had to enact in order to break through the ranks of the establishment. Delacroix, who nurtured such ambitions, may even have represented himself in this figure (one of his older biographers, in fact, suggested that this was a self-portrait).[24]

The intellectual and political message of Delacroix's *Bonhomme de lettres* was amplified to include aesthetic issues in his two lithographs for the *Miroir*, *Le Grand Opéra* (Fig. 73) and *Théâtre Italien* (Fig. 74) published, respectively, on 26 July and 13 August 1821.[25]

Although issued separately, a few weeks apart, the prints were obviously intended as pendants in both form and content. Two well-known theatrical establishments of the time, the Grand Opéra and the Italian theater, are personified as their quintessential exponents. The Opéra is a grotesque portrait of star dancer Vestris in classical tunic and wig adorned with flowers; perched on strange, broom-like crutches, he performs an airborne stride to the music of a tiny violinist standing on a barrel. The Italian theater is evoked by the Italian composer Rossini, whose head and hands support diminutive figures of his operatic characters, Otello, Rosina and Figaro.

The Empire, exerting a control on the performing arts as stringent as that applied to the press, had limited the number of Parisian theaters to a total of eight. These, in turn, were divided into two distinct categories: major or "literary" theaters, devoted to the production of classical tragedies in the grand manner, and minor or "popular" ones, specializing in the lighter genres, such as vaudeville, comedy and melodrama.[26] The reinstatement of the monarchy

brought about a release of the imperial strictures and with it a proliferation of theatrical activity. Dozens of new theaters were founded, each championing a different theatrical genre. Melodrama and vaudeville were performed at the Ambigu, the Variétés, the Gaîté and the Vaudeville. Foreign *drames noirs*, English or German, were imported at the Porte Saint-Martin. Pantomime and circus routines were the specialty of the Théâtre Olympique. The Feydau showed contemporary bourgeois drama, while the Théâtre Français (or Comédie Françaisc) favored the French classics. The Théâtre Italien staged mostly Italian *opera buffa*, and the Grand Opéra performed operas in the grand classical tradition. Opening nights were public events. Audiences were involved and vociferous. Actors, singers, composers, playwrights and stage-designers became the talk of the day.[27]

Through their specific repertoires, theaters acquired personalities as well defined and individualized as contemporary newspapers and, like them, were given human form in the satirical imagery of the time. Here the *Nain jaune* was once again a pioneer. In its issue of 15 January 1815, it offered a colored caricature entitled *Les Théâtres*, an allegorized panorama of the seething theatrical world represented as a performance in progress (Fig. 72). On stage are personified Parisian theaters each enacting its own special repertory – drama, comedy or vaudeville – for an audience of likewise personified newspapers (including the *Nain* itself in yellow jester's outfit). In the right foreground, the Grand Opéra is shown as the dancer Vestris, a pathetic presence, whose ageing

72. Anonymous, *Les Théâtres*. Etching, from *Le Nain jaune*, 1815, Paris, Bibliothèque Nationale, Imprimés.

Le grand Opéra.

Litho. de l.Motte, R. des marais.

73. Delacroix, *Le Grand Opéra*, 1821. Lithograph, Paris, Bibliothèque Nationale, Cabinet des Estampes.

Théâtre Italien.

74. Delacroix, *Théâtre Italien*, 1821. Lithograph, Paris, Bibliothèque Nationale, Cabinet des Estampes.

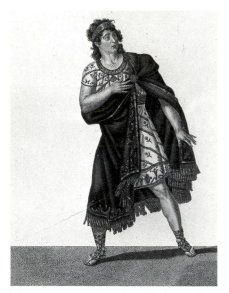

75. Anonymous, *Vestris. Rôle de* L'Enfant Prodigue. Engraving, Paris, Bibliothèque de l'Opéra.

76. Anonymous, *Les Coulisses de l'Opéra*. Etching, Paris, Bibliothèque Nationale, Cabinet des Estampes.

figure and white hair clash discordantly with his youthful role and attire as Zephyr.[28]

In his day, however, Marie-Auguste Vestris (1760–1842) had been one of the glories of French ballet.[29] The heir to a family of famous dancers, he was a child-prodigy who made his stage debut when only twelve and at fifteen was already a full member of the Opéra ballet. His dancing style, airy, energetic and expressive, brought him immediate acclaim. He was particularly admired for his light *pirouettes* or *voltiges*, airborne convolutions which made him excel as Zephyr or Cupid. "If Auguste was not afraid of embarrassing his colleagues," his father, the dancer Gaëtan Vestris, was heard bragging, "he would remain permanently in the air."[30] As agile on the political as he was on the theatrical stage, Vestris had danced for Louis XVI at Versailles under the Ancien Régime; had performed wearing the costume of a *sans-culotte* during the Revolution; and had danced, again, to the applause of the Empire.[31] Old but indomitable, he was still on stage in 1814, when he starred in the title role of Henri Montan Berton's opera *L'Enfant prodigue* (Fig. 75). Although officially retired by 1816, he frequently braved public ridicule by appearing on the scene as Cupid or Zephyr, an event which won him the nickname "Le Père l'Amour" (Old Man Love).[32] It is this latter-day, self-deluding vanity of the old dancer that provoked the mockery of the *Nain jaune* as well as that of another anonymous caricature in which Vestris, complete with the short tunic, wig, and wreath of Zephyr, is seen rehearsing back-stage in the company of a much younger Flora (Fig. 76).

An aged Vestris in the role of Zephyr also holds the stage in Delacroix's *Le Grand Opéra* (Fig. 73). But in addition to depicting the dancer as a ridiculous old man, Delacroix represented Vestris as an invalid. His crutches symbolically suggested the state of the Paris Opéra in the early years of the Restoration, and, beyond it, the romantic avant-garde's perception of academic classicism.

82

Since the beginning of the Restoration, the once prestigious Grand Opéra or Académie Royale de Musique, as it was renamed in 1815, had been on a steady decline. Under the tutelage of musician members of the Académie des Beaux-Arts, the theater struggled to survive by reiterating a worn-out repertory of operas in the classical tradition by older (Glück, Spontini) or contemporary composers (Le Sueur, Boieldieu, Berton). Typical works included Spontini's *La Vestale* and Berton's *L'Enlèvement des Sabines* or *L'Enfant prodigue*. Performances were pompous and tedious, and audiences declined considerably.[33] Already in 1801, a newspaper was describing Opéra patrons as "fed up with the sublime productions of Glück which it [the public] has been given, now, for the past twenty-five years and of which it has not yet heard anything comparable."[34] The institution's only saving grace, the newspaper added, was its ballet which performed at interludes between operatic acts: "Nowadays, good society only arrives at the Opéra when it is time for the ballet; one can virtually hear a fly when Vestris, mademoiselle Clotilde, or madame Gardel are dancing; in contrast, everyone coughs, spits, gossips and flirts when Alceste or Iphigénie are singing."[35] The situation did not greatly improve with time, either, as is suggested by a note in the *Miroir* of 1822: "Music makes little progress in this theater [the Opéra]...and Terpsichore [muse of dance] has completely invaded the domain of Polymnia [muse of lyric poetry]."[36]

As opposed to the Grand Opéra, the fortunes of the Italian theater had been on the rise. Founded in the last years of the Ancien Régime as the permanent home of itinerant Italian troupes, the Théâtre Italien's heyday was under the Empire when it enjoyed personal protection from Napoleon and Josephine (it even took, for a while, the name of Théâtre de l'Impératrice). Although administratively attached to the Académie Royale de Musique during the Restoration, the theater maintained complete independence in matters of repertory and staffing.[37] It was precisely because of its innovative repertory, developed in the early 1820s and consisting, almost exclusively, of operas by the fashionable Italian composer Rossini, that the Théâtre Italien grew into one of the most popular theaters of Paris.

Gioacchino Rossini's (1792–1868) phenomenal success in the nineteenth century was indeed partly enacted in France.[38] Virtually self-taught, at nineteen he was already famous, his works performed throughout Europe. His specialty was *opera buffa*, a genre which allowed for greater naturalism in the action and more versatility in the singing and musical orchestration than did classical, grand-manner opera. In contrast with the latter's high-minded mythological, historical and biblical themes, *opera buffa* dealt with the fashionable topics of the day, which it presented in the form of light comedies, romances and melo-dramas. Rossini's operas, for example, were inspired by the taste for Shakespeare's plays, Walter Scott's novels, and orientalist themes including the current war of the Greeks against the Turks.[39]

Rossini's success in Paris was moderate at first. In 1817, the *Italiana in Algeri*, his first work to be performed at the Théâtre Italien, was quietly received. Two years later, *L'Inganno felice* and *Il Barbiere di Siviglia* were greeted with mounting enthusiasm. In 1820, the second run of the *Barbiere* was an overwhelming success. For its 1821–2 season, the Italian theater had scheduled no less than six operas by Rossini, including *Otello*, *La Gazza ladra* and *La Cenerentola*. Paris was

swept by all-consuming Rossinist fever: "There is no longer a ball in which Rossini is not heard. People do not dance any more without the *Gazza ladra*, do not waltz without the *Barbiere*. The most determined detractors of the *giovine di gran genio* [the genial youth] cannot but agree that he is at least the most 'dancing' composer of our age," reported the *Miroir*.[40]

Almost overnight, the Italian opera became the most popular theater in Paris and the Académie Royale de Musique's principal rival. "The sad condition of our Grand Opéra, . . . the poor success that has greeted the recent pieces of our musicians, the vogue of Rossini, more brilliant than substantial, everything contributes to the great anticipation with which the public flocks to the Théâtre Italien," the *Miroir* observed.[41] To the Rossini furor that engulfed Paris, Delacroix joyfully abandoned himself.

Delacroix's lifelong fascination with music and theater was equal only to his enthusiasm for literature and poetry.[42] In 1820, while living on a shoestring budget, he set aside a sum large enough to purchase a harpsichord.[43] "And when I am in pocket," he boasted in a letter to his sister, "I treat myself to the theater."[44] His love of music and performance merged with his longing for Italy. "My whole being yearns for Italy," he wrote to Frédéric Soulier in Florence,[45] and to Achille Piron he confided his regret at "being neither a musician nor an Italian."[46] *Opera buffa* was his favorite, and he spoke passionately about Cimarosa, Paesiello and Mozart. In his diary he copied a passage from Madame de Staël's *Corinne* that corresponded to his feelings

> The Italians have for centuries passionately loved music. . . The gaiety which music *buffa* knows how to elicit so well is not a vulgar gaiety, one that does not speak to the imagination. Within the pleasure that it gives us there are poetic sensations, and a pleasant reverie that verbal witticisms [*les plaisanteries parlées*] would never be able to inspire.[47]

Under the circumstances, therefore, it is easy to understand his fascination with Rossini. From 1820 on, he was a regular at "les Italiens," as he referred to the Italian theater. He attended performances of the *Barbiere di Siviglia*, *Otello*, and *La Gazza ladra* more than once. He saw Rossini's first *opera seria*, *Tancredi*, three times.[48] He idolized Rossini's interpreters, Giuseppina Ronzi, Giuditta Pasta, Madame Mainvielle-Fodor, Filippo Galli and Manuel Garcia. "When I go to the theatre, at the *Italiens* mostly," he wrote to Soulier, "you can be sure that I miss you. This Ronzi has still the same beautiful eyes that we have admired together. . ."[49] "How I love these Italians!" he burst out elsewhere,

> I am consuming myself at the Louvois theater [the Italian theater was then located in the rue Louvois] listening to their beautiful music and devouring their lovely actresses with my eyes. We have a new kind of Ronzi in this theater now. . . Her name is Madame Pasta. One has to see her in order to imagine her beauty, her nobility and her marvellous acting.[50]

Brimming as he was with Rossinist fervor, he must have followed with interest the musical battle, waged in the columns of the *Miroir*, which opposed supporters of the classical operatic tradition and the "Rossinistes" or "dilettanti," Rossini's progressive followers. Spokesman for the first group was the Academician Henri Montan Berton; champion for the "Rossinistes" was the writer

Stendhal, who wrote music reviews for the *Miroir*. It is in the pages of the *Miroir*, and through the allied contributions, artistic and literary, of Delacroix and Stendhal that Rossinism came to be confronted with academic classicism and conservatism, and gained its credentials as an emblem of romanticism and modernism.

In June 1821 Stendhal had left Italy, his home for the past ten years, and had settled permanently in Paris. During his Italian stay, his longstanding passion for music had developed into a scholarly occupation which yielded several critical essays and a book of musical biography.[51] In the fashionable circles of musical amateurs and intellectuals of Milan, he had met Rossini.[52] Back in Paris, his nostalgia for Italy and Italian music naturally led him, as it had Delacroix, to the Italian theater; he even rented rooms at 63, rue Richelieu, round the corner from the theater and in the very same building in which Rossinist prima donna Giuditta Pasta lived.

It was Stendhal's laudatory essays on Rossini, published anonymously in the *Miroir* during June and July 1821, that triggered the irate reaction of Berton. Berton, then in his mid-fifties, was an important figure in the contemporary musical world. An accomplished violinist and composer of grand-manner opera, he had served as director of the Italian theater and *Chef de chant* of the Grand Opéra. The Restoration showered him with honors: in 1815 he was elected member of the music section of the Académie des Beaux-Arts and professor at the Conservatoire, and he was decorated by Louis XVIII. All this would suggest that, in politics, Berton was a conservative royalist. He certainly was during the Restoration. But before that, and much like Vestris, he had consecutively bowed to all succeeding regimes and composed, for example, comic operettas for Ancien Régime aristocratic patrons (*Les Promesses de mariage*, 1787), operas to celebrate revolutionary valor (*Viala*, 1792), and songs extolling Napoleon's campaigns (*Le Chant du retour*, 1805).[53] To the Liberals of the Restoration, Berton epitomized the political weathervane, and he deservedly held a place in the satirical publication, *Dictionnaire des girouettes*.[54]

Berton's anti-Rossinist invective was contained in a three-part article, "De la musique mécanique et de la musique philosophique," published in *L'Abeille*, a magazine of conservative tendencies on whose editorial board sat prominent Academicians, including Berton himself.[55] Berton described "musique philosophique," philosophical music, as music with high-minded moral and spiritual content and unity, purity and harmony of form, exemplified by great masters of the past, such as Mozart, and perpetuated by grand-manner composers, such as his fellow Academicians and himself. Philosophical music, according to Berton, was governed by Aristotelian logic and respect for musical rules, grammar and syntax. It was the parallel of the paintings of Raphael and Poussin, and of the plays of Racine.

To philosophical music, Berton opposed what he called, with a highly personal usage of the term, "musique mécanique," or mechanical music. This Berton defined as music characterized by trivial content, formal incoherence, and profuse and facile instrumental effects achieved especially with the use of brass instruments, trumpets, horns or cymbals. The work of modern, younger composers (by which Berton implied, without naming him, Rossini) fell into this category. "Mechanical" musicians abandoned rules and conventions in

77. Anonymous, *Il Signor Tambourossini ou La Nouvelle Mélodie.* Lithograph, Paris, Bibliothèque de l'Opéra.

favor of "an unlimited profusion of accessory and incoherent means, a spontaneous succession of motifs with no link between them, and, finally, an almost complete violation of the dramatic conventions."[56] The modernists' ultimate goal, Berton contended, was "effet," which they achieved by means of extravagant formal and technical feats including orchestration that evoked "an artillery battery [comprised of] trumpets, trombones, cymbals and tom-toms. . ."[57] For Berton, barbarian and Gothic art was the equivalent of such music. Echoing his views, a contemporary cartoon showed an Othellesque Rossini (for barbarism and Rossini's own opera) as an "homme orchestre" whose clanging dissonant brass instruments, the symbols of *musique mécanique,* drive away the god of music Apollo while donkey-eared Midas, a symbol of stupidity, marvels (Fig. 77).

Touched to the musical quick, Stendhal lashed back swiftly from the pages of the *Miroir* in two articles, of 5 and 11 August, the latter issued only a few days before Delacroix's *Théâtre Italien* lithograph (Fig. 74). The aesthetic point of view formulated in these essays foreshadows Stendhal's polemical pamphlet of 1823, *Racine et Shakspeare.* Stendhal called, essentially, for an aesthetic that would be original and would reflect the specific character of the times – their culture, interests, ideas and fashions. The heyday of classicism had been the eighteenth century (when it reached its apex with a painter such as J. L. David, whom Stendhal admired along with the ancients, the original classics.) But that era was over now, and so should be classicism. Prolonging its life into the present, as the academic classicists of Berton's ilk insisted on doing, was a bankrupt pursuit leading only to lifeless and unoriginal repetition of what had, at one time, been original. The Academy, in particular, had become a fossilized institution dedicated to the perpetration of a likewise fossilized tradition passed

on by means of rigid rules and formulas. A new aesthetic should be born of the new age. To modern times and modern men, a modern art. Although Stendhal did not name it in his *Miroir* articles (as he was to do in *Racine et Shakspeare*), the new aesthetic, which he described as expressive, imaginative, inspired, spontaneous and, above all, representative of the tastes and sensibilities of contemporary society, was, of course, romanticism. Rossini and *opera buffa* were its exponents.[58]

In keeping with these ideas, Stendhal denounced Berton and the Academicians as mere slavish imitators: "M. Berton does not content himself with admiring the ancients, he also attempts to imitate them. . . ."[59] They were mere "musiciens anatomistes," musical dissectors, overly concerned with technicalities (rules, canons, conventions) and, in so doing, overlooking "the merits of originality, wit, and dramatic verve when concerned with the irregularities of a finale or the imperfections of a quintet."[60] The public, he contended, took little notice of rules and conventions, but instead judged a work of art mostly by its ability to express and arouse emotion: "In order to be moved, it [the public] does not await the permission of the purists of the rue Bergère [the location of the Music Conservatory], and its 'bravos' are independent of the correctness of counterpoint."[61] Technical dexterity was only the tool to achieve such expression and produce the pleasure anticipated by the audience:

> A greater musical harmony, elsewhere, a more severe and correct style, a more scrupulous obedience to the rules of composition, all these qualities are useful auxiliaries to the creation of dramatic effect, but are not its essential constituents. . . When I go to the theater, I am looking for laughter or emotion.[62]

In that sense, Rossini's operas, technically imperfect by academic standards but responding to contemporary concerns, tastes and sentiments, were more likely to touch a nineteenth-century public than the Greek and Roman evocations of the Academic composers and even – Stendhal added at the risk of sounding sacrilegious – of the Rococo splendors of Mozart himself (Stendhal, who adored Mozart, deliberately exaggerated here in order to make the point):

> It might be true that Mozart is more rich and harmonious, Pergolese more polished and correct, Sacchini more suave and pure. Nevertheless, neither the public nor myself is at fault if we find that Rossini addresses our intelligence better, and possesses the secret of our tastes and our impressions more intimately. In the music of Rossini there is something indefinably alive and actual which is lacking in Mozart's magnificence.[63]

Stendhal's call for a new aesthetic adapted to modern sensibility also included a definition of the creative process as spontaneous and inspired, and of the artist-creator as a natural genius who produced oblivious to and unhindered by rules. These definitions called forth two interrelated romantic myths, that of the natural genius creating with the unselfconscious ease of a tree bearing fruit, and that of the genius rising above the rules. In an article on Rossini published in the *Paris Monthly Review* of January 1822, Stendhal described the Italian composer as

a self-taught original and as an inspired, spontaneous creator for whom "the labor of composition is nothing."[64] His vitality was prodigious: he moved indefatigably from city to city, from theater to theater, "his luggage filled. . . more with musical scores than with fine linen or valuable objects."[65] Stendhal's *Vie de Rossini* (1823), in turn, spoke of Rossini as a genius superior to man-made rules:

> In Bologna, M. Gherardi replied to the protests of the pedants who reproached Rossini for the numerous infractions of the rules of composition: "Who has made these rules? are they men who have a genius superior to that of the author of *Tancredi*?"[66]

For Stendhal, moreover, whose aesthetic thought was colored by republican Bonapartist sympathies, the antithesis Berton–Rossini, classicist–romantic, conservative–progressive, was bound to call forth political parallels.[67] He thus denounced Berton and his colleagues of the Institut as "partisans of the Ancien Régime of music,"[68] and as "rigorists. . . who hold in music almost the same role as the members of the French Academy with regard to the three unities [the theatrical unities of time, space and action which governed classical French theater]."[69]

Rossini he hailed as the mighty conqueror of new musical territory, as the Napoleon of the operatic scene, and as an emblem of enlightened progressivism and modernization: "Ever since the death of Napoleon," Stendhal was to write in 1823, "there has been another man [i.e. Rossini] of whom people speak every day from Moscow to Naples, from London to Vienna, from Paris to Calcutta. The glory of this man knows only the boundaries of civilization and he is barely thirty-two years old."[70]

Published within a few days of Stendhal's articles in defense of Rossini, Delacroix's twin cartoons, *Le Grand Opéra* and *Théâtre Italien*, are visual summations of Stendhal's ideas, and demonstrate the closeness – unnoticed until now – of the writer and the artist as early as the summer of 1821. The monstrous distortions of Vestris's figure echo Stendhal's sarcastic anti-academic and anti-classical sallies, while Rossini's energetic character vibrates with the writer's praise of the heroism of youth, innovation and modern life.

The depiction of the decrepit Vestris, a representative of the inept and ridiculous old guard, borne on crutches like an invalid, denounced academic classicism as impotent and obsolete. Like the mindless followers of the classical school, Vestris is a mere imitator, a performer who simply executes and replicates, but does not create (his crutches may also be symbolic of the academic rules, "those crutches for weakness and taskmasters" incompatible with genius, in the words of the German dramatist Friedrich Schiller).[71] With the same servile exactitude with which the classicists obeyed the canons of harmony and composition, the dancer's movements conform to the musical beat struck by the diminutive violinist. The latter is almost certainly an allusion to the violin-playing Berton, in whose *Enfant prodigue* Vestris, as we saw, had danced the title role. Berton is mounted (his middle name was Montan and he had also written an opera titled *Montano*) on a barrel, or *tonneau*, a reference, perhaps, to his loud protests in an angry tone (*sur un ton haut*). Vestris's crutches are shaped like brooms (*balais*), a

visual and phonetic pun for *ballet*, and an allusion, possibly, to the critics' pronouncements that the Grand Opéra's only redeeming grace were its ballets (the size and background placement of the violinist with respect to the prominently foregrounded Vestris also suggest the primary role of dance at the expense of music.) As the *Miroir*'s explanatory text put it: "We do not know whether the Grand Opéra will eventually devote itself a little more to the cult of Polymnia...But considering that, to this day, it has only sacrificed to Terpsichore we are presenting it to the public supported by its... ballets."[72]

As for the *Théâtre Italien*, it stands for Stendhal's and Delacroix's conception of the modern romantic aesthetic in which actuality, inspiration and individual expression were key notions. Youthfully and elegantly dressed in the latest fashions, Rossini represents contemporary taste and the modern era. As opposed to Vestris, a slavish imitator, Rossini is an original creator obeying an inner generating urge. His body sways with the surge of inspiration. His pockets are packed with musical scores. Like fruit ripening on the branches of a tree, the characters of his operas sprout from his head and hands, the seats of creativity, turning him into the actual embodiment of the romantic "vegetable genius." (In the 1850s, Gautier would actually refer to Rossini as an orange tree spontaneously producing its round, golden fruit.)[73]

Significantly, this romantic vision is also loaded with classical references, including evocations of a Heaven-bearing Atlas and of a mutant Daphne sprouting laurel boughs (and, of course, of Zeus giving birth to his brainchild, Athena). The conflation of romantic and classic metaphors comes as a reminder that Delacroix's attack against classicism – just like Stendhal's – was not aimed at the classical past and the heritage of antiquity, which the artist, just like the writer, revered, but instead against classicism's contemporary formulaic practice enforced by the Academy and the slavish imitators of David's school (what I have called, here, "academic classicism"). In fact, *Théâtre Italien* may be an early testimony to Delacroix's effort to synthesize classical legacy and romantic innovation just as it may represent his attempt to lend a modern idiom to that legacy (bringing it up-to-date, so to speak) while, at the same time, recapturing its true spirit, which Delacroix perceived as vital and full of energy, and more faithfully embodied by Rubens or Michelangelo than latter-day classicists such as Ingres, Guérin or Gérard.

Already in 1819, Delacroix had referred to the declining fortunes of academic classicism as a viable modern manner in more satirical images that, like his *Miroir* prints and like his contemporaries Stendhal and, later, Hugo, set their argument in the context of the French stage, the literary locus of classicism's most stringent control (exemplified, particularly, by the quasi-religious observance of the canonical three unities, of time, space and action). In a drawing of 1818–19 (Fig. 78), he showed an actor of classical plays whose foolish grin and pose along with his outsized Roman costume are an overt parody of classicism, denouncing it as ridiculous and obsolete.[74] And in a lithograph, *Artistes dramatiques en voyage* (Fig. 79), he depicted classicism on the demise in the guise of a ragged troupe of comedians who cart away the paraphernalia of classical drama including plays by Racine, Crébillon and Voltaire (who disliked Shakespeare, as will be recalled, and whose own plays, as opposed to his philosophical writings, were considered

78. Delacroix, *Une figure, costume antique*, 1818–9. Drawing, Paris, Musée du Louvre, Cabinet des Dessins (RF 10294).

79. Delacroix, *Artistes dramatiques en voyage*, 1819. Lithograph, Paris, Bibliothèque Nationale, Cabinet des Estampes.

Artistes Dramatiques en voyage.

*Le Doyen des Zéphirs,
ou
Le Roi des Voltigeurs.*

80. Anonymous, *Le Doyen des Zéphirs ou Le Roi des voltigeurs*. Etching, Paris, Bibliothèque Nationale Cabinet des Estampes.

reactionary by the modernists). Cart, actors and props are as decrepit and wretched as Vestris, and like him stand as the laughable vestiges of an irretrievable past.[75]

For Delacroix, as for Stendhal, moreover, the opposition of old and new, academic classicism and romantic modernism, Vestris and Rossini, also encapsulated the warring political ideals of his day. The pirouetting Vestris, a typical "weathervane" who had opportunistically served royalty and Revolution alike (while fraternizing with the British enemies of France), was also a Restoration *voltigeur*, a survivor of the old regime and latter-day Bourbon sympathizer. (Berton, whose career paralleled Vestris' in political disloyalty, was yet another *girouette* in the picture.) A contemporary caricature showing a nimbly pirouetting Vestris does, in fact, dub the dancer "Dean of the Zephyrs or King of the Voltigeurs" (Fig. 80).

In contrast to Vestris and academic classicism, Rossini and romanticism were hailed as champions of the joint causes of political and aesthetic innovation: Delacroix's lithograph of the Italian theater, the *Miroir* declared, will certainly be regarded by conservatives as "a new aggression by the detractors of the musical Ancien Régime."[76]

But already by 1821 the forces of change were inexorably on the move, as the intoxicating popularity of Italian opera began eroding the very foundations of the Académie Royale de Musique itself. This the *Miroir* readily applauded, praising the influence of the Italian opera on "our own French opera" and of ultramontane melodies on the sensibilities of "our amateurs." As a result, the daily observed, French music has become more melodious, more piquant, more facile, and "the French lyre produces new harmonies."[77]

Indeed, Rossini and Italian opera were soon to be regarded as the only means

GALERIE DE LA GAZETTE MUSICALE.
N.3.
Compositeurs dramatiques modernes.

1. Halevy.　2. Meyerbeer.　3. Spontini.　　8. Auber.　　4. Rossini.　　10. Berton.
5. Berlioz.　6. Donizetti.　　7. Onslow.　　　　　　5. Mendelssohn.

81. Anonymous, *Galerie de la Gazette musicale*. Lithograph, Paris, Bibliothèque de l'Opéra.

for revitalizing the moribund French operatic establishment.[78] As early as January 1821, the French Embassy in Rome acting on behalf of the French government had requested Rossini's permission to have one of his works performed at the Grand Opéra, "as soon as possible would be best; for our Grand Opéra is threatened with a total eclipse; only Rossini could give it back some glow and warmth."[79] In November 1823, Rossini's first visit to Paris was an apotheosis. He was honored in a banquet of two hundred, which included the cream of Parisian intellectuals and artists. Stendhal was among the guests. A master of irony, the author of the articles against Berton must have especially relished that evening: for the toast to the Italian composer was delivered by the Academician Le Sueur, the dean of the musical old guard. Politely, Rossini responded with a toast to the French school of music.[80] That same year, Rossini was elected member of the Académie des Beaux-Arts (in a contemporary group portrait he is shown sitting close to his detractor Berton, who had just witnessed the failure of his *Virginie* produced at the Grand Opéra; Fig. 81); one year later, on the advice of Sosthène de la Rochefoucauld, Director of Fine-Arts, Louis XVIII named Rossini "Directeur de la musique et de la scène du Théâtre Italien." Rossini's complete control of the French lyrical scene, including that of the Grand Opéra, was sanctioned in 1826, when Charles X appointed him "Inspecteur général du chant en France."[81]

During these very years, Delacroix spearheaded the romantic movement in painting. His *Massacres of Chios* at the Salon of 1824 obeyed the directives of Stendhalian modernism with its depiction of a contemporary event in which rebellious modern Greeks, not their high-minded ancestors worshipped by the Academy, were portrayed with expressive immediacy. Set within the parameters of the continuing conflict between old (academic classicist) and new (romantic) guard, the Academician Gros's well-known quip of a "massacre de la peinture," takes on additional meaning. More than just an aesthetic reproof, it represented the academic establishment's outburst of annoyed irritation – analogous to Berton's for Rossini – at the emergence of the romantic heretics on the official artistic scene (intensified, to be sure, by the award of a medal and the government's purchase of Delacroix's picture).

Ironically, the Academy and its followers were not alone in their rebuke. For Stendhal, whose taste in art proved, in application, much more conservative than the bold ideas he expounded in his writings,[82] also voiced shock at what he deemed the picture's thematic and formal excesses: "There is a *Massacre de Scio* by M. Delacroix which is in painting what the verses of MM. Guiraud and de Vigny are in poetry, an exaggeration of the melancholic and the gloomy. But," he continued, "the public is so bored with the academic genre and the copies of statues which were so fashionable ten years ago that it stops in front of the livid and half-finished cadavers which Delacroix's picture offers to us."[83]

Despite its damning sarcasm, this last sentence contains an inverted compliment. For in it Stendhal indirectly (and involuntarily) acknowledged Delacroix's picture as the antithesis and the denial, extreme but final, of the last vestiges of academic classicism.

The Comic as Dissent and Modernity

This is the direction in which I, as a comic poet, must work in order
to be useful to the nation, by annihilating the power of the tyrants
over her, and hence bringing her closer to the *divina libertà*.

Stendhal, *Pensées. Filosofia nova* (1804)

ONE TUESDAY EVENING, in late December 1817, Delacroix wrote from his sister's
house, at the Forest of Boixe, to his friend Jean-Baptiste Pierret, in Paris:

> Oh! my dear friend, I've absolutely got to talk to you tonight, because I am
> full of news; so full that everything is in confusion within me and I don't
> know what to say or where to begin. This evening, with the help of my
> dictionary, I made up a wretched letter which will say things as best it can. I
> don't understand it too well myself and Heaven knows if somebody else will
> understand it; my soul was in suspense, torn between listening and the wish to
> say something that made sense. At nine o'clock I heard my signal, and in four
> bounds I was upstairs. There I found you know who, waiting faithfully as her
> delightful custom is. Today my blood was on fire more than usual, and she
> seemed to me ten times more desirable. . . Click! I bolted the door and there
> we were by ourselves, at night, on one chair, with our knees touching and
> soon with our knees interlocked. O God: I had never felt my heart throb so
> violently. Yorick bent his head on Eliza's bosom, Yorick seized Eliza by her
> slender waist and drew her close to his lips. . . But one moment! Stop, what
> are you imagining? Perhaps I have let you suppose that I had attained my goal!
> Alas, in the midst of my physical and moral tension, just as shameless desires
> were raising their heads and giving my soul the courage of a demi-god, there
> was a knock on the door. . . to hell with the knocker! and I kissed her other
> cheek: the knocking was renewed. . . Protector of virtue! it was my sister. . .[1]

He signed his letter "Yorick." "Eliza" and "Yorick" – the latter named after
Shakespeare's jester in *Hamlet* – referred to characters from Laurence Sterne's
novels, which Delacroix must have been reading at the time. In fact, Delacroix's
entire account of reckless love-making is itself virtually a pastiche of a scene
from Sterne's *A Sentimental Journey* (1768), in which the witty parson Yorick
attempts to seduce a pretty maidservant, a "fair *fille de chambre*," during his
travels through France.[2]

At first glance, Delacroix's amorous escapade strikes us as no different or
more significant than the many similar adventures with which his early diaries
were soon to be filled. Yet if examined in the context of a study of Delacroix as a
satirist, this humorous episode of seduction obviated – a parody of the secret

love tryst with the artist portrayed as its laughable protagonist and fallen "demi-god" – becomes meaningful for two reasons in particular. It tells, first, of the presence of genuine and spontaneous wit in the youthful Delacroix, which compelled him to turn real life into comedy and himself into its clowning hero. Second, aside from confirming what we already know about his keen interest in English literature, it points to Delacroix's less explored fascination with a particular genre, the eighteenth-century satirical novel, to the degree of emulating Sterne's style and enacting the roles and identities of Sterne's characters.[3]

Delacroix as Hamlet or Childe Harold has for long been a familiar vision, indeed our only vision of the artist as a youth.[4] His frail constitution permanently prey to bouts of fever, the haunting pallor of his complexion set off by his dark eyes and hair and, above all, his intellectual earnestness in which Shakespeare and Byron vied with Dante, Tasso, Virgil and Horace, naturally lent themselves to the more dramatic literary embodiments of the brooding and restless romantic hero.[5] But of the young Delacroix as Yorick, wit and prankster, amateur of puns, wordplay and rebuses, reader of satirical novels and maker of cartoons, what do we know? What do we know, indeed, of the laughing romantic hero and, more generally, of the meaning of his laughter in the intellectual and ideological setting of early nineteenth-century France?

Yorick

We get a glimpse of the lighter, fun-loving and humorous side of Delacroix's youthful persona from his early letters to his schoolday friends, Pierret, Soulier, Piron and the two Guillemardet brothers. Writing from the Forest of Boixe, where he spent several months a year, he spoke enthusiastically of his enjoyment of life in the countryside, of brisk hunting and riding outings, and of lively evenings around tables laden with hearty food and good wines. Drinking and merrymaking, he asserted, were supreme pleasures, and he recommended them against the tedium of routine to the less fortunate Félix Guillemardet, who languished as a lawyer's clerk in Paris:

> [when drunk] you feel a sort of well-being, of contentment which makes you gayer and better. You laugh all the time and at everything, and all the sorrows of the world seem remote. When New Year's Eve comes, in Paris, we shall be able to enjoy this delightful condition, which is just what you need in order to make up for your daily labours.[6]

The New Year's Eves (Saint-Sylvestre), which Delacroix invokes here, were an established tradition among the friends who took turns in celebrating them every year in each other's house. Along with wine, food and music, wit flowed freely in these gatherings. "There," Delacroix wrote, "under the even light of a candle, we sit at a table and rest our elbows on it, and we drink and eat a lot, so that we can have plenty of the good spirit of a well-warmed up man..."[7]

The caricatural drawings that fill the *Album de la Saint-Sylvestre* preserve some of the bubbly, nonsensical and irreverent mood of these evenings.[8] Among them are also more elaborate drawings that record each year's celebration in the guise of commemorative group portraits. We see, for example, in a brush and lavis

82. Delacroix, *Saint-Sylvestre of 1817–18*. Drawing, Paris, Musée du Louvre, Cabinet des Dessins (RF 9140 folio 32r).

83. Delacroix, *Saint-Sylvestre of 1820–21*. Drawing, Paris, Musée du Louvre, Cabinet des Dessins (RF 9140 folio 102r).

drawing of the Saint-Sylvestre of 1817–18, Delacroix's cronies sprawled by a blazing fire drinking and singing to the sound of a guitar (Fig. 82). A similar scene, a pen drawing of the 1820–1 revelry, subtly transmutes reality into fantasy, anecdote into caricature (Fig. 83). While his partying friends empty glass after glass of wine, Delacroix depicts himself, in the front, caught in what can be called a parody of one of his typical moral dilemmas. At his feet he envisions his "morning-after" self, sick with the evening's unrestrained drinking. Behind his back, the voice of temptation, in the guise of a goat-legged devil, whispers enticingly against reason and points to his empty glass on the table. Once again, Delacroix-Yorick laughs at himself, now in visual terms and borrowing the formulas of contemporary cartooning, in this case a charge against the crafty Talleyrand shown attentively listening to the devil, a parody of the traditional evangelist portrait (*c.* 1814–15; Fig. 84). In art, as in life, Delacroix the jester-cartoonist would nimbly turn the tables on reality to reveal its humorous underside.

It is to this whimsical side of his nature that we owe not only his involvement with caricature but also his broader interest in graphic satire more generally, which led him at the same time to collect, copy and emulate works by other cartoonists. As early as 1817–18 he owned a complete series of Goya's *Caprichos* (1799) whose impact on his paintings has often been pointed out, but whose effect on his caricatural depictions of gluttonous, lecherous and scowling priests

96

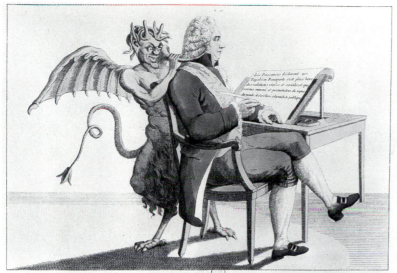

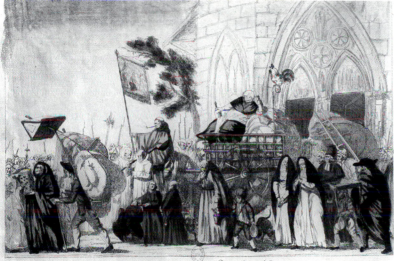

84. Anonymous, *M. Tout à tous* (Talleyrand). Etching, Paris, Bibliothèque Nationale, Cabinet des Estampes.

85. Anonymous, *Le Déménagement du clergé*, 1799. Etching, Paris, Bibliothèque Nationale, Cabinet des Estampes.

is also undeniable (Figs 9, 10). The example of Goya, an established artist who fruitfully and without prejudice engaged in lowly caricature, may even have acted as a model or a prompt in his pursuit of graphic satire.

Revolutionary cartooning was another obvious pole of attraction for a Restoration satirist. That Delacroix was well aware of it seems certain, as borrowed motifs and themes in his cartoons confirm. Such is the theme of moving house, for example, a metaphor for the expulsion of undesirable institutions, the Catholic church in the revolutionary *Déménagement du clergé* (1799; Fig. 85), censorship and classicism in Delacroix's *Déménagement* (Fig. 67) and *Artistes dramatiques en voyage* (Fig. 79). Also, in Delacroix's *Déménagement*, the motif of the goose on donkey-back harks back to such antecedents (although hardly to revolutionary ones exclusively) as J. L. David's *L'Armée des cruches*, one

of the two cartoons David did for the Committee of Public Safety in 1793–4.[9] Turning humans into human-animal hybrids suggestive of inner psychological traits had been one of caricature's physiognomic standbys since antiquity. Revolutionary cartoons applied the device to anti-royalist jabs, such as as *Les Animaux rares* (1792; Fig. 86) poking fun at Louis XVI, Marie-Antoinette and their family, an image Delacroix may have known or even owned, as some of his drawings suggest (Fig. 87).[10]

For Delacroix, however, as for French caricature more generally, the inexhaustible fountainhead of imagery, motifs and styles was incontestably English graphic satire. After 1815 English cartoons freely circulated in France

where, along with English novels, English theater and English poems, they became a cultural fad, especially among the Liberal middle classes, who looked upon England as a political model. Delacroix owned at least eight of such English prints, hand-tinted in watercolor, a technique he himself was learning at the time.[11] His drawings show him copying or freely interpreting English prototypes by Gillray and Rowlandson (c. 1817–25; Figs 88, 89).[12] His prints point to

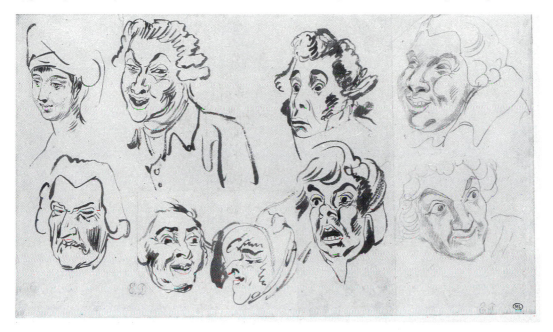

88. Delacroix, *Heads after Rowlandson*, c. 1817–25. Drawing, Paris, Musée du Louvre, Cabinet des Dessins (RF 10182).

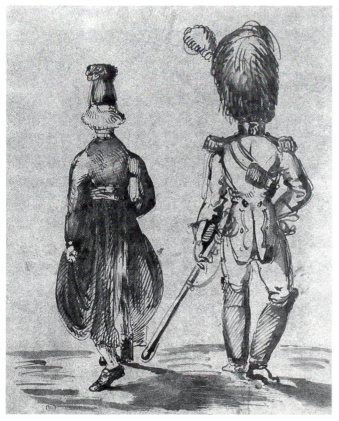

89. Delacroix, *Figures* (after Gillray?), c. 1817–25. Drawing, Paris, Musée du Louvre, Cabinet des Dessins (RF 9140 folio 52).

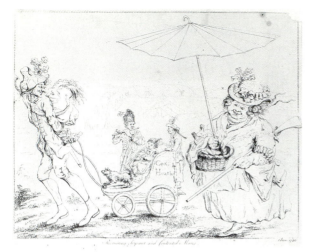

90. Austin, *Recruiting Serjeant and Contented Mates*, 1780. Engraving, London, British Museum.

91. Cruikshank, *General Swallow Destroying the French Army*, 1799. Engraving, London, British Museum.

further connections. For example, the idea of a British soldier's portable household in *Bagage de campagne* (Fig. 14) may have been suggested to him by such antecedents as William Austin's *Recruiting Serjeant and Contented Mates* (1780; Fig. 90); and Isaac Cruikshank's *General Swallow Destroying the French Army* (1799; Fig. 91) may have provided the model for the sword-wielding ogre "De Monts-Coupés," in *Gare derrière!!!!* (Fig. 69). In both Cruikshank's and Delacroix's prints, the device of blowing the evil character up into a menacing giant faced by timorous Lilliputians is intended to suggest awesome power; the power of war, in Cruikshank, that of abusive political authority, in Delacroix. Motifs, finally, such as the flying devil of *Le Déménagement* (Fig. 67), are reminiscent of Gillray's agile demons, while the fluid calligraphy of *Bagage de campagne* evokes Gillray's unbroken, expressive line.

Such parallels can, of course, be multiplied. The real point, here, is to establish Delacroix's expansive and all-absorbing interest in the comic – literary, visual, or even as lived reality. This leads to an attempt to probe the meaning that notions related to caricature, such as comedy and the grotesque, held for the young Delacroix and his contemporaries.

Comedy, the grotesque, and "le comique romantique"

Delacroix's dual alias, Hamlet/Yorick, symbolized the aesthetic controversy revolving around the drama, the locus of the bitterest clashes between classicist traditionalists and romantic modernists around 1800. Taking Shakespeare as their model, early exponents of the romantic school demanded a revitalization of the theater in the name of greater naturalism. One important aspect of such reform was to be the harmonious fusion of tragic and comic genres, tragedy and comedy. (That Delacroix would be aware of such debates is certain; witness his own interest in the theater and his theater-related cartoons, *Artistes dramatiques en voyage*, *Le Grand Opéra*, and *Théâtre Italien*, among others.)

100

Comedy, in particular, regarded by the classicists as an inferior, less noble genre, profited from the libertarian surge of the late eighteenth century, shedding all previous moral justifications for its existence and asserting itself as a dramatic form in its own aesthetic right. Romantic theorists of the theater, in particular, saw in comedy's commitment to unadorned actuality the answer to their demands for naturalism in drama. William Hazlitt, although lamenting the waning of the comic spirit in his own age, devoted several pages to the exploration of the nature of humor, wit and laughter, praised comedy as holding "the mirror up to nature" and reality more truthfully than history, and saw its origins in the rise of values such as naturalness, spontaneity, individualism and imaginativeness.[13] Other authors rose to comedy's defense, extolling its historical and literary credentials. Comedy was lauded as the most primeval of dramatic genres, a kind of "Urdrama" associated with the dawn of Western society and stemming directly from a nation's vital popular core. In 1804, the German writer Jean-Paul (Richter) maintained that "all imitation was originally ridicule. For this reason, drama among all peoples began with comedy." And again: "all primitive peoples began with comedy...because comedy, at first, was only mimical physical imitation, later mimical-mental repetition, until it became – not until late – poetic imitation."[14] Comedy would even be prized above its tragic counterpart by the poet Friedrich Schiller, himself, ironically, a writer of tragic drama. Schiller compared tragedy and comedy only to conclude that comedy was by far the more significant genre of the two, and that, were comedy to attain its ultimate corrective purpose, it would render all tragedy superfluous.[15]

Along with such declarations of dramatic respectability went theoretical attempts to define the nature of a new comic, suited to the modern sensibility. The most coherent and methodical approach to this problem was offered by the German critic and translator of Shakespeare, August Wilhelm Schlegel. In a series of lectures on drama delivered at the University of Vienna in 1808 and translated into French as *Cours de littérature dramatique* in 1814, Schlegel distinguished between three varieties of modern, post-Shakespearean, comic: "comic of observation," a version of the typical *comédie de moeurs* in which a sense of comic was generated from the spectators' detection of the ills, vices and ridicules enacted on stage; "avowed comic," a kind of comic in which the characters themselves confessed their blunders with a wink of complicity to the audience; and "arbitrary comic," a highly imaginative, farce-like comedy in which the plot rambled disjointedly and reality was heightened with the addition of fantastic elements.[16] For Schlegel, "avowed" and "arbitrary" comic were kindred, nearly identical genres which shared the same imaginative quality. Examples of this type of comic, which Schlegel also described as "poetic" and as pertaining to "the region of the supernatural," included, primarily, works by English and Spanish authors, such as Shakespeare and Cervantes.[17]

The imaginative nature of the new comedy was also stressed by François Guizot, politician, historian and translator of Shakespeare, in his essay on Shakespeare of 1821. Like his German contemporaries whose theories he embraced, Guizot asserted that the first plays ever were comedies and that major playwrights, including Shakespeare and Corneille, had begun their careers as comic authors.[18] In these early comedies the imagination was allowed to frolic "free from the yoke of probabilities."

It [comedy in Shakespeare's time] did not limit its efforts to the delineation of settled manners or of consistent characters; it did not propose to itself to represent men and things under a ridiculous but truthful aspect, but *it became a fantastic and romantic work, the refuge of those amusing improbabilities which, in its idleness or folly, the imagination delights to connect together by a slight thread, in order to form from them combinations capable of affording diversion of interest, without calling for the judgement of reason* [my emphasis][19].

Schlegel's "arbitrary comic" was singled out as the most modern type of comedy by Madame de Staël, as well, who had attended Schlegel's lectures on the theater during her stay in Vienna. In her book *De l'Allemagne* (1813), she illustrated the new comedy with summaries of comic plays by Ludwig Tieck, a member of the circle of romantic writers around Schlegel. One of these plays, *Puss in Boots*, Madame de Staël described as a truly original extravaganza of fantasy and magic portraying a world upside-down, peopled with odd hybrid creatures, such as talking animals enacting human roles.[20]

The centerpiece of both "avowed" and "arbitrary comic" was to be, according to Schlegel, a sympathetic clowning character portrayed as "an exaggerated caricature," at times "intelligent and spirited, at times dumb and clumsy," and endowed with "the joyful inspiration, the sincere abandon and the freedom to say everything." This "privileged merry-maker [*bouffon privilégié*]," as Schlegel called him, would have two sides: one serious, and one humorous. In his humorous guise the jester-hero would be partly the naive and good-humored victim of his own blunders. In his more earnest guise he would act as spokesman for the author and laugh, in amicable alliance with the spectators, at the stupidity and wickedness of the other characters.[21]

Along with a release of the imagination, comedy – the locus, traditionally, for a freer use of language including wordplay and punning – also provided the prototype for new linguistic freedom in drama. As a result, A. W. Schlegel, his younger brother Friedrich, and members of their circle of romantic innovators, including the poet Klemens Brentano, undertook the rehabilitation of the rejects of classical linguistic decorum, such as the pun, the joke and wordplay.[22] In that respect, too, Shakespeare pointed the way. A. W. Schlegel wrote, for example, that Shakespeare's use of a mixed language, at once noble and coarse, decorous and bawdy, highlighted with puns, wordplay, and even shocking sexual innuendoes, offensive to a classicist's ear as it might be, nevertheless best expressed the social fashions of Shakespeare's times while also adding vivacity and sparkle to his verse. In his discussion of *Love's Labour's Lost*, Schlegel praised "the uninterrupted succession of sallies and wordplays which barely allow the spectator to catch his breath. It is a firework sparkling with wit, a real carnival, where the quick repartees recall the railleries that are thrown at random in a masked ball."[23]

The revalidation and redefinition of comedy as a genre portraying reality heightened with eccentric, even wild, fantasy was part of romanticism's larger aesthetic overhaul, which included a renewed appreciation of the grotesque, the aesthetic category that valued imagination, irregularity and diversity above the classicists' reason, symmetry and unity. The grotesque was the antithesis of the sublime and the beautiful, a mode associated with youth and renovation that

challenged the norm and rebelled against the officially sanctioned canon. And the new comic hero, wise buffoon or jester, was the grotesque's response to the lofty classical heroes. In his 1827 Preface to *Cromwell*, Victor Hugo devoted a lengthy passage to praise of the grotesque, which he called the quintessential element of the modern aesthetic: "In the thought of the Moderns...the grotesque plays an immense part. It is everywhere"; he also defined it as "this seed of comedy co-opted by the modern muse."[24]

In the last decades of the eighteenth century, theorists of early romanticism had already been stressing the critical meaning of the grotesque for the new aesthetic. With regard to the wildly imaginative tales of his contemporary Jean-Paul, Friedrich Schlegel, for example, stated: "I admit the colorful hodgepodge of sickly wit, but I shall defend it and emphatically maintain that such grotesques and confessions are the only romantic productions of our unromantic age."[25]

In literature, Gothic, picaresque and satirical novels, with their freely sprawling plots and surreal fantasy, were regarded as exemplars of the grotesque aesthetic. The works of Ariosto, Cervantes, Rabelais, Ann Radcliffe and British eighteenth-century satirical novelists (Fielding, Smollett, Defoe, Sterne) were most frequently cited (in France, Sterne's works had been translated and even adapted for the theater in the early nineteenth century). Among these, romantic critics eagerly in search of individualism and self-expression singled out one kind in particular, the confessional piece, a work in which the protagonist is the witty and lighthearted, but also sharp and critical, narrator of his madcap travails. "Confessions especially," wrote Schlegel, "mainly by way of the naive, develop of themselves into arabesques [a term Schlegel used synonymously with grotesque]."[26]

For Schlegel, Sterne's *Tristram Shandy* was the epitome of the confessional grotesque novel. (Schiller, too, had listed Sterne among the mightiest geniuses, on a par with Dante, Tasso, Cervantes and Shakespeare, and had marveled, "how readily can laughing Yorick touch our minds at will so loftily and so powerfully.")[27] Addressing a young woman named Amalia who posed as a confirmed romantic modernist, Schlegel alluded to her infatuation, to the point of self-identification, with Sterne:

> But then perhaps you remember that there was a time when you loved Sterne and enjoyed assuming his manner, partially to imitate, partially to ridicule him. I still have a few jocular letters of this kind from you which I will carefully save. Sterne's humor did make a definite impression on you.[28]

Modeled on Rabelais's and Cervantes's novels, Sterne's works, portraying a topsy-turvy world as a series of loosely collated adventures narrated with an intimate and humorous tone by their spirited hero, conformed to Friedrich Schlegel's vision of literary grotesque just as they illustrated August Wilhelm Schlegel's idea of "arbitrary comic." Yorick, Sterne's engaging clowning protagonist, heaped sarcasm on the world around him while also expounding his own very definite opinions. Here, for example, is Yorick's satirical and idiosyncratic view of gravity as voiced in *Tristram Shandy*:

> For, to speak the truth, Yorick had an invincible dislike and opposition in his nature to gravity; – not to gravity as such...but he was an enemy to the

affectation of it, and declared open war against it, only as it appeared a cloak of ignorance, or of folly. . .t'was a taught trick to gain credit of the world for more sense and knowledge than a man has worth; and that with all its pretensions, – it was no better, but often worse, than what a French wit had long ago defined it, – viz. *A mysterious carriage of the body to cover the defects of the mind*; which definition of gravity, Yorick, with great imprudence, would say, deserved to be wrote in letters of gold.[29]

For Friedrich Schlegel, such works of literary grotesque, novels or plays, had their visual counterparts in the painted fantastic ornaments called *grotteschi* or "arabesques."

> Even though it [Sterne's novel] was not ideally perfect form, yet it was a form, and a witty one which captivated your imagination. . .now ask yourself if your enjoyment was not related to what we often experience while viewing the witty paintings called arabesques.[30]

Wit, imagination and expressive imperfection (Schlegel's "not ideally perfect form") likewise determined caricature, an artistic genre Schlegel admired and defined as "a passive union of the naive and the grotesque."[31]

The romantic perception of the comic grotesque and its protagonist, the whimsical yet shrewd buffoon, found their way into the theoretical writings of Stendhal as well, where they merged with the political typology coined by Liberal propaganda to form the core of a new and militant *comédie romantique*.

Although Stendhal's interest in the drama was comprehensive, it is clear that comedy held a special place in his thought from the very start. He had, in fact, begun his career by proclaiming himself a comic author destined to be the Molière of his age. To that end, he not only filled his notebooks with observations on comic plays and abbreviated plots for comedies of his own, but also wrote (much like Hazlitt, his fellow correspondent for the *New Monthly Magazine*) at least three theoretical essays on comedy, the comic, and laughter: *La Comédie* (1813), *Traité de l'art de faire des comédies ou Collection méthodique de mes observations présentes et futures sur cet objet* (1813), and *Du Rire. Essai philosophique sur un sujet difficile* (1823). The ideas developed in these early works were eventually to become part of Stendhal's *Racine et Shakspeare* (1823 and 1825), his polemical pamphlet calling for a general overhaul of French drama.

As Gisela Moinet has shown, Stendhal's ideas about modern comedy developed through two phases.[32] In the earlier phase, starting around 1804, Stendhal's views on comedy were governed by the example of Molière and the *comédie de moeurs* tradition of French theater. A second phase began with Stendhal's discovery of A. W. Schlegel's theory of "arbitrary" or "avowed" comic, possibly in or immediately after 1814, the date of the French publication of Schlegel's lectures on drama which Stendhal had carefully read and annotated. The two approaches eventually combined in Stendhal's formulation of a theory of the "comique romantique," in *Racine et Shakspeare*.

Based on the *comédie de moeurs* model, Stendhal envisioned modern comedy as dealing with a contemporary subject, revolving around the concerns of a liberal middle class, and written in the comfortable prose of ordinary, spoken language. Since laughter was comedy's ultimate aim, Stendhal pondered at length on its

origins and mechanisms. In the end, he adopted the definition of laughter proposed by the seventeenth-century English philosopher Thomas Hobbes, which he paraphrased as "this physical convulsion, which as everyone knows, is produced by the unexpected sight of our superiority over another."[33] He illustrated his words with examples drawn from caricature and theatrical performance:

> Caricature depicting a husband burdened with the little dog which escapes, the umbrella, the little girl etc. etc., makes us laugh in the same manner as such comical situation in Molière or in a comic ballet in which a man of importance who attempts to look dignified falls and breaks his nose.[34]

For Stendhal, therefore, as for Hobbes, laughter was an expression of superiority and scorn. The kind of misfortune likely to trigger modern man's superior expression of mirth was, according to Stendhal, that of the individual who would knowingly reject the values leading to happiness in his own times. If material wealth was the acknowledged means to happiness in the modern age, Stendhal explained, an individual who sought a different path to social well-being would inevitably appear ridiculous: "Among us, the ridiculous individual would be the one who, neglecting or despising wealth, takes another road in order to attain happiness, and who is mistaken."[35] By the same logic, a man attached to the political system or the tastes of another age, such as, for instance, an Ultra loyal to the Ancien Régime or an Academician defending classicism, would inevitably, for Stendhal, become the target of a modernist's scorn.

In Stendhal's later views on comedy, such a socially oriented conception of the comic became infused with the imaginative element central to A. W. Schlegel's "arbitrary comic," to shape his theory of a *comique romantique*. Stendhal now demanded that the writer of comedies not only be a perceptive observer of the fashions of his day but also that he should be a "bel esprit ivre," a drunken, inspired wit, a visionary probing the realm of the irrational. The result of this combination would be a mixed genre which Stendhal called a "comédie du bonheur," a comedy of manners heightened with "un genre de gaîté détachée de la terre [a kind of gaiety detached from the earth]," a light, uplifting and imaginative creation:

> Something airy and fantastic in the comic, something that would produce sensations analogous to those of music. . . . In order for this type of gaiety to please me, the drunken wit [*le bel esprit ivre*] must not be conscious all the time that he is doing beautiful things. . . . I want the author to be a man happily endowed with a powerful imagination at play, in a state of sweet delirium.[36]

At the center of Stendhal's romantic comedy would be a character, witty, prankish and speaking his mind, very similar to A. W. Schlegel's "bouffon privilégié" and to the romantics' jester-hero fashioned after Sterne's Yorick. Stendhal opposed this happy fellow to a gallery of grimly wicked opponents over whom his hero eventually triumphs through wit and laughter. In a sketch for such a potential comic scenario, Stendhal specified:

> The gay man, a comedy in five acts and in verse, who does not let himself be overwhelmed by anything and, as he laughs, extracts himself from the

greatest hardships and attains happiness. [*L'homme gai, comédie en cinq actes et en vers, qui ne se laisse accabler par rien et tout en riant se tire des plus grands embarras et parvient au bonheur.*][37]

Such a hero, laughing his way through adversity, was also to be the protagonist of Stendhal's unrealized comedy *Lanfranc ou Le Poète* (*c.* 1820). Pitted against a hostile establishment of wealthy, pompous nobles and ambitious, stodgy *hommes de lettres*, the young poet Lanfranc, brimming with youth and talent, fights back with laughter and disarming candor, as well as, more pragmatically, by publishing a corrosive pamphlet, an action that lands him in prison for a while before his final victory, and the play's happy end.[38]

By portraying his *homme de génie* as a young man attuned to modern times, and his adversaries as the vicious and old members of the social and intellectual establishments, Stendhal reiterated the emblematic dualisms, young versus old, bourgeois versus noble, Liberal versus Ultra, of current Liberal propaganda. His projected comic plays, therefore, were to be carriers of a political message as militant as political cartoons. As to the laughter of their heroes, it was no less subversive than that of Boilly's jovial Liberal poking fun at his weeping Ultra mate (Fig. 29).

In real life, too, Stendhal posited laughter as the modern hero's weapon against the profound gravity ("sérieux profond") of the reactionary establishment. Like Sterne's Yorick, he associated such profound gravity with deceit and ignorance, the latter best exemplified by members of the French Academy. Tongue in cheek, Stendhal summoned up a vision of the Academy's "quarante personnages graves" headed by Auger, the sworn enemy of romanticism, expressing outrage at the romantics' tendency to unveil truth through ironic, mocking laughter:

> These poor men [i.e. the romantics] put foward the gothic and un-academic excuse that they want to keep the privilege to say on everything what they deem to be the truth. They add. . .this dangerous maxim, subversive of all propriety in literature: RIDENDO DICERE VERUM QUID VETAT? *What seems to us to be true, why not say it with laughter?*[39]

Like the fictional Lanfranc's, therefore, the role of the modern comic poet, according to Stendhal, was to be socially and politically reformatory and militant. To that end, he admonished himself: "This is the direction in which I, as a comic poet, must work in order to be useful to the nation, by annihilating the power of the tyrants over her, and hence bringing her closer to the *divina libertà*."[40]

For Stendhal, the pamphletist Paul-Louis Courier embodied the archetypal militantly laughing romantic, the real-life Lanfranc (also a pamphlet writer) at war against the pompous gravity of reaction. Stendhal's admiration for Courier can be gauged from his 1825 survey of the French literary scene for the *New Monthly Magazine*, in which he compared the pamphletist to the great Pascal (a reference to Pascal's pamphlet-like *Les Provinciales*) and proclaimed him the foremost French author of his day, second only to Chateaubriand.[41]

Courier's own description of his pamphlets as "ephemeral writings, these papers that are passed from hand to hand and speak to men of the present of the

events and the things of today,"[42] exemplified Stendhal's concept of modern, engaged comic. Like Lanfranc's and Yorick's, Courier's strategy was irony and sarcasm. And his disparaging references to his opponents were couched in the extreme, distortive language of caricature. He would allude, for example, to the duc d'Angoulême as a "niais fanatique" and to a village *curé* as a "sinistre fantoche."[43]

Courier's style acquired bite through the use of popular expressions, jokes, wordplay, innuendoes and calembours (or "méchantes plaisanteries" as his opponents preferred to call them).[44] At times his prose would even take on the crude simplicity of the rural idiom, just as the author himself, a sophisticated classical scholar, deliberately took on the peasant identity of a wine grower, "Paul-Louis Courier, vigneron," whose feigned naivety set off ever more ruthlessly the stupidity and vices of his political foes. In an essay of 1822, Courier had defended linguistic simplicity and "le mot propre" against the "langue courtisanesque" of academic writers whom he also held responsible for instituting "this jargon, this courtly tone which infected the theater and literature under Louis XIV and has since ruined many an excellent mind. . ."[45] Stendhal, too, contrasted the pompous and often obscure academic style with the originality, naivety, clarity and piquancy of Courier's writings, which for that very reason – he argued – appealed to men of all social and educational backgrounds: "M. Courier's style, quick, concise, pleasant, *naif*, and intelligible to the most humble as well as to the most elevated spirit, forms a peculiar contrast with the ambitious manner, academic and sometimes obscure, of M. Chateaubriand."[46]

Competing with Courier in popularity was the *chansonnier* Pierre-Jean Béranger, one of the champions of the literary Left and, for Stendhal at least, "le plus grand poète de l'époque."[47] Béranger's poems were political satires which, although firmly grounded in contemporary issues and concerns, transformed reality into a fantastic world of caricatural, monstrous humans existing in harmony with purely magical creatures: devils, dwarfs, angels or giants. Their wild, unorthodox imaginativeness epitomized the romantic grotesque, just as their polemic conception coincided with Stendhal's militant *comédie romantique*. Thus, as the unglorious "roi d'Yvetot," Louis XVIII was depicted as a sleepy, rotund and gouty character (reminiscent of contemporary cartoons and of Delacroix's own satirical drawings) riding a donkey and coiffed with an *éteignoir*-like bonnet ("Le Roi d'Yvetot," 1813). The despised Catholic missionaries were turned into repulsive hybrids, half-human half-devil, their pointed tails peering from under their cassocks ("Les Missionnaires," 1819). In 1823, Stendhal listed Béranger's songs, along with the vaudevilles of Scribe and Arnault's comedies, as among "the most romantic of contemporary comedy."[48]

Borrowing the naive format and the coarse, earthy language of popular *chansons à boire*, ballads or rondos, and set, in addition, to popular tunes of the day, Béranger's poems commanded enormous public success, even as, in both content and form, they flew in the face of political and academic orthodoxy. Béranger's poem "Le Bon Dieu" (*c.* 1820) was condemned, for example, as much for its use of "des formes et un langage ignoble," as for its caricatural portrayal of God as "une image grotesque et bouffonne."[49] In a poem of 1822, Béranger contrasted the aesthetic independence of the humble *chanson* with the despotism of the strictly regulated official literary genres (symbolized by the names of the

two muses Thalia and Melpomene), comparing the freedom of the popular song to that of a republic:

> Je laisse donc Thalie et Melpomène
> Pour la chanson, libre en dépit des rois.
> Sans le régir, j'agrandis son domaine;
> D'autres un jour lui traceront des lois.
> Qu'en république on puisse y toujours vivre:
> C'est un état qui n'est pas sans douceur.
> Pauvres Français, ah! que Dieu vous délivre,
> Vous délivre au moins du censeur.[50]

Thus, in order to attain their polemical goals, both Courier and Béranger adopted the structures and style of the new, romantic comic simultaneously with Stendhal. Their satirical outlook on political and social actuality took on the look of a fantastic comedy peopled by grotesquely deformed real characters and symbolic, unreal creatures, a Punch and Judy show skillfully orchestrated from backstage by the poet-jester, disguised as a naive and witty storyteller. Caricature was the paradigm and the end result of such writings of militant humor.[51] Their grotesque imagery was paired with a deliberately grotesque linguistic form that thrived on the coarse simplicity of the popular idiom, as well as on exaggeration, distortion and expressivity.[52]

Delacroix's laughter and the language of modernism

The romantic comic and caricature ushered in Delacroix's modernism, too. As Yorick, Delacroix proclaimed his modernity on several levels. First, his literary preferences which included, as we saw, Sterne, but also comprised Cervantes, Rabelais as well as, in 1824, the contemporary Népomucène Lemercier's *La Panhypocrisiade* (a disjointed and hybrid satirical epic, half-history, half-allegory, lauded by Stendhal), marked him as a supporter of the new taste for literary grotesque embraced by other romantic modernists such as the Schlegels and Hugo. His own literary attempts, his two youthful novels and a play, followed the Gothic taste. His enthusiasm for *opera buffa* was part of the same taste now transferred to the realm of music. That, in his mind, caricature was yet another facet of the same aesthetic is clear in statements such as this, a diary entry of 7 April 1824, in which he associates lithographic caricatures with Cervantes and Goya: "Worked on the little *Don Quixote*. In the evening, Leblond, and tried some lithography. Superb ideas for that subject. Caricatures in Goya's manner." Satire, the grotesque captured the spirit of the times and therefore stood for modernity, he implied further in the same entry: "The people of the present time: Michelangelo and Goya. Lemercier, not Charlet. The lash of satire. Read the *Panhypocrisiade*." On one level, therefore, Delacroix's identification with Yorick reveals the artist's deeply felt wish to live up to a modern persona, to be a man of his age who creates according to and for the taste of his age.

On another level, Delacroix's assumed comic identity also points toward a novel heroic ideal, itself shaped by the renewed popularity of the comic grotesque. Its models were the buffooning protagonists of the *comédie romantique*

and of satirical novels, such as Lanfranc and Yorick. In Delacroix's immediate environment of politicized popular creations, there was also the *Nain jaune*, the scourge of political reaction and untruth, personified, as we saw, as a diminutive jester in the fool's traditional attire. Youth, laughter and spontaneous wit were the jester-hero's attributes. Such a prototype was undoubtedly on Stendhal's mind when he set down, in 1817, his prerequisites for a timely "beau idéal moderne," youthful, gay, witty and intellectually alert, as opposed to an obsolete "beau idéal antique," strong, prudent and grave.

1. An extremely vivacious spirit.
2. Very graceful features.
3. A sparkling eye, not with the fire of passion, but rather with the fire of a witticism...
4. A great deal of gaiety.
5. A background of sensibility.
6. An elegant figure and especially the agility of youth.[53]

Modern visions of the genius did not fail to adopt some of these features. Shakespeare himself was described as carefree and mischievous in his youth. In his biography of Shakespeare, for example, Guizot showed the great man sharing in the "grotesque follies," the pranks, and the drinking of the merry youth of Stratford:

And Shakespeare, who, we are assured, was no less a connoisseur in beer than Falstaff in canary sack, formed a part of the joyous band from which, doubtless, he rarely separated... All that we know, however, combines to portray to us his merry and quick imagination disporting itself with complacency amid the uncouth objects of his amusements.[54]

Stendhal's Rossini fell into a similar mold. Stendhal described the genial maestro as brimming with youth and with "that lively, ardent spirit sensitive to the slightest impression..."[55] His gaiety, wit and good humor were a match for the agility of his movements and the charm of his features. As with Lanfranc, moreover, his fictional *homme de génie* and comic hero, Stendhal used Rossini to make a political point. In that aim, he opposed the young and playful composer to the old and ill-tempered members of the musical establishment. Thus in Italy,

the director of the theater, in which he [Rossini] was to be hired, had only a very mediocre opinion of the composer, as much because of his extreme youth as because of his excessive gaiety which did not differ in anything from the carefree prankishness of a schoolboy.[56]

Apart from its political underpinnings, the image of the *homme de génie* unrecognized by philistine society, which Stendhal conjures up here, was a familiar romantic topos. In the nineteenth century, the theme found its way into literature and art in the iconographic guise of yet another image of the grotesque – the "sad clown."[57] Stendhal's evocations of Lanfranc and Rossini embodied such a concept. And so, in a way, did Delacroix as a young man. Exceptionally gifted and motivated, but also merry, spirited and lively, he saw himself, much like Rossini and Lanfranc, as pitted against a reactionary and hostile establishment with as his only weapons his wit and his crayon. Like that of the typical "sad

clown," Yorick or Lanfranc, his laughter would ultimately ring with a bitter, satirical note, thereby reconciling Delacroix the jester with his other half, Delacroix the dark prince, bonding together in one whole Yorick and Hamlet, grotesque and sublime, the complementary opposites of both the romantic persona and the romantic aesthetic.[58]

In cartooning Delacroix would have found the romantic comic author's equivalent of the *comique romantique*, a genre that offered the liberating possibility of a free play of the imagination just as it permitted him to express dissent, political and aesthetic. In the cartoons, the grim realities of the day – censorship, favoritism, oppression and bigotry – are transmuted into images of a mad world in which humans rub shoulders with extraordinary beings – straggling crayfish, soaring winged scissors, wigged, gaitered and monocled newspapers, and brutish monsters. Against this topsy-turvy world Delacroix sets his modern, laughing *alter ego* in the guise of young and fashionable observers, the only characters that escape distortion in the cartoons. They are the group of personified Liberal journals watching the Cervantesque duelists of the *Duel polémique* (Fig. 64); they are the men who rejoice at the departing censors (Fig. 67); and they are the calm and controlled bourgeois-military pair in the center of the whirling *voltigeurs' manège* (Fig. 32). In their blend of real and fantastic vocabulary and their militant content, the cartoons thus appear as the counterparts of Courier's pamphlets and Béranger's poems, as well as of Stendhal's *comédie romantique*. *Les Écrevisses à Longchamps* (Fig. 68) in particular almost literally illustrates Stendhal's politicized definition of laughing superiority at the ideological misfits of modernity. The crayfish convoy that deviates from the official track (modernity) alludes to the Restoration's reactionary leaders' mistaken political course. The two young and fashionable bourgeois whistling at it are the laughing counterparts of Yorick or Lanfranc (and of Courier, Béranger, Stendhal, and Delacroix himself), the surrogates of Stendhal's *poète comique* in his struggle to establish *divina libertà*.

The cartoons also offered Delacroix the possibility to experiment with an alternate visual language which countered the academic norm in its deliberate cultivation of a coarse, childlike and popular idiom proper to satire. Like Courier and Béranger, Delacroix couched subversive message into fittingly subversive form. His humorous drawings, especially, expressive and fluid, announce his contemporary studies for "high art" creations. The cartoons, in fact, may in part hint to his preoccupation, at the time, with the merits of contour, even in its most spare, primitive and quintessential form. The diary entry of 7 April 1824, significantly begins with his stated intention to illustrate Don Quixote with lithographic caricatures in Goya's manner before it launches into a praise of contour: "The first and most important thing in painting is the contours. The rest could be quite ignored since, if they are there, the painting is strong and finished. I, more than others, need to check up on myself on this matter: think constantly of it and always begin that way." Another diary entry, of 4 April 1824, first records his desire to make drawings after Lemercier's satirical *Panhypocrisiade* and then urges: "Try to recover the artlessness of the little portrait of my nephew" (Delacroix's portrait of his nephew? Or, and more intriguingly, the artlessness of his young nephew's childish doodle of a portrait?)

Such statements, with their broader implications for Delacroix's approach to

painting, call forth his cryptic allusion to the cartoons' "germes précieux." Accordingly, the last section of this chapter will be an attempt to assess the place and significance of the cartoons in Delacroix's later *oeuvre*.

"Germes précieux"

Liberal and modernist, how much of the message of the cartoons can be traced in Delacroix's later paintings? The task of making direct connections between Delacroix's graphic satire and his works as a painter is a risky one, and – considering the wealth and plurality of visual stimulation that contributes, on both conscious and less conscious levels, to the making of a work of art – one likely to be speculative, possibly even misleading. For, unless we decide to limit ourselves exclusively to the detection of common iconographic motifs in cartoons and painted or later graphic works,[59] distinguishing between what particular conceptual or formal elements in Delacroix's later *oeuvre* were derived specifically from caricature (as opposed, for instance, to popular prints, medieval and Oriental miniatures, or book illustrations, of which Delacroix made abundant use) might prove a daunting, if not impossible undertaking. Nevertheless, and with such potential pitfalls in mind, some links can still be proposed.

Undoubtedly, for example, there is ideological continuity between the libertarian beliefs formulated by means of ephemeral symbols in the cartoons, and those expressed in less immediate, inverted and timeless terms in Delacroix's large compositions of the 1820s. Anonymous and unassuming from an artistic point of view, the cartoons enjoyed the freedom – rare in a time of increasing absolutism – of virtually unrestrained and militant outspokenness; there was not even an aesthetic tradition to defer to, since what could be called tradition for caricature was no more than the permanent defiance of existing aesthetic models. Not so for painting, for which the power of tradition was as restrictive as the concern with one's reputation and personal success within the only (still) truly viable professional environment, that of the official artistic establishment and of the state. In the paintings, therefore, the specific political allusions that underlie the cartoons – Ultra/Liberal, reaction/progress – were translated into the loftier (and "safer") vocabulary of universal moral conflicts – good against evil, light against dark, civilization against barbarism – thereby transforming Delacroix's monumental historical and literary themes into emblematically charged images and ideological metaphors.[60] Wrapped in the varied cloaks of historicism, exoticism and Byronism, Delacroix's important compositions of the period, *Massacres of Chios* (1824), *Execution of Marino Faliero* (1824), *Tasso in Prison* (1824), *Greece on the Ruins of Missolonghi* (1826), *Death of Sardanapalus* (1827) and *Liberty on the Barricades* (1830), must indeed be interpreted as grand moral fables meant to indict absolutism (*Chios*, *Missolonghi*) and aristocratic abuse (*Tasso*, *Marino Faliero*), or, in turn, to celebrate their demise (*Sardanapalus*, *Liberty*).

Undoubtedly, too, the concern with actuality was a continuous trait in the cartoons and in some of Delacroix's major paintings. Caricature's commitment to contemporaneity may have alerted Delacroix to the inspirational potential of the immediate present, even in its most temporal and journalistic guise. In that

sense there seems to be, in fact, no extraordinary conceptual leap between the cartoons – the modest documents of history in the making – and Delacroix's allegorized historical documentaries of the 1820s, such as *Massacres of Chios* or *Liberty on the Barricades*.

Some structural and formal affinities between the early cartoons and Delacroix's paintings can also be signaled. Delacroix's lifelong insistence upon unity and clarity, for example, is already announced in the cartoons.[61] Here, as in the paintings, the energetic pulse of extravagant forms is never allowed to dominate the image in the unruly manner of, for instance, British cartoons, but is instead submitted to sobering rational formats. In fact, even by comparison with French contemporary satirical prints, Delacroix's stand out with their carefully conceived structures and clearly articulated visual components, two features that bring them closer to "high art," thus betraying their author's training and principal aesthetic direction. Symmetrically balanced masses, piled in neat pyramidal aggregates or arranged in regularly designed circles and ovals, and parallel planes receding progressively into the distance, give the composition of the cartoons an almost staid conformist look, often in stark contradiction to their unpredictable imagery.

Such contradictions are only apparent, however, for they really represent yet another form of unity. By joining regular to irregular, and classical to expressive, Delacroix's cartoons reflect the balanced dualism – sublime and grotesque – demanded by the romantic aesthetic. In that sense, the prints are significant as early exemplars of similar solutions observed in Delacroix's paintings. In the *Barque of Dante* (Fig. 92) and *Massacres of Chios*, for example, conventionally constructed scenes are punctuated by elements of the grotesque, some of them possibly derived from graphic satire, such as the damned gnawing at Dante and Virgil's boat, or figures directly quoted from Michelangelo and Rubens, two of the old masters whose work harmoniously joined sublime and grotesque, according to Hugo (in fact, in *Théâtre Italien* [Fig. 74], Rossini's profile thrust against his breast, reiterates a familiar michelangelesque motive). Likewise, cartoons like the *Déménagement* (Fig. 67), with its neatly assembled pyramid of freakish creatures over which one towering figure appears to command, forecast the frontal, pyramidal and planar arrangement of *Liberty on the Barricades* (Fig. 93) with its fiercely realistic protagonists. And the circular vortex around which revolve the grotesque riders of *Manège de voltigeurs* (Fig. 32) announces the ovals and circles underlying, among others, the explosive formal twine of felines and humans in the *Lion Hunts* of the late 1850s and early 1860s.

More broadly, familiarity with caricatural grotesque may have also provided Delacroix with specific formal solutions in the course of his elaboration of a style that challenged the conventions of descriptive illusionism through the use of a more abstract, expressive vocabulary. In that spirit, for example, F. D. Klingender has compared the unrealistic vertical rendering of space in Delacroix's *Christ on the Lake of Genezareth* (1853) and the very similar treatment of the background in a caricatural drawing by Rowlandson.[62] And combined with the experience of medieval illuminations (the repositories of the grotesque element, par excellence, in their marginalia) the foray into caricature may underlie the bold linear breaks and formal torsions of Delacroix's lithographs for *Faust* (1828) and *Hamlet* (1834).

112

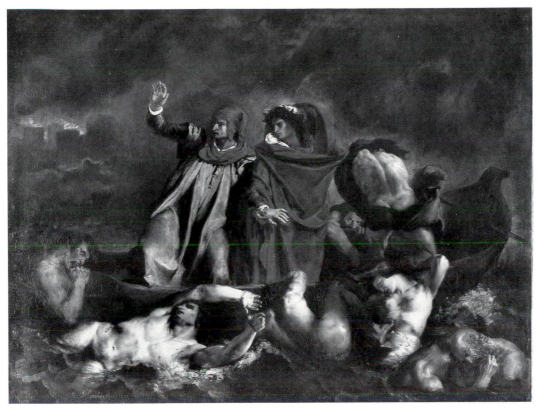

92. Delacroix, *The Barque of Dante*, 1822. Paris, Musée du Louvre.

93. Delacroix, *Liberty on the Barricades*, 1830. Paris, Musée du Louvre.

94. Delacroix, *Paganini*, 1831. Washington, The Phillips Collection.

95. Anonymous, *Paganini. Exercises sur une seule corde sans balancier.* Lithograph, Paris, Bibliothèque Nationale, Cabinet des Estampes.

The search for greater expressivity in the paintings, too, may owe something to caricatural grotesque. A case in point would be that of the portrait of Rossini's contemporary, the violinist *Paganini* (Fig. 94), twisting upward like a somber flame with the surge of inspiration. Compared with a contemporaneous anonymous cartoon of the musician performing, it is evident that Delacroix has put caricature's playful distortions to work in view of attaining a much more serious goal: the infusion of matter with soul (Fig. 95).[63]

Yet caricature's meaning for Delacroix's *oeuvre* is more than just such single, itemized features. Its more tangible contribution would rather be the sum of these individual parts, and lies, instead – as I have tried to suggest – in its role as witness to the painter's early identification with the ideals and the aesthetic of romantic modernism.

EPILOGUE

WHAT BROUGHT ABOUT the end of Delacroix's cartooning days after 1822 is a matter for speculation. Greater financial ease for the artist as well as developments in internal French politics marked by increasing repression, restriction of personal liberties, and renewed press and print censorship may partly account for such a withdrawal. Adding to the severity of the print law of March 1820, a law passed in March 1822 had further tightened and made permanent preliminary censorship of political prints. Yet such restrictive measures, although undoubtedly inhibiting, were not fatal and simply forced Restoration caricature to adopt subtler, less explicit means of communication.[1] The *Miroir*, as we saw, still managed to publish its periodical cartoons till 1823, when it was ordered to silence.

By far a more important impulse for Delacroix's abandonment of satire may have been his increasing absorption in his career as a painter. The overall positive reception of the *Barque of Dante*, Delacroix's first Salon submission in 1822, and its subsequent purchase by the state, aside from temporarily allaying financial worries and raising hopes of security and of future official support, must also have bolstered Delacroix's self-confidence and his desire for further achievement in the grand manner. Indeed, no sooner had the Salon closed down than he was planning his next picture, a life-size image of *Tasso in Prison*; and in May 1823 he announced his decision to paint a scene inspired by the recent Turkish massacre on the Greek island of Chios, a work which he hoped would bring him public recognition in the following Salon, of 1824. In such circumstances and in the light of such ambitions, it is easy to understand that the whimsical world of graphic satire may suddenly have appeared artistically and materially unrewarding, as well as politically unwise, perhaps even harmful.

Yet Delacroix's memory of the cartoons and of the spirit that infused them did not wear off with time. He encouraged Burty, as we saw, to include his satirical prints in a comprehensive catalog of his graphic works.[2] And in an article of 1862 written in defense of Charlet against Baudelaire's snubs, he respectfully called the older artist, whom he admired throughout his life, the true heir to the great tradition of French satire, from Rabelais to La Fontaine and Molière.[3] Using a simile evocative of the metaphors of his own cartooning days, Delacroix opposed the meaningful irregularities of caricature, a reflection of nature's truth,

to the vapid harmonies of classical ballet, the result of mere artifice divorced from reality. The former he saw as a manifestation of the genuine, unaffected popular spirit of which Charlet was the exponent; the latter he associated with upper-class dishonesty and social deceit:

> He [Charlet] is merciless toward affectation and false sensibility. . . Even less is he a man of the drawing room: the robust fabric of his spirit was unable to content itself with this kind of society which only lives by candlelight and only sees Nature through the Opera, which despises Rubens and finds beauty only in the poses of a dancer.[4]

The same essay attributes to caricature "all the merits of painting" and compares Charlet to Rubens (an artist re-evaluated as a result of the rise of romantic grotesque and one consequently revered by many a cartoonist, including Gillray).[5] In so doing, Delacroix expressed the new all-inclusiveness of romanticism and its abolition of hierarchical distinctions between historical painting and cartoon, major and minor genres, tragedy and comedy.[6]

The heir to a similar egalitarianism, Baudelaire, Delacroix's spiritual disciple, rose in simultaneous defense of caricature as a legitimate artistic genre in its own right and of Delacroix's use of expressive form as the soul of good and vital art.[7] In both he recognized a common target: challenging the lifeless academic tradition to a deadly duel. Caricature, he wrote in his celebrated essay on laughter and the comic, of 1855, was the nemesis of

> the sworn professors of seriousness, charlatans of gravity, pedantic cadavers emerged from the frigid undergrounds of the Institut, and returned on the earth of the living like some stingy ghosts in order to draw out a few pennies from complacent ministries. To begin with, they would say, is caricature a genre? No, their colleagues would reply, caricature is not a genre. I have heard with my own ears such heresies in dinners of academicians.[8]

That same year, and fending off critical attacks on Delacroix's allegedly faulty drawing, Baudelaire drew an analogy, echoing Stendhal's thoughts more than thirty years previously, between the stifling regularity of classicist drawing, the strictures of classical tragedy, and the cruelty of political despotism: "A good drawing is not a hard line, cruel, despotic, immobile enclosing a figure like a straitjacket; drawing must be like nature, alive and moving; simplification in drawing is a monstrosity similar to tragedy in the world of drama."[9] Delacroix's drawing, Baudelaire contended, stood as a "perpetual and effective protest against the barbarous invasion of straight lines, of this tragic and systematic line whose ravages are already immense in the painting and the sculpture of our time."[10] For Baudelaire, Delacroix's impetuous line, just as caricature's irreverent jibes, represented the living denial of the artistic and political status quo.

APPENDIX 1

Chronological List of Delacroix's Satirical and Political Prints

1814	*"Buonaparte,"* etching.
1815 (September)	*Les Trois Nains littéraires,* etching.
1815 (October)	*Troupes anglaises. Le bagage de campagne,* etching.
1817 (August)	*Le Retour de Calicot ou Les Calicots n'ont pas fait baisser la toile,* etching.
1817 (August)	*M. Calicot à la réforme,* etching.
1819 (January)	*Artistes dramatiques en voyage,* lithograph.
1820 (February)	*Louis Pierre Louvel,* lithograph.
1820 (March)	*La Consultation,* lithograph.
1821 (May)	*Un Bonhomme de lettres en méditation,* lithograph.
1821 (June)	*Un Bonhomme de lettres en méditation* (second version) lithograph.
1821 (July)	*Le Grand Opéra,* lithograph.
1821 (August)	*Théâtre Italien,* lithograph.
1821 (September)	*Duel polémique entre Dame Quotidienne et Messire Le Journal de Paris,* lithograph.
1822 (February)	*Le Déménagement,* lithograph.
1822 (March)	*Leçon de voltiges (Manège de voltigeurs),* lithograph.
1822 (April)	*Les Écrevisses à Longchamps,* lithograph.
1822 (May)	*Gare derrière!!!!,* lithograph.

APPENDIX 2

Explanatory Texts of Delacroix's Cartoons for Le Miroir des spectacles, des lettres, des moeurs et des arts

UN BONHOMME DE LETTRES EN MÉDITATION
27 juin 1821

A ce regard peu perçant, et dont la direction semble indiquer le regret du passé; à ce nez qui ne ressemble pas au bec d'un aigle, et qui "*par sa quiétude a quelque chose de comme aspirant à la tombe*", pour parler le langage de M. JOURDAIN; à cette oreille, humaine par sa conformation, mais dont la longueur démesurée fait penser au moins savant des animaux; à cette mâchoire assez large et assez lourde pour donner son nom à la figure où elle occupe une place si considérable; à cette physionomie plus maussade que grave, plus rêveuse que méditative, qui ne reconnaîtrait *un bonhomme de lettres*, quand sa condition ne serait pas indiquée ici, par les accessoires dont il est entouré.

Ces accessoires sont parlans. Sur une tête à perruque, par là j'entends la tête de bois, on voit une *perruque à la brigadière*, couverte d'un chapeau retapé à la suisse, et garni de plumes anglaises, dont les touffes ressemblent à des poignées de cette chicorée, dite barbe de capucin.

Au pied d'*icelle*, un parasol militaire et une épée pacifique se croisent en trophée. Sur la table, sont: une bouteille d'eau, produit net du plus utile des pélerinages; un PÂTÉ...*Je...e...sais ce que c'est!* Et des BRIOCHES, je sais encore ce que c'est, *le sacristain a apporté*; deux éteignoirs coiffent, l'un une chandelle, l'autre un cerveau où la lumière n'a jamais brillé. Différens volumes placés suivant les affections ou les aversions du *bon homme* lui servent de coussins dans le fauteuil où il dort, ou de marche-pied dans le fauteuil où il rêve; enfin un arbre généalogique, le portrait de M. Malboroug, un vieux tapis de Turquie et le tableau d'un *auto-da-fé*, égayent, meublent et décorent le cabinet, où, la tête dans la main, ce penseur se consume à rassembler les souvenirs, à composer les portraits qu'il va griffonner sur les papiers dont sa table gothique est couverte. Mais ce *bonhomme*, quel est-il? Le marquis de CROCHEPATTE? – Je ne vois pas là sa légende: *Rien de mutuel.* – Serait-ce M. DE CLOPINEAU? Il est entouré de *rogatons*; il y a près de lui une béquille. – N'importe, *Clopineau* n'a pas besoin d'une béquille pour faire son chemin, et puis, le *bonhomme* que voici pense, et il est seul: or, M. DE CLOPINEAU n'a jamais pensé seul, et quand il écrit, ce n'est pas ce qu'il pense; comme quand il lit, ce n'est pas ce qu'il a pensé. Cela est de notoriété publique. – Attendez, m'y voilà: c'est l'ABBÉ BOURRIQUET! – Quelle idée! A cause de l'*Histoire des naufrages* qui se trouve sur cette table?... Ce philanthrope s'est fort occupé de naufrages, on le sait. Comme le personnage de ce dessin, il tourne naturellement le dos à une épée, on le sait aussi; mais voyez-vous les œuvres de *Collot d'Herbois*, objet de ses premières méditations?... – Non; mais j'y suis cette fois. A cet air naïf et préoccupé, peut-on le méconnaître? C'est frère LA CRESCELLE? – Ce n'est pas lui. – C'est donc frère TORTICOLIS, frère GRINCE DES DENTS? Et non, non, non...!

Ne nous fatiguons pas, lecteur, à chercher une ressemblance particulière dans des traits généraux. Le personnage que vous avez sous les yeux est un être idéal. Composé de détails empruntés aux uns et aux autres, ce *bonhomme* est le type de la sottise, comme la *Vénus* de Zeuxis était celui de la beauté.

LE GRAND OPÉRA
26 juillet 1821

Nous ne savons pas si le grand Opéra se vouera un peu plus au culte de Polymnie, dès qu'il sera installé dans son nouveau local; mais, comme jusqu'à ce jour, il n'a guère voulu sacrifier qu'à Terpsicore [sic], nous le présentons au public appuyé sur ses ballets.

THÉÂTRE ITALIEN
13 août 1821

Voici pour le coup un dessin d'une hardiesse peu commune et d'une impertinence qui mérite correction. Rossini soutenant à lui seul tout l'Opéra Italien!... quel blasphème! A quoi la témérité du lithographe ne va-t-elle pas nous exposer? Les foudres du conservatoire sont-elles donc épuisées? La haine des professeurs de clavecin est-elle éteinte, et M. Berton, qui rédige un article aussi facilement que Rossini compose un opéra, laissera-t-il impunie cette nouvelle agression des détracteurs de l'ancien régime musical? Je voudrais bien savoir où M. Lacroix a *pris ses licences* pour oser se prononcer de la sorte en faveur de l'auteur de *Moïse* et d'*Othello*? Je suis très-convaincu que *Mr.* Rossini sera le premier à désavouer de telles exagérations; je ne doute même pas qu'avant peu de temps il n'écrive dans tous les journaux pour réclamer contre les éloges dont il est l'objet, et se plaindre de l'empressement avec lequel on se porte au théâtre de la rue de Louvois, toutes les fois qu'on y représente un de ses opéras.

J'ai nommé l'auteur de la lithographie que nous offrons à nos abonnés; mais il mérite de graves reproches pour ne s'être pas nommé lui-même. Quand on prend parti dans une discussion d'une nature aussi grave, il n'est pas permis de laisser ignorer qui l'on est. Peu importe que son idée soit originale, que son dessin soit piquant et spirituel, un lithographe, qui, pour adresser un hommage à Rossini se cache sous le voile de l'anonyme, mérite d'être sévèrement réprimandé. Il faut signer tout ce que l'on fait, soit qu'on dessine une caricature sans conséquence, soit qu'on écrive avec l'approbation du public dans une feuille recherchée, soit qu'on débute sans succès dans un recueil estimable et obscur.

DUEL POLÉMIQUE ENTRE DAME QUOTIDIENNE ET MESSIRE LE JOURNAL DE PARIS
12 septembre 1821

Nous avons annoncé la grande querelle qui s'est élevée entre la *Quotidienne* et le *Journal de Paris*. Celui-ci a traité la *Quotidienne* de délatrice, de philosophe, d'athée; la *Quotidienne* (tant de fiel entre-t-il dans l'âme des dévots), a traité le *Journal de Paris* de somnifère et de grossier. Quand se sont bien dit leurs vérités, des gens d'honneur comme la *Quotidienne* et le *Journal de Paris* n'en restent pas là. On s'est envoyé de part et d'autre un cartel en bonne forme. Quoique la *Quotidienne* vantât sa noblesse, elle voulut bien descendre jusqu'à se compromettre avec le *Journal de Paris*, qui n'est qu'un vilain. On décida que l'affaire se viderait en champ clos, et qu'un combat à outrance aurait lieu entre les champions, à l'instar du fameux combat do Saint-Maigrin. La *Quotidienne* exigea qu'on observât toutes les règles des combats du huitième siècle, appelés jugemens de Dieu, et la lice fut préparée à sa requête dans le cimetière des Innocens.

On se disputa d'abord sur le choix des armes; des arbitres prononcèrent qu'on se battrait à la plume. Une longue plume de paon, armée d'une aiguille anglaise à tricoter dont on avait effilé la pointe, fut remise à la *Quotidienne*, et le *Journal de Paris* reçut une plume fraîchement arrachée du croupion d'une dinde aux truffes, et dans laquelle on avait emmanché le trident d'une fourchette d'acier.

A l'heure indiquée, les échafauds qui entouraient la lice selon la vieille mode, se garnirent des abonnés de la *Quotidienne* et du *Journal de Paris*. Il y avait fort peu de monde.

Le Moniteur, connu pour son impartialité, fut nommé juge du camp, et s'assit sous un dais à vieilles crépines, dont son bonnet pointu, formé d'une de ses longues feuilles roulée en cornet à pain-de-sucre, touchait presque la faite.

Autour de lui, se rangèrent en amateurs le *Constitutionnel*, et le *Courrier*, sous la bannière de la Charte; le *Journal du Commerce*, armé d'un caducée pacifique; le *Miroir*, quit enait en bouclier une glace des Gobelins, où se réfléchissaient les sottises et les caricatures du temps; le *Journal des Modes*, orné de fanfreluches éphémères, et quelques autres qui restèrent inaperçus dans la foule.

Tous les spectateurs rangés, le juge du camp imposa silence aux partisans des champions, donna le

signal, et la barrière s'ouvrit aux deux extrémités de la lice. Les fanfares résonnèrent aussitôt. D'un côté les cloches et les serpens retentirent; de l'autre, un charivari de casseroles frappa les airs. Les serpents appartenaient à la *Quotidienne*; le bruit des casseroles était la musique ordinaire du *Journal de Paris*.

Les parrains des combattans entrèrent les premiers. Du côté de la *Quotidienne*, parurent le *Drapeau Blanc* en habit complet de voltigeur de l'autre siècle, et dame *Gazette de France*, qui, pour la circonstance, avait pris le costume de Jeanne d'Arc, rehaussé d'un panier, d'une fontange et d'un vertu gadin. Leurs abonnés n'ayant pu les monter, ils étaient à pied. Du côté du *Journal de Paris*, s'avancèrent l'*Etoile des rues*, vêtue d'un frac en peau de chauves-souris, et le *Journal des Maires* en habit d'ordonnance.

Enfin, au bruit des fanfares et des acclamations des deux partis, on vit entrer la *Quotidienne* et le *Journal de Paris*. La *Quotidienne* était montée sur le fameux Rossinante; elle était vêtue d'une robe à ramage, retroussée dans les poches; elle avait des bottes à la Suwarow et à talons rouges; par dessus sa coiffe à dentelles, reluisait le plat à barbe de don Quichotte, orné, au lieu d'ailes de génie, de deux ailes de merle blanc et surmonté d'une chimère. A l'arçon de sa selle pendait un encensoir dont elle se donnait à chaque instant par le nez. D'un bras décharné, recouvert d'une mitaine noire, elle brandissait sa plume de paon et son aiguille. Quoiqu'elle eût mis du rouge, elle était pâle, et le fond de son teint était *feuille morte*.

Le *Journal de Paris*, en bas de soie blancs, en jabot de mousseline et en habit noir, était à califourchon sur le coursier de Sancho-Pança. Il s'était plastronné sous son gilet du tirage entier de son numéro du jour; il portait à sa boutonnière un thermomètre; sa tête un peu faible était garantie par une marmite renversée, au-dessus de laquelle tournait une petite girouette argentée. Sou ventre énorme était protégé par un large baromètre; deux bouteilles de Malvoisie sortaient de sa poche, et, de toute la longueur de sa plume de dinde, il tendait en avant sa fourchette d'acier.

Les deux champions firent le tour de la lice en saluant les spectateurs. Quand ils passèrent devant le Miroir, la *Quotidienne* se trouva bien laide et le *Journal de Paris*, malgré son ventre, se trouva bien plat. Ils regagnèrent leurs places; le juge du camp défendit les coups de jarnac, la botte secrète, et les trompettes sonnèrent la charge. Rossinante s'élança dans la carrière, et trouvant que la *Quotidienne* ne pesait pas une once, galoppa pour la seconde fois de sa vie. Le *Journal de Paris* piqua des deux; mais comme la *Quotidienne* donnait beaucoup trop à droite, les deux héros passèrent sans s'atteindre. A la seconde course, le *Journal de Paris* qui pendait les étriers par habitude, s'arrêta tout court devant la *Quotidinne* qui tourna bride, emportée par Rossinante. La pauvre bête avait pris le *Journal de Paris* pour un moulin à vent. Enfin, les deux champions se joignirent; le *Journal de Paris* reçut dans la poitrine l'aiguille à tricotter de la *Quotidienne*, qui, au défaut de sa respectueuse, reçut en même temps dans l'estomac la fourchette du *Journal de Paris*. Tous les deux mordirent la poussière; on les crut morts, et le juge du camp les fit couvrir d'un *Moniteur avec son supplément*. Cependant la *Quotidienne* n'était que blessée, et le *Journal de Paris* n'était qu'étourdi, attendu, qu'heureusement pour lui, il avait le cœur dans l'abdomen; on les vit remuer; le *Journal de Pharmacie*, après avoir mis ses lunettes, administra à la *Quotidiee* un clystère anodin qui la fit revenir; le *Journal de Paris* se releva, grâce au ministère de la *Gazette de Santé*. Les deux champions, tout surpris de n'être pas morts, s'embrassèrent par l'intervention du *Galiany-Messenger*, et allèrent, comme de raison, déjeûner ensemble au café Turc.

LE DÉMÉNAGEMENT
11 février 1822

Il était à peu près neuf heures du soir, et nous allions, victimes obéissantes, soumettre à l'examen des bésicles censoriales nos malices innoffensives, lorsque nous rencontrâmes au détour du quai Voltaire, que recouvrait un épais brouillard, un petit chariot trainé par un coursier à longues oreilles. Soit préoccupation d'esprit, soit illusion produite par l'obscurité qui dénature les objets et qui empêche de les voir tels qu'ils sont, ce qui nous apprend pourquoi tant de gens la recherchent et travaillent à la faire naître, l'équipage grotesque s'offrit à nous tel que nous essayons de le retracer dans la lithographie que nous joignons à ce numéro. Nous ne chercherons point à expliquer notre vision, nous laisserons ce soin à nos lecteurs, en nous bornant à leur confier, sous la foi du secret, qu'arrivés à l'hôtel où se réunissaient les anatomistes chargés à disséquer nos pensées, nous trouvâmes maison nette, et apprimes qu'ils venaient de déménager.

LEÇON DE VOLTIGES (MANÈGE DE VOLTIGEURS)
8 mars 1822

Le temps qui mûrit les bons fruits fait aussi renaître les plantes parasites. La vieille féodalité qui, depuis de longues années, avait reçu les invalides, et n'était plus qu'une ombre proscrite par les loix nouvelles, se mit dans l'esprit de reparaître sur la scène du monde, de faire rebrousser le siècle et de ressaisir les antiques prérogatives qu'elle avait perdues. L'Extravagante, gonflée par quelques avantages remportés momentanément sur la Raison, crut que la puissance de son souffle suffirait pour éteindre toutes les lumières, renverser le pacte consacré, et déjà secondée par la chevalerie démontée, qui la servait à pied depuis quelque temps, voulut profiter des jours gras pour la remettre à cheval. Elle avait éprouvé plus d'une fois la vérité du proverbe: *Laissez leur prendre un pied chez nous, ils en auront bientôt pris quatre*, et se flatta qu'elle serait inébranlable une fois qu'elle serait remontée sur ses grands chevaux.

Cependant la gothique chevalerie avait perdu l'habitude de se tenir en selle. Il fut donc résolu qu'avant de se donner en spectacle aux vilains de la capitale, espèce railleuse et sifflante, les chevaliers qui représentaient les vieilles institutions prendraient quelques leçons de manège et de voltige. En conséquence, on se présenta dans un cirque favorable aux exercices de ce genre. On comptait tellement sur l'admiration et les applaudissemens, que les curieux furent admis sans difficulté dans les tribunes. Les chevaliers revêtus de leurs armures et de leurs insignes choisirent dans les écuries du manège les *destriers* qui convenaient le mieux à leurs caractères, et qui passaient pour caracoller sous leur maître avec le plus de souplesse et de soumission. *Le comte du quatorzième siècle* enfourcha l'*Arrogant*, cheval de parade, hors d'âge, et depuis longtemps sur les boulets. *Le duc de Vasselage* s'empara du *Tyran*, bête fougueuse, qui ne connaissait aucun frein, et se nourrissait comme les chevaux de Diomède. *Le marquis du Droit du seigneur* retint pour lui le *Vampire*, étalon vicieux, poussif et ruiné du devant. *Le vicomte du Droit d'aubaine* se saisit du *Vautour*, vieux cheval arabe qui vivait aux dépens de tout le monde, et n'avait jamais gagné son avoine. *Le chevalier de la Capitainerie* se jeta sur l'*Épervier*, ancien cheval de chasse, hongre et de race anglaise, grand dévastateur de moissons, intrépide contre les animaux timides et sans ardeur à la guerre. *Le baron de haute et basse justice* s'accommoda de l'*Arbitraire*, cheval toujours affamé quoiqu'il dévorât la part de tous les autres. Enfin, *le grand sénéchal de la Coutume de Gascogne* s'appropria le *Montgomery*, avide palefroi, qui ne souffrait au ratelier que lui seul.

Le cirque était déjà rempli de spectateurs; les gens à leur aise étaient aux premiers rangs et la canaille derrière, comme dit Figaro. La Féodalité, voyant ses cavaliers à cheval, les pressa de marcher. Le son des cors anglais annonça l'entrée des voltigeurs. Ils saluèrent d'abord pour se concilier les suffrages, et marchèrent au pas, afin de n'effaroucher personne. La Féodalité leur cria : *plus vite!* Les plus sages d'entre eux répondirent: "*Qui veut cheminer loin ménage sa monture*. Laissez-nous chercher notre aplomb et trouver le fond de la selle. Ils firent quelques tours assez lentement pour qu'on s'accoutumât à les voir. Tant qu'ils firent peu de poussière, on se contenta de sourire et de les railler; ils prirent le silence pour l'approbation et s'enhardirent. La Féodalité fit claquer son fouet, et les chevaux qui se reposaient depuis longtemps, commencèrent à trotter. *Rendez et reprenez*, criait la Féodalité; les cavaliers, beaucoup plus disposés à *reprendre qu'à rendre*, ne marchaient que par saccades, et s'arrêtaient tout court, dès qu'ils perdaient les étriers. Leur maladresse se signalait dans les *changemens de mains*; il maniait gauchement les rênes et osaient encore se servir des éperons. Cependant, comme il ne tombaient pas, ils se crurent excellents cavaliers, se complimentèrent, et se proclamèrent les premiers écuyers du monde. Impatiens de dominer sur les spectateurs, ils s'aidèrent des poignets, et, tant bien que mal, se dressèrent en pied sur leurs chevaux, en agitant d'un air de triomphe les bannières où les antiques châtelaines avaient brodé leurs devises.

La Féodalité, enivrée du premier succès de ses cavaliers, cria tant de fois *bravo*, qu'ils s'imaginèrent avoir toutes les voix. *Le baron de haute et basse justice* lâcha la bride à l'*Arbitraire*, qui prit le mors aux dents, et jeta son cavalier par terre. Un saut de mouton renversa le *Vasselage*. Une pointe du *Vampire* culbuta le *Droit du Seigneur*. Le *Droit d'aubaine*, mis à bas par un écart du *Vautour*, le ressaisit aux crins, et fit de vains efforts pour se remettre en selle par la droite. Une pétarade de l'*Arrogant* désarçonna *le quatorzième siècle*. La *Capitainerie* glissa sous l'*Épervier*, et la *Coutume de Gascogne* fut lancée hors de la lice par une réaction du *Montgomery*.

Au même moment, un guerrier nommé *Senatus* qui s'honorait du titre de *Constitutionnel*, et qui portait un étendard sur lequel on lisait : *Gloire, honneur et patrie*, se présenta dans l'arène, monté sur un cheval tranquille et vigoureux; il était escorté d'un piéton nommé *Populus*, habillé à la française, et dont la devise était : *Beaux-arts, industrie, commerce, talens, vertus*. Le guerrier moderne fit le tour du cirque, aux applaudissemens de la multitude; il se montre calme et ferme au milieu des Voltigeurs démontés, que les *vilains* bénévoles se hâtèrent de relever et de secourir; il triomphait sans orgueil des maladroits qui s'étaient culbutés pour avoir choisi de mauvaises montures, et paraissait attribuer son succès à la bonne constitution de son coursier que l'on nommait *la Charte*.

LES ÉCREVISSES À LONGCHAMPS
4 avril 1822

Quoique le temps se fit un peu refroidi ses jours derniers, la promenade de Lonchamps n'a pas été moins suivie que les années précédentes; elle a offert les mêmes plaisirs et les mêmes tableaux. L'observateur y a remarqué les mêmes ridicules: hommes et bêtes ont également prêté à rire, et si le fouet des Phaétons, à trente sous par heure, s'est cruellement agité sur les flancs décharnés des Rossinantes de louage, le fouet de la satire n'a pas manqué de s'exercer au passage sur les puissans du jour et les Crésus modernes. Quelque rapide ou quelqu'élevé que soit un char, il ne garantit point l'automate doré qui le remplit des traits acérés dn malin piéton, et les quolibets et les buées, armes innocentes des *petits*, ont plus d'une fois forcé les prétendus *grands* de baisser leurs stores, ou de lever leurs glaces.

L'ordre le plus parfait a régné pendant la marche, où tous les états, toutes les classes se trouvaient confondus dans les sapins, les remises, les wiski, les coupés, les demi-fortunes, les calèches, les boguey, les tilbury, les charabancs et même les coucous nombreux qui composaient le cortège, où l'élégance et le grotesque, rapprochés quelquefois de la manière la plus bizarre, et roulant à la file dans la poussière, formaient un coup-d'œil aussi piquant que varié. Ici la prude châtelaine suivait, dans sa berline armoiriée, le landau brillant de la danseuse; là le financier de Béthanie précédait le banquier citoyen, et plus loin, le petit-maître du faubourg Saint-Germain trottait, sans en paraître humilié, derrière le bidet du marchand de Poissy. Tout dans ce tableau aurait assez bien retracé la confusion naturelle des rangs, si quelques carosses à soupentes échappés du Marais, et quelques cavaliers aux ailes de pigeon, en chapeau à trois cornes, en bottes à l'écuyère, et en selles à la française n'eussent rappelé de temps en temps le Longchamps *d'avant la révolution*.

Une vieille dame, en robe à ramage, traînée, dans un berlingot de l'autre siècle, par des chevaux à tous crins, qui paraissaient en être aussi, a surtout excité l'hilarité des spectateurs. Les uns assuraient que cette bonne dame s'appelait Mme *Jadis*; les autres, lui voyant un perroquet sur le bras et un marcassin sur les genoux, soutenaient que c'était la *Gazette de France*, et que l'écuyer cavalcadeur, qui caracollait galamment à sa portière, sur un cheval que l'on prétendait être celui de l'Apocalypse, étoit le *Drapeau blanc*.

Toutefois ce grand concours d'équipages vieux et modernes a défilé sans que l'*opinion* ait occasioné la moindre rixe; le hasard a donné les places; La sottise, arrivée la dernière, n'a point eu le pas sur le mérite; les ambitieux n'ont pu marcher plus vite que les autres, et les cavaliers n'ont blessé personne.

Tout se serait passé comme à l'ordinaire si les *bons hommes de lettres* n'eussent été attirés à Longchamps par les *ténèbres*. Tout le monde n'a pas eu l'avantage d'apercevoir ces illustres pelerins; il aurait fallu regarder trop bas, et, dans la poussière qui les enveloppe, ils sont presque toujours invisibles; mais comme Énée reçut au siège de Troie la faculté de voir à travers les nuages qui les dérobaient aux mortels, les divinités infernales qui sapaient avec fureur les fondemens du brillant empire de Pergame, quelques amis de la clarté reçurent du ciel des yeux assez perçans pour distinguer dans la poudre la cavalcade et les manoeuvres des bons hommes. Ils cheminaient gravement portés par des écrevisses. Cette monture convenait parfaitement à des gens qui ne s'élèvent jamais, et vont habituellement à reculons. Fiers de leur nombre et de leur rang, ils avaient pris le haut du pavé, et marchaient à la suite les uns des autres comme les mulets qui vont au moulin.

Le bon homme *Pain-de-Sucre*, juché sur *la chaise*, montait la première écrevisse; il se parait encore des insignes de la défunte censure; des abeilles voltigeaient autour de lui, et le piquaient de leurs aiguillons; il tournait le dos à l'Arc-de-Triomphe, vers lequel son écrevisse recula maladroitement. Tous les bons hommes se briseraient contre les débris de notre gloire, *ils sont pour eux d'acier, d'airain, de diamant*. L'écrevisse se cassa les pattes en abordant ce dangereux écueil, et se précipita dans les fondations, d'où son cavalier ne put jamais se retirer faute de lumières.

La seconde écrevisse, qui était de la plus grosse espèce, venait sans doute de Laybach, mère-patrie des écrevisses, portait, à la maniere des chevaux de Franconi, plusieurs bons hommes en grand costume, et la *Quotidienne*, qui redoutait tant le grand jour, qu'elle s'était munie d'une ombrelle de fer-blanc pour se garantir des rayons du soleil. Presque tous ces bons hommes avaient des bésicles et n'en étaient pas plus clairvoyans. L'écrevisse reculait aussi vite que les embarras de la route le lui permettaïent, et obéissait de son mieux au cri de: *en arrière, marche*, que les cavaliers répétaient à tort et à travers; elle manqua la porte *Maillot*, et, par un instinct naturel, conduisit les bons hommes à la rivière, où elle se hâta d'entrer sans qu'ils eussent pu éviter ce malheur, parce qu'ils n'y voyaient goutte, et ne savaient où ils allaient. L'écrevisse, qui avait trouvé les bons hommes un peu lourds, se mit à la nage pour s'en délasser; les pauvres cavaliers, qui se noieraient dans une cuillerée d'eau, auraient infailliblement péri, si des mariniers humains ne les avaient secourus. La *Quotidienne*, qui s'en allait à vau-l'eau,

fut repêchée dans une trublette; elle a été tellement trempée, qu'elle sera enrhumée pour plus de quinze jours. Ses fontanges sont perdues, et ses talons rouges sont entièrement déteints.

Les autres écrevisses ont éprouvé divers accidens; plusieurs ont été se jeter sous des fiacres, d'autres n'ont pu éviter les pieds des chevaux; l'une d'elles a été rencontrée par un barbet, qui l'a proprement rapportée à son maître avec le bonhomme qui la montait.

La société, convaincue désormais des inconvéniens de la marche rétrograde, a, dit-on, renoncé aux écrevisses, et arrêté que ses membres iraient aujourd'hui chercher les ténèbres montés sur des hiboux et des taupes. Cette nouvelle ne peut manquer d'attirer à la promenade un grand nombre de curieux.

GARE DERRIÈRE!!!!
30 mai 1822

"*Croquemitaine*, le grand, l'illustre, l'européen Croquemitaine eut, de la fée *Ogresse*, deux fils; *Coupe-jarrets* était l'un, *De Monts-coupés* était l'autre. *Coupe-jarrets* devint père de nombreux enfans, *gentlemen* de grandes routes, dévaliseurs de diligences, incendiaires de hameaux, qui perpétuèrent leur race maudite jusqu'à nos jours, où ils sont en horreur à tous voyageurs, passagers et bons citoyens des villes, bourgs et villages.

"*De Monts-coupés* était d'un tout autre caractère. Bon, humain, sensible, doux, généreux, il n'avait qu'un défaut, celui de vouloir passer pour un exterminateur. Il avait une réputation terrible parmi les marmots de son endroit; on les menaçait du sabre de *Monts-coupés* comme on les avait menacés du sabre de Croquemitaine, son honorable père.

"*De Monts-coupés* grandissait, et avec lui la terreur qu'inspirait son nom. Fier de la haute réputation qu'il s'était acquise dans son endroit, *De Monts-coupés* voulut voyager. En ce temps-là, de hautes montagnes encombraient les grands chemins, et nuisaient aux piétons et aux cavaliers dont elles entravaient la marche. Le vigoureux *De Monts-coupés* résolut de les abattre. Poussé par ce zéle philan-tropique qui prête de la force au plus faible, le fils de Croquemitaine se mit à donner d'estoc et de taille sur toutes les montagnes qui n'en pouvaient; mais chaque coup de sa redoutable flamberge abattait la tête d'un monticule, sapait la base d'un rocher, ou renversait la crète d'une *cathédrale de la nature* (comme dit le vicomte). Il entreprit de raser les Alpes, les Pyrénées et les glaciers de la Suisse; il parvint à applanir la montagne de Tarrare; il échoua contre le pic de Ténériffe qui résista à ses efforts soutenus, et renonça à ses hasardeuses tentatives; après avoir brisé son sabre contre une haute montagne d'Amérique, qu'on appelle le *Peuple-géant*.

"Son grand exploit est celui que le lithographe a reproduit, et dont nous adressons la représentation à nos abonnés; il consiste en un fait tout simple que voici: *De Monts-coupés* abattit, en 203, le *Fantôme*, montagne très-élevée, située près du Mississipi; il mit à fin cette grande entreprise d'un seul revers de sa flamberge, avec laquelle il coupa pardessus le marché trente mille soldats cuirassés, qui n'avaient pas fui au cri : *gare derrière*! qu'avait proféré le redoutable *De Monts-coupés*.

"*De Monts-coupés* est aujourd'hui écuyer tranchant du prince Galaor dans le royaume de Monom-otapa."

NOTES

INTRODUCTION "Péchés de jeunesse"

1. Loys Delteil, *Le Peintre-graveur illustré*, vol. 3 (Ingres-Delacroix), Paris and New York, 1969. The prints appear under nos. 1, 6, 28–38. Under no. 10, Delteil lists a lithograph entitled *Le Cri public après le soufflet* (1818), which he considers doubtful. Both Delteil and Alfred Robaut, *L'Oeuvre complet de Eugène Delacroix*, New York, 1969, no. 17, comment on the obscure iconography of that piece of which they admit having seen only one copy. I, myself, have so far been able neither to locate an example of the print nor to decipher its meaning.

 Three additional Delacroix cartoons were identified and published in 1930 by Jean Laran, "Péchés de jeunesse d'Eugène Delacroix," *Gazette des beaux-arts*, series 6 (3), 1930, pp. 55 ff.

2. Adolphe Moreau, *Eugène Delacroix et son oeuvre*, Paris, 1873.

3. Robaut, *L'Oeuvre complet*.

4. Delteil, *Le Peintre-graveur illustré*.

5. E. M. Gombrich, "The Cartoonist's Armoury," in *Meditations on a Hobby Horse and Other Essays on the Theory of Art*, London and New York, 1971, pp. 127 ff.

6. On this, see J. Wechsler, "Editor's Statement: The Issue of Caricature," *The Art Journal*, Winter 1983, pp. 317 ff. Such an attitude may be on the wane, as the recent spurt of scholarly interest in revolutionary cartooning suggests. Witness such major events as the 1989 exhibition, *French Caricature and the French Revolution, 1789–1799*, and its accompanying catalog, (Los Angeles, 1988), at the Grunwald Center for the Graphic Arts (University of California, Los Angeles), the Grey Art Gallery (New York University), the Bibliothèque Nationale (Paris), and the Musée de la Revolution française (Vizille). More recently, *High and Low: Modern Art and Popular Culture*, exhib. cat., New York, 1990, and a related publication, *Modern Art and Popular Culture. Readings in High and Low*, New York, 1990, with essays by I. Lavin, L. Eitner, J. Weiss, R. Rosenblum and others. For a convincing argument in favor of the rehabilitation of so-called "low art," see also the introduction to Keith Moxey's *Peasants, Warriors and Wives. Popular Imagery in the Reformation*, Chicago, 1989, pp. 1–9.

7. A. Piron, *Eugène Delacroix. Sa vie et ses oeuvres*, Paris, 1865, p. 50. Piron is responsible for the erroneous assertion, in studies of Delacroix's graphic work, that the artist contributed cartoons to the satirical journal *Le Nain jaune*: "Au collège il dessinait déjà; je me rappelle qu'il avait fait étant très jeune deux caricatures pour le journal *Le Nain Jaune* qui traitaient ce qu'on appellait, en 1814, les voltigeurs de Louis XIV." Strangely enough, Delacroix himself seems to have encouraged the error when he told Burty, in 1862, that he had done two etchings for the *Nain jaune*. Philippe Burty (ed.) *Lettres de Delacroix*, Paris, 1878, p. 350. This misconception was conclusively dispelled by Jean Laran, "Péchés de jeunesse d'Eugène Delacroix", p. 56: "Il n'y a pas plus de Delacroix dans le *Nain jaune* qu'il n'y a de lithographies."

 My own research in the issues of the *Nain jaune* confirms Laran's conclusions. The confusion, both in the artist's memory and in the reports of his early biographers, may have originated from the fact that *Le Miroir des spectacles, des lettres, des moeurs, et des arts*, to which Delacroix indeed contributed cartoons, was the spiritual heir and sequel, so to speak, of the *Nain jaune*.

8. P. Burty (ed.) *Lettres de Delacroix*, p. 350, and Maurice Tourneux, "Croquis d'après nature. Notes sur quelques artistes contemporains par Philippe Burty," *Revue retrospective*, new series, 103–5, November 1892, pp. 294–8.

9. R. Escholier, *Delacroix 1798–1863. Peintre, graveur, écrivain*, vol. 1 (1798–1832), Paris, 1926, pp. 32, 42–3, 105–6, and *passim*.

10. E. Chesneau, "Eugène Delacroix," in *La Peinture française au XIX siècle. Les Chefs d'école*, Paris, 1872, p. 337.

11. E. Véron, *Eugène Delacroix*, Paris, 1887, p. 20.

12. "Dans la caricature, il n'est pas à son affaire. Son imagination divague et son dessin perd son originalité. *La Consultation*, une des meilleures pièces de la collection, n'est cependant qu'une satire macabre, plus grotesque que spirituelle, et denuée de véritable souffle artistique." E. Moreau-Nélaton, *Delacroix raconté par lui-même*, vol. 1, Paris, 1916, p. 33.

13. For example there is no mention of Delacroix's

graphic satire in the two official publications related to the Delacroix Memorial Exhibition at the Louvre, in 1963, the *Centennaire d'Eugène Delacroix 1798–1863*, exhib. cat., Paris, 1963, and M. Sérullaz's *Mémorial de l'exposition Eugène Delacroix*, Paris, 1963. In R. Huygue, *Delacroix*, Paris, 1963, p. 107, and F. A. Trapp, *The Attainment of Delacroix*, Baltimore and London, 1971, p. 16, we find only cursory references to the cartoons, though Trapp (p. 16, n. 24) does draw attention, with insight to their possible importance for Delacroix's later development. Ralph E. Shikes and Steven Heller, "The Art of Satire. Painters as Caricaturists and Cartoonists from Delacroix to Picasso," *Pratt Graphic Center Print Review*, 19, New York, 1984, pp. 17–19, includes a section on Delacroix as a cartoonist.

14. J. Laran, "Péchés de jeunesse d'Eugène Delacroix."

15. "Tout cela est bien obscur et ne mérite pas de fixer l'attention. Il existe, je me le rappelle, un certain combat du *Constitutionnel contre la Quotidienne* qui est une affreuse lithographie de ma façon, et je ne scais si cela a paru." P. Burty (ed.) *Lettres de Delacroix*, p. 350.

16. "Oui, car les premières même contiennent des germes précieux, surtout *La Consultation*." M. Tourneux, "Croquis d'après nature," pp. 297–8.

17. Lee Johnson, *The Paintings of Eugène Delacroix. A Critical Catalogue*, vol. 1, Oxford, 1987, pp. 163 ff.

18. For Delacroix's Liberal Bonapartist sympathies during the Restoration, see mainly Pierre Gaudibert, "Eugène Delacroix et le Romantisme révolutionnaire. A propos de la *Liberté sur les Barricades*," *Europe*, April 1963, 408, pp. 11 ff.; T. J. Clark, *The Absolute Bourgeois. Artists and Politics in France 1848–1851*, Princeton, 1982, pp. 16 ff; and my *French Images from the Greek War of Independence 1821–1830: Art and Politics under the Restoration*, New Haven and London, 1989, *passim*.

Delacroix's early liberalism, in line with his family's tradition, was certainly enforced in the turbulent climate of dissent that greeted the restored Bourbons: student uprisings in faculties and *lycées* around the country, including unrest in his own Lycée Louis-Le-Grand in 1819, street demonstrations in Paris and a spate of plots and conspiracies engineered by secret societies of radical idealists, politicians, bourgeois and military men. Most of his friends embraced the ideology of the Left: by 1818, Géricault had gone over to Bonapartism after a brief infatuation with the monarchy; Charlet, whom he also came to know about that time, was an uncompromising supporter of the Emperor. And then there were those who actually conspired: the Dutch brothers Henry and Ary Scheffer, whom he knew from Guérin's studio, and Horace Vernet, the host, in his Montmartre studio, of Liberal politicians and disgruntled Napoleonic officers.

In the exhibition catalog, *Delacroix, citoyen de Paris*, Paris, 1963, Raymond Escholier also suggested that Delacroix, like Horace Vernet and Ary Scheffer, might have been an active member of the radical Carbonaro secret sect. Escholier offered evidence from police archives in which the name "Delacroix" (sometimes also spelled as "Lacroix") featured among the list of suspects arrested after the uncovering of the Belfort anti-royalist conspiracy, of 1821–2, in which Carbonaro and Freemason initiates participated.

My own examination of the Belfort documents at the Paris Archives Nationales (Police générale. F2. 6726) has indeed yielded the name of one Delacroix or Lacroix "peintre graveur" and "se disant peintre d'histoire." G. Spitzmüller, "La Conspiration de Belfort," *Bulletin de la Société belfortaine d'émulation*, 10, 1890–1, Belfort, 1891, pp. 77–9, transcribing the same archives makes it clear, however, that the Delacroix in question was one "*Pierre Lacroix*, âgé de 25 a 30 ans, peintre lithographe demeurant à Paris." Bénézit's dictionary includes, indeed, a painter-engraver named Pierre Lacroix (1783–1856), an exact contemporary of Eugène Delacroix and, like him, living and working in Paris. It may well have been this artist who was the apprehended conspirator of 1822.

It is my belief that, no matter how won over to Liberal ideas Delacroix was, by nature and inclination, no activist. His way of voicing dissent found a more fitting alternative in graphic satire.

19. By birth and mentality, Delacroix identified with an elite bourgeois youth, highly educated and conscious of its historical mission, as shown by A. Spitzer, *The French Generation of 1820*, Princeton, 1987, *passim*. As Lee Johnson observed, *The Paintings of Eugène Delacroix*, vol. 3, p. xi, this identity had nothing in common with the rank-and-file bourgeois state of mind "characterized by acquisitiveness, philistinism, utilitarianism, lack of imagination and of any spiritual ideals of nobility of purpose," which Delacroix loathed.

20. With the exception of A. Blum's "La Caricature politique en France sous la Restauration," *Nouvelle revue*, 35, 1918, pp. 119–36, there is no separate modern study of Restoration political caricature. Among general studies of nineteenth-century caricature, J. Grand-Carteret, *Les Moeurs et la caricature en France*, Paris, 1888, pp. 117 ff. discusses Restoration satire as part of Chapter 6. Ralph Shikes, *The Indignant Eye. The Artist as Social Critic in Prints and Drawings from the Fifteenth Century to Picasso*, Boston, 1969, pp. 134 ff. devotes a few pages to it. Robert Goldstein's *Censorship of Political Caricature in Nineteenth-Century France*, Kent (Ohio) and London, 1989, pp. 99 ff. examines Restoration caricature from the point of view of censorship. Also helpful are B. Farwell, *French Popular Lithographic Imagery, 1815–1870*, vol. 8, Chicago, 1988; and B. Farwell, *The Charged Image. French Lithographic Caricature 1816–1848*, exhib. cat., Santa Barbara Museum of Art, 1989.

CHAPTER 1 Prints, Politics and Satire under the Restoration

1. J. Grand-Carteret, *Les Moeurs et la caricature en France*, Paris, 1888, pp. 117 ff; and B. Farwell, *French Popular Lithographic Imagery 1815–1870*, 12 vols, Chicago and London, 1981–

2. "Les caricatures se multiplient par centaines, les groupes de curieux grossissent à proportion, les quais et les boulevards sont obstrués." *Le Nain jaune*, 25 May 1815, p. 239.

3. "La boutique de Martinet a été, malgré la pluie,

assiégée par une foule de curieux, qui se pressaient autour de deux caricatures nouvelles. . ." *Le Nain jaune*, 15 December 1814, p. xv.

4. "La foule s'arrête devant Martinet, pour y voir une charge de Potier, dans le rôle du père Sournois. Cette caricature, piquante par sa parfaite ressemblance, est de l'auteur des dessins de l'*Observateur des modes*." *Journal des débats*, Tuesday, 1 February 1820, p. 2.

5. A. Blum, *La Caricature révolutionnaire*, Paris, 1916; *French Caricature and the French Revolution, 1789–1799*, exhib. cat., Los Angeles, 1988; and R. J. Goldstein, *Censorship of Political Caricature in Nineteenth-Century France*, Kent (Ohio) and London, 1989, pp. 92–9.

6. C. Clerc, *La Caricature contre Napoléon*, Paris, 1985; and Goldstein, *Censorship of Political Caricature*, pp. 92–9.

7. A. Blum, "La Caricature politique en France sous la Restauration," *La Nouvelle revue*, 35, 1918, pp. 119 ff. Goldstein, *Censorship of Political Caricature*, pp. 99 ff.

8. "La guerre des caricatures ne se rallentit pas. Elle pourrait alimenter une gazette spéciale. Les *ultra* ont essayé de renvoyer aux libéraux quelques uns des traits dont ceux-ci les accablent; mais ils leur faut faire de grands frais d'imagination, tandis qu'il suffit à leurs adversaires de saisir la ressemblance". *Le Constitutionnel*, 21 September 1819, p. 3.

9. L. Hautecoeur, "Une famille de graveurs et d'éditeurs parisiens. Les Martinet et les Hautecoeurs (XVIII et XIX siècles)," *Paris et Île-de-France*, vols 18–19, 1967–8, Paris, 1970, pp. 205–340 (a manuscript version of this article is preserved at the Cabinet des Estampes, Bibliothèque Nationale, Paris, Yb. 3. 3451a, in-4o). Also, M. Barbin and Cl. Bouret, *Inventaire du fonds français. Graveurs du XIX siècle*, vol. 15, Paris, 1985, p. 332.

10. "Celui de Martinet, rue du Coq-Saint-Honoré, est connu par les caricatures ingénieuses qui s'y débitent et qui sont pour ainsi dire, périodiques. . . Les caricatures sont établies partout, mais le grand bureau est chez Martinet, rue du Coq. Nous en avons périodiquement tous les quinze jours; les unes sont plaisantes, les autres morales, les autres égrillardes. En général, elles sont très bien dessinées et ont beaucoup de vérité." Cited in Hautecoeur, "Une famille de graveurs," p. 270.

11. B. Farwell, *The Cult of Images: Baudelaire and the Nineteenth Century Media Explosion*, exhib. cat., Santa Barbara, 1977. Generally on nineteenth-century and, in particular, Restoration lithography, see H. Bouchot, *La Lithographie*, Paris, 1895; W. Weber, *A History of Lithography*, New York, 1966; M. Twyman, *Lithography, 1800–1850*, London, 1970; W. McAllister Johnson, *French Lithography. The Restoration Salons 1817–1824*, exhib. cat., Kingston, Ontario, 1976; and Farwell, *French Popular Lithographic Imagery*, vol. 1, pp. vii–ix.

12. Bouchot, *La Lithographie*, pp. 62 ff.; Farwell, *The Charged Image. French Lithographic Caricature 1816–1848*, exhib. cat., Santa Barbara Museum of Art, 1989, p. 11.

13. "Les Bonapartistes n'ont que la lithographie pour eux, mais ils en font un fier usage. Les murs sont couverts de gravures à six sols représentant la vieille garde sous toutes ses formes. Celles qui sont coloriées ont le drapeau tricolore; ce qu'on en vend n'est pas croyable. Bonaparte se trouve dans plusieurs. Ce parti est le seul qui ait de la tenue at sache mener son fiacre. Les autres s'exaltent en paroles." J. Rumilly (ed.) *Manuscrit venu de Sainte-Hélène d'une manière inconnue*, Paris, 1948, p. 109.

14. *Gazette de France*, Friday, 12 March 1819, p. 284.

15. "Notre opinion, sur ce genre de gravure, n'a pas changée; nous le croyons toujours très fatal à l'art du burin et non persistons à blâmer l'abus qu'on en a fait depuis deux ans." Interestingly, in the same passage the *Quotidienne* discloses that, in order to hit back, conservatives were forced to adopt the "Liberal" lithographic medium, but put it to work on royalist themes: "Mais attaqués avec ces armes, les royalists ont dû les employer contre leurs adversaires, pour rétablir l'équilibre entre les forces; quant à la tactique, elle a tourné à notre avantage: nous avons répondu à des attaques honteuses contre des vieillards braves et sans pain, par des caricatures ingénieuses, où l'esprit révolutionnaire était mis à découvert; nous avons riposté à des fanfaronnades par des faits: au lieu d'exposer à la risée publique un grenadier mutilé faisant mettre bas les armes à trois régimens ennemis [allusion to Charlet's *Le Grenadier de Waterloo*, of 1817–18], nous avons offert à la vénération publique un chasseur saluant religieusement le tombeau de la Rochejacquelin." *La Quotidienne*, 25 August 1819, p. 2.

16. "Il y a dans un certain parti une telle haine pour toutes les choses nouvelles, que nous ne serions pas étonnés d'entendre des Tartuffes politiques s'écrire d'un ton inspiré, au sujet de la lithographie: 'La fin du monde est proche, le puits de l'abîme est ouvert; la bête de l'Apocalypse est lâchée. Les pierres elles-mêmes parlent, et retracent aux yeux du monde entier les triomphes des armées françaises. La lithographie découverte par un protestant, porte le dernier coup à la religion et aux bonnes moeurs: c'est une véritable invention de Satan.'" *Le Constitutionnel*, Monday, 26 April 1819, p. 4.

17. On the army under the Restoration, E. Bonnal, *Les Royalistes contre l'armée (1815–1820)*, 2 vols, Paris, 1906; J. Vidalenc, *Les Demi-solde. Étude d'une catégorie sociale*, Paris, 1955; D. Porch, *Army and Revolution. France 1815–1848*, London and Boston, 1974; I. Woloch, *The French Veteran from the Revolution to the Restoration*, Chapel Hill, North Carolina, 1979; and my article, "Sad Cincinnatus: The *Soldat Laboureur* as an Image of the Napoleonic Veteran after Waterloo," *Arts Magazine*, May 1986, pp. 65 ff.

On military conspiracies, E. Guillon, *Les Complots militaires sous la Restauration*, Paris, 1895; and A. Spitzer, *Old Hatreds and Young Hopes. The French Carbonari against the Bourbon Restoration*, Cambridge, 1971.

18. N. Richardson, *The French Prefectoral Corps 1814–1830*, Cambridge, 1966; and J. Siwek-Pouydesseau, "Sociologie du corps préfectoral (1800–1940)," *Centre de recherches d'histoire et de philologie de la IV section de l'École Pratique de Hautes Études*, V, vol. 32: "Les Préfets en France," Geneva, 1978, pp. 163 ff.

19. R. Magraw, *France 1815–1914: The Bourgeois Century*, New York and Oxford, 1986. G. Bertier de Sauvigny, *The Bourbon Restoration*, Philadelphia, 1966, pp. 73 ff.

20. A. Daumard, *La Bourgeoisie parisienne de 1815 à*

1848, École Pratique de Hautes Études. VI sectio. Centre de recherches historiques. Démographie et sociétés, no. 8, Paris, 1963, pp. 551 ff.; J. Vidalenc, *La Restauration 1814–1830*, Paris, 1966, pp. 24 ff; F. Braudel and E. Labrousse eds. *Histoire économique et sociale de la France*, vol. 3, part 2: P. León et al. "L'Avènement de l'ère industrielle (1789–années 1880)," Paris, 1976, pp. 829 ff; and Magraw, *France 1815–1914*, pp. 24 ff.

21. A. Spitzer, *The French Generation of 1820*, Princeton, 1987, p. 268.

22. ". . .7 à 8,000 individus éligibles, asthmatiques, goutteux, paralytiques, de facultés affaiblies, et n'aspirant qu'au repos"; and "Or, la production n'a de représentans que la jeunesse, qui veut jouir des biens de la vie en donnant en échange son activité et son travail. La vieillesse au contraire, se roidit contre le mouvement productif, croyant y voir la perte de ses capitaux péniblement acquis. Je ne crains donc pas d'affirmer que c'est à l'absence de la jeunesse dans les délibérations politiques qu'on doit attribuer tous les embarras de l'époque. . ." J. J. Fazy, *De la Gérontocratie; ou Abus de la sagesse des vieillards dans le gouvernement de la France*, Paris, 1828, pp. 1 and 34.

23. A. Jardin and A. J. Tudesq, *Restoration and Reaction 1815–1848*, Cambridge, New York and Paris, 1983, p. 87.

24. "France is the shadow of the ghost/ Of the France of my happy days./ It is only a very small kingdom;/ But the bearded ones are still ruling." P. J. Béranger, *Oeuvres complètes*, vol. 2, Paris, H. Fournier aîné, 1836, p. 316.

25. *Bibliographie de la France ou Journal général de la librairie et de l'imprimerie*, 10 July 1819, no. 449.

26. E. Hatin, *Bibliographie historique et critique de la presse périodique française*, Paris, 1866, pp. 320–3; J. Godéchot, P. Guiral and F. Terrou, *Histoire générale de la presse française*, vol. 2, Paris, 1969, pp. 39–42; 54–6; Goldstein, *Censorship of Political Caricature*, pp. 101–4.

27. Cited in Goldstein, *Censorship of Political Caricature*, p. 109.

28. "Tandis que les partis se font une guerre active par les journaux, dans les cabinets littéraires, ils se livrent de rudes combats sur les quais et les boulevards, au moyen de caricatures: . . . Grâce à la lithographie, le crayon est devenu pour nos polémistes une arme aussi prompte et aussi redoutable que la plume. La seule différence, c'est qu'on peut assister gratis aux escarmouches en plein air, et qu'il faut payer pour s'immiscer dans les querelles en champ clos. Les caricatures ont un autre avantage, elles parlent pour ainsi dire à l'instinct, et les journaux ne s'adressent qu'à l'intelligence. Tel musard illettré saisit très bien l'intention de ces grotesques tableaux, et reconnaît de prime abord les personnages de chaque parti qui y figurent. Mais comme il n'est pas toujours versé dans la connaissance des allégories, il s'expose souvent à de cruelles méprises. A force de voir des hommes en soutane armés de poignards et de torches, il s'accoutume à regarder tous les ecclésiastiques comme des assassins et des incendiaires." A. M., "Beaux-Arts. Sur les lithographies nouvelles," *Le Conservateur littéraire*, June 1820, p. 207.

29. Hatin, *Bibliographie historique*, p. 349. On the *Miroir*,

also see Godéchot et al., *Histoire générale de la presse*, pp. 71 ff.

30. "A quoi songez-vous donc, artistes qui pourriez si utilement employer vos crayons? Quoi, plus de caricatures! Martinet vous invoque, les originaux vous bénissent, et les musards de la rue du Coq ne savent plus à quel saint se vouer." *Le Miroir*, Tuesday, 13 November 1821, p. 3.

31. "'Ah que c'est bête!' est une exclamation qu'on entend souvent dans le monde, au spectacle, et devant les boutiques de marchands de caricature. . . L'observateur attentif juge avec moins de légéreté, et, sachant qu'on ne peut tout dire, tient compte de ce qu'on lui dit. Il y a des cas où il faut s'entendre à demi-mot. Supposez pour un instant de *mauvais génies*, qui, constamment armés d'un fer tranchant, viendront vous enlever la moitié et souvent plus des pensées ou des réticences que vous confiez au papier. Ne faudrait-il pas consentir à laisser votre ouvrage imparfait et l'intelligence du lecteur ne devrait-elle pas suppléer à ce qui manquerait. Ce que nous devons de dire doit pouvoir s'appliquer aux caricatures; leurs auteurs sont souvent obligés de sacrifier au mauvais goût pour faire une bonne plaisanterie, et, plus souvent encore, ils sont contraints à cacher tellement leurs pensée, qu'elle échappe au plus grand nombre des curieux arrêtés chez Martinet. Dieu nous préserve donc de penser que, si le nombre des caricatures est moins grand en ce moment qu'il ne l'a été à différentes époques, ce soient les sujets qui manquent; ils nous entourent, nous bloquent étroitement. Bien loin de se cacher, ils se présentent à nos yeux sous tous les costumes; en frac, en habit brodé ou en uniforme; il faut, sinon les admirer, mais au moins supporter leur présence." *Ibid.*, Thursday, 14 June 1821, pp. 3–4.

CHAPTER 2 Our Friends, the Enemies

1. Loys Delteil, *Le Peintre-graveur illustré*, vol. 3 (Ingres-Delacroix), Paris and New York, 1969, no. 1.; Adolphe Moreau, *Eugène Delacroix et son oeuvre*, Paris, 1873, pp. 15–16, no. 1; Alfred Robaut, *L'Oeuvre complet de Eugène Delacroix*, New York, 1969, no. 1.

2. On the subject of Napoleon's identification with the martyred Christ, see Frank Paul Bauman, "Le Christ romantique," in *Histoire des idées et critique littéraire*, 134, Geneva, 1973, pp. 171 ff.

3. "Absurde en administration, criminel en politique, qu'avoit-il donc pour séduire les Français, cet étranger ?" F. R. de Chateaubriand, "De Buonaparte et des Bourbons", in *Oeuvres complètes*, vol. 7, Paris, Garnier, n.d., p. 22.

4. "M. Dominique-Vivant Denon a tellement pris le muséum en amitié, qu'il n'a jamais voulu s'en séparer un seul instant." A. Eymery, (ed.) *Dictionnaire des girouettes ou Nos Contemporains peints d'après eux-mêmes . . . par une société de girouettes*, Paris, 1815, p. 132.

5. On the hunchback as a popular satirical device under the Restoration, see J. Grand Carteret, *Les Moeurs et la caricature en France*, Paris, 1888, pp. 134. One such famous caricatural *bossu* was the type named Mayeux, invented in the 1820s and adopted by the cartoonist Traviès.

6. For arguments against Talleyrand's paternity of Delacroix see A. Joubin, "Les sources du Massacre de Scio de Delacroix. Talleyrand et le Nain jaune," *Bulletin de la société d'histoire de l'art français*, 1935, pp. 40–1; P. Loppin, *Delacroix père et fils*, Paris, 1973, *passim*; F. A. Trapp, *The Attainment of Delacroix*, Baltimore and London, 1971, pp. 11–12. Most conclusive against Talleyrand's paternity of Delacroix is Lee Johnson, *The Paintings of Eugène Delacroix. A Critical Catalogue*, vol. 1, Oxford, 1987, p. xv, n. 1.

7. "La Cour est une des plus odieuses inventions des hommes. La Cour est un foyer d'intrigues, d'ambition, de bassesse, où se machinent continuellement les projets les plus détestables, où sont sans cesse fomentés les cabales, les brigues, les partis... A voir les courtisans s'observer avec soin et affecter les dehors des vertus que tout le monde sait fort bien qu'ils n'ont pas, on pourrait pendant quelque temps être séduit par les apparences. Mais en considérant de plus près, on découvre la fausseté et la contrainte. Le vice perce partout." E. Delacroix, *Les Dangers de la cour*, ed. J. Marchand, Avignon, 1960, pp. 38–9.

8. As opposed to *Les Dangers de la cour*, *Alfred* remains unpublished. J. Marchand, "Eugène Delacroix, homme de lettres d'après trois oeuvres de jeunesse inédites," *Le Livre et l'estampe*, 19, 1959, pp. 173 ff.

9. For a comprehensive catalog of Delacroix's drawings at the Cabinet des Dessins of the Louvre, see M. Sérullaz *et al.*, *Musée du Louvre. Cabinet des dessins. Inventaire général des dessins. École française. Dessins d'Eugène Delacroix*, 2 vols, Paris, 1984. The drawings discussed here are to be found in vol. 1, p. 318, no. 777, p. 324, no. 807; and vol. 2, p. 245, nos 48r and 50r.

10. "Le Missionnaire de Mont-Rouge," in P. J. Béranger, *Oeuvres complètes*, vol. 2, Paris, Fournier aîné, 1836, p. 325.

11. "Le Bon pape," *ibid.*, p. 223.

12. "Les Révérends pères," *ibid.*, p. 36.

13. "Qu'il en confesse encore quelqu'une jeune, jolie, et qu'elle lui résiste, il en fera comme des autres, sans perdre pour cela le paradis." P. L. Courier, *Oeuvres complètes*, Paris, La Pleiade, 1951, p. 159. Also, L. Desternes, *Paul-Louis Courier et les Bourbons. Le pamphlet et l'histoire*, Moulins, 1962, *passim*.

14. Whereas Delteil (no. 6), Moreau (no. 12) and Robaut (no. 4) date this print as 1816, Laran, based on the *État des gravures déposées*, the register of new prints deposited at the Direction Générale de l'Imprimerie et de la Librairie (Paris, Bibl. Nat., Cabinet des Estampes) according to which the print was deposited on 28 october 1815, corrected its date to 1815. Jean Laran, "Péchés de jeunesse d'Eugène Delacroix," *Gazette des beaux-arts*, series 6 (3), 1930, p. 57. The print was announced in the *Bibliographie de la France*, Saturday, 4 November 1815, p. 476, no. 1126.

15. "Le tableau était sinistre, car il avait pour cadre ces hordes d'étrangers qui bivouacquaient sur nos quais et sur nos places publiques." *Mémoires et souvenirs du baron Hyde de Neuville*, vol. 1, Paris 1888, p. 121.

16. "Cette entrée des armées étrangères jeta une grande tristesse et une profonde terreur dans ma famille." And "ce fut pour moi une bien vive émotion de rencontrer de ces barbares dans les rues de Paris."

17. I saw the wild horses of
 the soldiers of Germany
 Wandering on the lawns of our magnificent gardens
 Among those demi-gods that genius created.
 I saw batallions, tents, chariots,
 And a whole encampment inside the temple of the
 arts.
 Must we, as silent witnesses, accept so many
 insults?

 C. Delavigne, "Messénienne sur la bataille de Waterloo", in *Victoires, conquêtes, désastres, revers et guerres civiles des français de 1792 à 1815, par une société de militaires et de gens de lettres*, vol. 27, Paris, 1821, p. 323.

18. How money poured like rain when the Russians
 Pushed up the price
 Of all the "ladies" of Paris!

 . . .

 But since they are coming back, we must wait for
 them.
 We'll see again Bulof, Titchakof,
 And Platof;
 The good Saken, who has a heart of gold,
 And then this dear. . .
 This dear Mister Blucher:
 They will give us all that they will take
 Long Live our friends
 Our friends the enemies!

 Béranger, "L'Opinion de ces demoiselles," in *Oeuvres complètes*, vol. 1, Paris, Fournier aîné, 1836, pp. 193–5.

19. Announcements of such prints abound in the *Bibliographie de la France*, 1815–18. See particularly the issues of October and November 1815 (*Troupes Russes, Troupes Prussiennes, Troupes Autrichiennes, Un Anglais d'autrefois, Un Anglais d'aujourd'hui, Officiers Prussiens se saluant, Officiers Anglais et Écossais* etc.) The issue of 13 January 1816 includes a *Bivouac de la garde royale prussienne*; that of 20 January 1816, *Bivouac anglais dans les Champs-Elysées, Galanterie prussienne*; that of 27 April 1816, *Camp des Anglais, Irlandais, Écossais aux Champs-Elysées*, etc.

20. "Mais avant tout, morbleu, il faut faire une paix honorable à la France. Le Roi n'a qu' à dire un mot, et à l'instant il a quatre-cents mille braves..." (Anonymous), *La Petite lanterne magique ou Récit des grands événements*, Paris, 1814, p. 11.

21. But if the hour of vengeance
 Were to strike, noble soldiers
 Rally to this call of valor:
 "The Guard will not surrender, but will die."

 "Le Dernier Cri de la garde impériale," in *Victoires, conquêtes, désastres*, vol. 27, p. 320.

22. "Ce vieux médecin qui ne veut pas assister à l'agonie du malade qu'il a soigné..." Champfleury, *Histoire de la caricature sous la République, l'Empire et la Restauration*, Paris, 1874, p. 309.

23. "Si le sort des batailles a dû faire remettre momentanément la capitale aux mains des ennemis, ils ont pris l'engagement *solennel* de respecter les personnes, les propriétés publiques et particulières, nos institutions, nos autorités, nos couleurs nationales."

L. Véron, *Mémoires d'un bourgeois de Paris*, vol. 1, Paris, 1856, p. 218.

Cited in R. André, *L'Occupation de la France par les alliés en 1815*, Paris, 1924, p. 5.

24. *Ibid.*, *passim*; S. Charléty, in *La Restauration*, vol. 4 of E. Lavisse's *Histoire de France contemporaine*, Paris, 1921, p. 115, calculated to 633,040,530 francs the total cost to France of the maintenance of allied troops over the three years of the occupation.

25. André, *L'Occupation de la France*, pp. 125–6.

26. R. Magraw, *France 1815–1914. The Bourgeois Century*, New York and Oxford, 1986, p. 34.

27. Also on this subject, M. Moraud, *La France de la Restauration d'après les visiteurs anglais 1814–1821*, Paris, 1983, *passim*.

28. "Le rosbiff à la main, voilà le vrai penseur". *Le Nain couleur de rose. Journal politique, littéraire et moral*, 1815, 2 (4) 30 December 1815, between pages 96 and 97. The explanation of the caricature is on p. 96. Compare a similar print, *La Collation à l'anglaise, ou L'Occupation favorite d'un peuple pensant*, published by Martinet and announced in the *Bibliographie de la France*, Saturday, 4 January 1817, p. 8, no. 12.

29. "*A déjeuner*. Un filet entier de boeuf, un pain de quatre livres, une tourte de fruits, quatre bouteilles de bière forte. *A dîner*. Une pièce de boeuf salé, une tranche de boeuf rôti, quelques fricassées de la cuisine du roi, un pain de quatre livres, quatre bouteilles et demie de bière forte. *A goûter*. Une brioche, deux bouteilles et demie de bière forte . . ." *Le Miroir des spectacles, des lettres, des moeurs et des arts*, 22 March 1822, p. 3.

30. See *English Caricature 1620 to Present*, Victoria and Albert Museum, London, 1984, pp. 17–18, no. 100. On Gillray, more specifically, Draper Hill, *Fashionable Contrasts. Caricatures by James Gillray*, London, 1966.

31. The theme of Mr Croûton, who is also shown sometimes painting billboards, recurs repeatedly in Restoration satire and has, I suspect, a deeper political significance. Croûton, dubbed a mere "peintre à la brosse" and a "barbouilleur," is said to specialize in the depiction of *bras d'or*, of golden arms, a symbol, during the Restoration, of the various, and often contradictory, oaths of allegiance taken by political opportunists under the rapidly succeeding recent regimes of France. This was, among others, the subject of a play by Lafortelle *et al.*, *Monsieur Croûton ou l'Aspirant au Salon*, "pièce grivoise, en un acte, mêlée de couplets, représentée pour la première fois à Paris, sur le Théâtre des Variétés, le 24 novembre 1814, Paris, 1814." A reference to Croûton as painter of "l'enseigne du bras d'or" occurs, among others, in *La Quotidienne*, 30 August 1819, p. 1.

32. *Bibliographie de la France*, 2 November 1816, no. 875; 22 March 1817, no. 230; 6 September 1817, no. 746; 7 June 1817, no. 419.

33. Sérullaz, *Dessins d'Eugène Delacroix*, vol. 2, p. 245, nos. 50r and 51r.

34. *Lord Ure* recurs as a theme in a printed sheet containing eight caricatures of Englishmen and entitled *Les Anglais pour rire*, published by Ledoyen in 1822. Its companion piece was *Les Anglaises pour rire*. *Bibliographie de la France*, 4 May 1822, p. 278, no. 274. For the scatological in relation to caricatural imagery, A. Boime, "Jacques-Louis David, Scatological Discourse in the French Revolution,

and the Art of Caricature," in *French Caricature and the French Revolution, 1789–1799*, exhib. cat., Los Angeles, 1988, pp. 71 ff.

35. E. Lucie-Smith, *The Art of Caricature*, Ithaca, NY, 1981, p. 60, suggests that the word *campagne* (campaign) may be a pun on *compagne*, for the soldier's wife, who would thus be suggested as being part of the soldier's burden.

36. Delacroix often punned with his last name which he deconstructed to form verbal and visual rebuses. See J. Spector, *Delacroix: The Death of Sardanapalus*, London, 1974, pp. 93–4. One such signature looked like this: Eugène **2 ✠** + *Eugène Delacroix*, exhib. cat., Zurich, 1987, p. 8.

37. "C'était en 1816 ou 1817, alors que les humiliations infligées á la France à la suite de nos désastres avaient au plus haut point le sentiment national." E. Delacroix, "Charlet," in A. Piron, *Eugène Delacroix, sa vie et ses oeuvres*, Paris, 1865, pp. 364–5.

CHAPTER 3 *Voltigeurs* and Weathervanes, Crayfish and Candle-extinguishers

1. *Bibliographie de la France*, 11 March 1820, no. 149. The print, a lithograph, was also available in color. Robaut (no. 31) dates it to 1820 and identifies it as one of Delacroix's contributions to the *Miroir*. But as Delteil (no. 29) correctly notes, this journal circulated for the first time in 1821. Delteil, however, accepts the date of 1820. For Delacroix's mention of this piece, which he considered one of his most successful early prints, see M. Tourneux, "Croquis d'après nature. Notes sur quelques artistes contemporains par Philippe Burty," *Revue rétrospective*, new series, 103–5, November 1892, p. 298.

2. J. Basket and D. Snelgrove, *The Drawings of Thomas Rowlandson in the Paul Mellon Collection*, New York, 1978, p. 62.

3. E. Helman, *Transmundo de Goya*, Madrid, 1963, p. 64; and E. Lafuente Ferrari, *Los Caprichos de Goya*, Barcelona, 1977, p. 41.

4. "Les Bourbons seuls conviennent aujourd'hui à notre situation malheureuse, *sont les seuls médecins qui puissent fermer nos blessures*. La modération, la paternité de leurs sentiments, leurs propres adversités, conviennent à un royaume *épuisé, fatigué de convulsions* et de malheurs" (my emphasis). F. R. de Chateaubriand, "De Buonaparte et des Bourbons," in *Oeuvres complètes*, vol. 7, Paris, Garnier, n.d., p. 34.

5. "Un homme très connu dans le monde est malade dans ce moment-ci . . . Un conseil de médecins s'est assemblé pour lui administrer un traitement. L'habile docteur qui présidait cette assemblée, après une assez vive altercation avec un de ses confrères, qui n'est pas partisan de la médecine expectante, a fini par faire prévaloir ce système curatif . . . Voici donc ce qu'il a dit à la garde: 'La maladie du sujet est grave; c'est ce que nos auteurs nomment une maladie constitutionelle . . .'" *Le Miroir des spectacles, des lettres, des moeurs et des arts*, 28 December 1822, p. 4.

6. On Boilly's emblematic usage of dress to impart social and political overtones to his paintings, see

P. H. Sands, "L. L. Boilly and the Politics of Dress," *Marsyas. Studies in the History of Art*, vol. 22, 1983–85, New York, 1986, pp. 47 ff.

Generally on Boilly, see H. Harisse, *L. L. Boilly, peintre, dessinateur et lithographe*, Paris, 1898; J. S. Hallam, "The Genre Works of Louis-Léopold Boilly", Ph. D. diss., University of Washington, Seattle, 1979; and *Boilly 1761–1845, un grand peintre français de la Revolution à la Restauration*, exhib. cat., Lille, Musée des Beaux-Arts, 1988, especially the essay by Susan Siegfried which establishes Boilly's republican sympathies during the Revolution. On Boilly's Restoration series of lithographs *Les Grimaces* see B. Farwell, *The Charged Image. French Lithographic Caricature 1816–1848*, exhib. cat., Santa Barbara, 1989, pp. 38–45.

7. On the café Lemblin as a mostly Liberal Restoration "haunt," see L. Véron, *Mémoires d'un bourgeois de Paris*, vol. 3, Paris, 1857, pp. 6–10.

8. *Bibliographie de la France*, 12 July 1823, no. 469.

9. Delacroix's lithograph was published by Motte and was entitled *Manège de voltigeurs* in its first and second states. See also, Loys Delteil, *Le Peintre-graveur illustré*, vol. 3 (Ingles-Delacroix), Paris and New York, 1969, no. 36; Adolphe Moreau, *Eugène Delacroix et son oeuvre*, Paris, 1873, no. 98; Alfred Robaut, *L'Oeuvre complet de Eugène Delacroix*, New York, 1969, no. 5.

10. *Le Miroir*, 8 March 1822, p. 2. Compare also, *Le Miroir*, 21 July 1821, p. 4, commenting on the obsolescence of the terms (and the concepts) of *droit d'aubaine, vasselage*, etc.

11. "Le temps qui mûrit les bons fruits fait aussi renaître les plantes parasites. La vieille féodalité qui, depuis longues années, avait reçu les invalides, et n'était plus qu'une ombre proscrite par les loix [sic] nouvelles, se mit dans l'esprit de reparaître sur la scène du monde, de faire rebrousser le siècle et de ressaisir les antiques prérogatives qu'elle avait perdues...Cependant, la gothique cavalerie avait perdu l'habitude de se tenir en selle. Il fut donc résolu qu'avant de se donner en spectacle aux vilains de la capital, espèce railleuse et sifflante, les chevaliers qui représentaient les vieilles institutions prendraient quelques leçons de manège et de voltige." *Le Miroir*, 8 March 1822, p. 2.

12. See the various meanings of *voltigeur* in E. Littré, *Dictionnaire de la langue française*, Paris, 1873, vol. 4, p. 2540, among which, "Voltigeur = celui qui voltige sur un cheval"; and "Voltigeur: sous la Restauration, voltigeur de Louis XIV, émigré rétabli sur les cadres de l'armée."

13. J. Vidalenc, *Les Émigrés français 1789–1825*, Paris, 1963, *passim* and pp. 436 ff. For a militantly favorable account of the history of the French émigrés, including the so-called "army of Condé," see F. R. de Chateaubriand, "Mélanges politiques," vol. 7, chs 7 and 8 of *Oeuvres complètes*, pp. 67 ff; vol. 9, chs 8–10, pp. 494 ff; and A. Antoine, *Histoire des émigrés français depuis 1789 jusqu'en 1828*, vol. 3, Paris, 1828, *passim*. For a politically opposite version of the subject see A. de Lamartine, *Histoire de la Restauration*, vol. 2, Paris, 1851, pp. 90–2, and *passim*. For a diary-like contemporary point of view, see L. Véron, *Mémoires*, vol. 1, p. 231.

14. Cited in Vidalenc, *Les Émigrés français*, p. 436.

15. D. Porch, *Army and Revolution. France 1815–1848*, London and Boston, 1974, p. 2.

16. Roman d'Amat, *Dictionnaire de biographie française*, vol. 9, Paris, 1961, p. 1302, no. 11; and La Gorce, *La Restauration. Louis XVIII*, vol. 1, Paris, 1926, pp. 36–8.

17. "Ce ne fut bientôt contre les émigrés que pamphlets et caricatures" Véron, *Mémoires*, vol. 1, p. 231.

18. P. Larousse, *Grand Dictionnaire universel du dix-neuvième siècle*, vol. 9, Paris, Geneva, 1982, p. 993: *Jobard*, for stupid, naive.

19. *Le Nain jaune*, 5 July 1815, pp. 409–10.

20. Co-authored by Scribe, Joubin and Carmouche, the play is mentioned in *Le Conservateur littéraire*, May 1820, 12e livraison, pp. 117–18.

21. "Dialogue entre un officier à la demi-solde et M. Desroseaux," in *L'Homme Gris ou Petite Chronique*, 1817–18, pp. 313 ff.

22. Véron, *Mémoires*, vol. 1, p. 231.

23. On Charlet, see J. F. Le Blanc de La Combe, *Charlet, sa vie, ses lettres suivi d'une description raisonnée de son oeuvre lithographique*, Paris, 1856. The two prints are nos 94 and 275 of La Combe's catalog, and are dated 1820 and 1822 respectively.

24. On "gout" as a Restoration satirical theme with precise political overtones, see the essay "Le Goutteux," *Le Nain jaune*, 20 April 1815, 362, pp. 52–4; and "Le Goutteux. Pot pourri moral, politique, critique et litteraire", 10 May 1815, 366, p. 148.

25. La Combe, *Charlet, sa vie, ses lettres*, no. 292. The print is dated 1823.

26. "...un vieux Monsieur en perruque à fer à cheval, l'épée au côté, le parapluie à la main...– Au diable l'imbécile...c'est un habit militaire qu'on te demande. – Un habit militaire à Monsieur? – D'officier général. – D'officier général! Sans doute, ajouta mon bourgeois...et je vais montrer à M. le chevalier un magnifique uniforme de lieutenant général, qui lui ira comme s'il eut été fait pour lui; c'est celui que portait le général G...sur le dernier champ de bataille où il succomba; j'ai eu soin de laisser voir la reprise qu'on a faite sur la poitrine à l'endroit ou est entrée la balle qui a privé ce héros de la vie; mais il est facile d'en faire disparaître jusqu'à la moindre trace. – Non pas, s'il vous plait, j'ai été blessé tout juste à la même place à l'attaque de Sainte-Lucie, dans la guerre d'Amérique, et je ne suis pas fâché de porter sur mon habit la cicatrice de ma blessure.

On lui fit voir l'habit; il l'essaya. Jamais figure plus grotesque ne s'était offerte à mes yeux; et il ne fallait rien moins que le sang froid dont je suis pourvu pour retenir le rire dont j'étais suffoqué, en voyant ce brave homme, déguisé en héros, se pavaner devant une glace." *Le Miroir*, 29 September 1822, p. 2.

27. Umbrellas, although manufactured and used in France for centuries, were especially associated with England which, because of its more humid climate, had developed an especially thriving umbrella industry. Hence the French proverb "Un anglais ne sort jamais sans son parapluie." During the Restoration, umbrellas became the symbol of the émigrés, the majority of whom, including the king and his family, had spent their years of exile in England. By transforming the umbrella into a symbol of stupidity and reaction the French Liberals

telescoped both their anti-English and their anti-aristocratic sentiments. For example, *L'Homme gris*, 1817–18, pp. 114–20, contained a satirical piece entitled "Premières campagnes de M. le Marquis de la Vulpilière," in which the marquis' great contribution to war was said to be his introduction of umbrellas in the fighting regiments composed of "gentilshommes": "On imagina vers cette époque les parapluies," the marquis narrated. "Dès que cet instrument fut connu, je ne sortis jamais de ma chambre sans en être muni. . .j'écrivis à ce sujet un mémoire pour faire adopter le parapluie dans les régiments; il le fut et l'on put enfin faire la guerre sans se mouiller. Cela me valut de l'avancement, les officiers me félicitèrent. . ." (pp. 117–18).

In "Modes. Ombrelles et parapluies," the *Miroir*, 31 October 1822, 646, p. 3, associated umbrellas with bourgeois complacency and military cowardice. It concluded: "Allumons au feu d'une noble indignation les foudres qui doivent terrasser le parapluie! Ne craignons pas de le frapper d'un patriotique anathème. . .Que le parapluie reste dans les mains de ces prétendu soldats dont le ridicule a depuis longtemps fait justice (i.e. émigré officers). . .La main d'un Français qui ne s'est point avili doit rester libre, même pendant l'orage."

The *parapluie* became a seditious attribute in the eyes of the Restoration government, as suggested by police documents ordering the seizure of a satirical brochure entitled *Le Parapluie patrimonial* (Archives Nationales, BB 30. 221, May–July 1822).

Later, in the opposition to the July Monarchy regime, the umbrella became the attribute of Louis-Philippe, the Citizen-King who had also weathered the Revolution in England. See Larousse, *Grand Dictionnaire*, "parapluie."

28. Compare a similar device in the satirical piece "Dialogue entre un officier à la demi-solde et M. Desroseaux," published in *L'Homme gris*, 1817–18, pp. 313 ff. The article, which pokes fun at émigrés, imagines a dialogue between the émigré M. Desroseaux and a napoleonic half-pay officer. To the former's "j'étais capitaine des grands gendarmes de Louis XV," the latter replies, "Moi, Monsieur, j'ai été militaire, je le suis encore, car bien que je n'aie que demi-paye, j'ai tout autant de droits au titre d'officier français. . .Lorsque moi et mes camarades nous étions dans les rangs, nous aurions bien envoyé au diable les queues poudrées, les longs et larges habits, les boucles pommardées: je vous demande, que signifiait tout cet attirail de tailleur et de perruques?"

29. ". . .on ne peut être admis en qualité d'élève avant l'âge de soixante ans révolus. . .Les voltigeurs une fois en selle, font les manoeuvres au pas et à la platte-longue pendant quelques semaines, on les hasarde ensuite au petit-trot entre deux écuyers attentifs à suivre tous leurs mouvements, et à leur rendre l'équilibre qu'ils sont sujets à perdre. . . MM. Franconi. . .se proposent avant deux ans, de mettre sur pied dix escadrons de voltigeurs de cette espèce, pour remplacer la cavalerie d'élite, que nous avons perdu à Waterloo." *Le Nain jaune réfugié*, 1, Brussels, 1816, pp. 55–6.

30. "Nul ne pourra faire partie de l'ordre de la Girouette s'il ne prouve avoir changé trois fois de suite d'opinions, et avoir servi au moins trois gouverne-

ments." *Le Nain jaune*, 1, 1815, p. 524. See also *Le Miroir*, 16 July 1821, pp. 3–4 which states, ironically, that the origin of the weathervane is very old: "elle remonte jusqu'au bon vieux temps de la féodalité."

31. *Le Miroir*, 3 March 1822, p. 3.

32. "Les Chevaliers de l'Éteignoir s'engagent à combattre corps à corps toute vérité contraire aux intérêts de l'Ordre, et à ne reculer devant aucune absurdité, quelque grossière, quelque palpable qu'elle puisse être, s'il y a plus de profit à l'avancer, que de honte à la soutenir." *Le Nain jaune*, January 1815, p. 8.

33. ". . .une image parfaite de la ténébreuse obscurité de son cerveau." *Ibid.*, p. 38.

34. Archives Nationales, BB 30. 220 (dossier 3).

35. On Achille Devéria's liberalism and anti-clericalism in the 1820s, which, much like Delacroix's, found expression in political satire, see a brief mention in *Musée Rohan-Scheffer. Achille Devéria, témoin du romantisme parisien 1800–1857*, exhib. cat., Paris, 1985.

36. M. Sérullaz et al., *Musée du Louvre. Cabinet des dessins. Inventaire général des dessins. École française. Dessins d'Eugène Delacroix*, 2 vols, Paris, 1984, vol. 1, no. 785.

37. "Neigh with arrogance, O my loyal steed!/And at your feet trample peoples and kings./. . ./ All this splendor for which Europe is proud, / All this knowledge that does not assist her,/ Will be engulfed in the dusty whirls/ That all around me your legs will raise./ Erase, erase, in your new cavalcade, /Temples, palaces, fashions, memories and laws." P. J. Béranger, *Oeuvres complètes*, vol. 2, Paris, Fournier aîné, 1836, pp. 221–2.

CHAPTER 4 Louvel, the Murderer

1. The print is extremely rare. Delteil, (*Le Peintre-graveur illustré*, Paris and New York, 1969, no. 30) and Robaut (*L'Oeuvre complet de Eugène Delacroix*, New York, 1969, no. 32) date it 1821, but as Laran ("Péchés de jeunesse d'Eugène Delacroix," *Gazette des beaux-arts*, series 6 (3), 1930, p. 59) has shown, it was deposited at the Direction Générale de la Librairie ("dépôt légal") on 25 February 1820. The lithograph is not listed by Moreau, *Eugène Delacroix et son oeuvre*, Paris, 1873. Tourneux, "Croquis d'après nature. Notes sur quelques artistes contemporains par Philippe Burty," (*Revue retrospective*, new series, 103–5, November 1892, p. 295) says, Delacroix did the portrait from memory. The rarity of the print is attributed to its explicit anti-royalist content in *Eugène Delacroix. Themen und Variationen. Arbeiten auf Papier*, exhib. cat., Frankfurt am Main, 1987, p. 32.

2. See J. Lucas-Dubreton, *Louvel le régicide*, Paris, 1923; and accounts of the murder in, among others, F. R. de Chateaubriand, "Mémoires sur le duc de Berry," in *Oeuvres complètes*, vol. 9, Paris, Garnier, n.d.; A. de Lamartine, *Histoire de la Restauration*, vol. 5, Paris, 1851, pp. 197 ff; A. de Vaulabelle, *Histoire des deux Restaurations*, vol. 6, Paris, 1858, pp. 108 ff; and Imbert de Saint-Amand, *The Duchess of Berry and the Court of Louis XVIII*, New York, 1892, pp. 146 ff.

3. "Le vil esclave des libéraux jacobins." Cited in S.

Charléty, *La Restauration*, vol. 4 of E. Lavisse's *Histoire de France contemporaine*, Paris, n.d., p. 140.

4. On 29 September 1820, the Duchess of Berry gave birth to a male child, the duc de Bordeaux, who became the new heir to the French throne. Had it not been for that posthumous issue, Louvel's plan to annihilate the Bourbon line would have been successful.

5. "Oui, monsieur Decazes, c'est vous qui avez tué le duc de Berry." Cited in Charléty, *La Restauration*, p. 142.

6. "La main qui a porté le coup n'est pas la plus coupable. Ceux qui ont assassiné Mgr le duc de Berry sont ceux qui . . . établissent dans la monarchie des lois démocratiques . . . ceux qui ont cru devoir rapeller les meurtriers de Louis XVI . . . ceux qui ont livré les emplois aux ennemis des Bourbons et aux créatures de Buonaparte . . . Voilà les véritables meurtriers de Mgr le duc de Berry." *Le Conservateur*, 6, Paris, 1820, pp. 382–3.

7. "Non. Le forfait de Louvel n'est point un forfait isolé; c'est le forfait d'un parti exécrable, dont un furieux n'a été qu'un instrument docile." *Journal des débats*, 17 February 1820, p. 2.

8. "Une race impie, connue en 1790, sous le sobriquet de jacobins, et en 1815, sous le titre de libéraux, a préparé, par des menées sourdes, l'extinction de la famille des Bourbons et la chute des rois de l'Europe." Robert, *Conjuration permanente contre la maison de Bourbon et les Rois de l'Europe. Depuis le ministre Necker, jusqu'au ministre de Cazes, et depuis l'abbé Grégoire, jusqu'à Louvel*, Paris, 1820, p. 1.

9. ". . . monstre à face humaine . . ." Anonymous, *L. P. Louvel devant la cour des pairs*, Paris, n.d. (1820), p. 3.

10. Such comparisons occur frequently in the press and incidental publications of the time, but most explicit was the pamphlet *Détails exacts et circonstaciés sur Louis-Pierre Louvel, Jacques Clément, Jean Châtel, Ravaillac et Damiens, et les supplices qu'ils ont subis*, Paris, n.d. An illustration on its first page represented, in a central oval, Louvel, and around him, in medallions, the busts of the other four regicides.

11. ". . . ce n'est point une haine particulière mais bien vos doctrines qui ont armé l'assassin . . ." *Précis sur la vie et les derniers moments de S.A.R. Mgr le duc de Berry assassiné le 13 février 1820, par l'infâme et exécrable Louvel*, Nantes, 1820, pp. 3–4.

12. "Qui a mis le feu homicide dans les mains du garçon sellier, Louvel? Le vertueux Grégoire . . . Qui a exaspéré sa tête? L'homme de l'île d'Elbe." Robert, *Conjuration permanente contre la maison de Bourbon*, p. 57.

13. ". . . un prince aimé par les braves, chéri par les pauvres . . ." *Ibid.*, p. 56.

14. *Ibid.*, and Charles Nauroy, *Les Derniers Bourbons, le duc de Berry et Louvel*, Paris, 1883, p. 63.

15. "Dans ce dernier et cruel moment, je crus apercevoir au-dessus . . . les bustes de Louis XVI et de Marie-Antoinette. Je n'ai pu vérifier depuis s'ils y étaient réellement ou si mon imagination préoccupée les avait associés à cette scène de douleur." Nauroy, *Les Derniers Bourbons*, p. 63.

16. *Ibid.*, p. 61.

17. ". . . ne se contentant pas d'appliquer ses lèvres sur les pieds et les mains de son Sauveur, mais aller ensuite les coller avec une tendre affection sur la plaie de son côté; comme s'il eut pressenti, que, blessé un jour au même endroit, il trouverait dans le coeur adorable de Jesus, le don du répentir et la grâce des prédestinés." Anonymous, *Louvel au Luxembourg ou Le Songe*, Paris, 1820, p. 4.

18. *Le Conservateur*, 6, Paris, 1820, p. 341.

19. "Le crime atroce de Louvel est un crime isolé, rien n'est plus sûr. Tout bon citoyen en a frémi d'horreur. Qu'ils sont coupables les hommes qui insultent à la douleur publique, au deuil de la France, par de lâches calomnies et de mensongères délations." *Le Constitutionnel*, 18 February 1820, p. 2. A similar message informs the anonymous pamphlet entitled *Écoutez-moi donc*, published in Paris on 26 May 1820, from the printshop-bookstore of Alexandre Corréard, the *Méduse* survivor turned publisher of radical literature in the Palais-Royal: "Reste donc le seul Louvel, dont l'isolement est bien constaté, malgré les efforts innouis de la faction [i.e. the Ultras] pour lui trouver des complices, ou plutôt pour augmenter le nombre des coupables." (p. 10)

20. *Le Constitutionnel*, 16 February 1820, p. 1.

21. ". . . l'indignation qu'ils ont ressentie en apprenant qu'on avait pu croire le monstre qui lui a donné la mort sorti de leurs rangs." *Ibid.*, 25 February 1820, p. 2. The royalist *Journal des débats* of 19 February 1820, p. 4, and probably other right-wing dailies too, had stressed Louvel's career in the army in an effort to discredit, indirectly, the reintegrated Grande-Armée officers in the form of a veteran reserve instituted by the Saint-Cyr military reforms of 1818–19. In some contemporary prints Louvel was, in fact, represented as a *demi-solde*, a Bonapartist half-pay officer.

22. Lucas-Dubreton, *Louvel le régicide, passim*.

23. "Un héros, dirigé par le bras de la liberté, vient de porter un coup mortel à une branche de la tyrannie . . . L'ami du peuple, l'intrépide, l'immortel Louvel, ce disciple des droits de l'homme, en se dévouant généreusement pour la patrie, laisse à ses successeurs habiles, l'exécution d'un piège que le tyran et son exécrable suite ne pourra éviter. Amis de la liberté, et de l'égalité, tout est prévu pour la destruction de cette dynastie. – Aiguisez vos poignards . . . Alors le cri de Mort aux Tyrans, et à tous les grands du monde, sera notre devise chérie, le partage de leurs biens notre juste récompense, et le fanatisme brûlé tout vif, sera chassé du temple de la raison et de la vérité." Archives Nationales, BB. 18. 1061 (pièce 3800. A. 5).

24. "Eh bien donc canaille qu'on appelle noblesse; vous marchands d'oremus, d'indulgences et de messes . . . et autres imbéciles, supports de l'esclavage; pourquoi cette douleur, pourquoi ce nouveau tapage? Je vous vois seuls en pleurs, qu'y a t-il d'affligeant? Qu'un franc cochon de plus . . . cesse d'être vivant." *Ibid.*, BB. 18. 1062 (pièce 3821. A. 5)

25. "La bouteille et le cotillon sont, dit-on, les plaisirs chéris du duc de Berry; il boit largement, dit-on . . . douze à quinze bouteilles de vins exquis très-forts par jour; c'est pour un jeune prince s'établir une réputation d'ivrognerie assez bien fondée; il a toujours après cela deux ou trois maîtresses qui se relayent tour-à-tour, ainsi il passe les plus beaux instants de sa vie entre bachus [sic] et l'amour . . .". Anonymous, *Le Mea culpa de M. le duc de Berry*,

Paris, n.d. pp. 2 ff. For a modern account of the duc's "secret life" see mainly Lucas-Dubreton, *Louvel le régicide*, pp. 19 ff. Several Ultra pamphlets attempted to "restore" Berry's reputation. In one, entitled *De l'Emigration suivie d'une notice sur la vie militaire de S.A.R. le duc de Berri par un émigré*, Paris, 1820, the author invites the French to consider the émigrés, and Berry with them, as "des enfants comme vous de la Patrie" (p. 33). The duc's amorous adventures were indulgently excused in B***, *Histoire de S. A. R. Monseigneur le duc de Berri*, Paris, n.d., pp. 36 ff.

26. Firmin-Didot (ed.) *Nouvelle biographie générale*, vol. 32, Paris, 1863, column 35.

27. "Mes opinions sont que les Bourbons sont des tyrans, et les plus cruels ennemis de la France," *Journal des débats*, 15 February 1820, p. 2; and Anonymous, *Louis Pierre Louvel devant la cour des pairs, ou Instruction du procès de l'exécrable assassin de S. A. R. Mgr le duc de Berri*, Paris, 1820, p. 25, where Louvel is cited as having said that "il regardait tous les Bourbons comme les ennemis de la France."

28. (The following spelling preserves, allegedly, Louvel's original): "Enfin arrivés à Paris les armés étrengers, la France fut trop tard instrui des crimes, de trahison et du comité secrés qui avet favorisé les armes étrangers et nui au salu de notre patri, ce fu alors que je concu mes projai. je voiliet que la nation alé tet gouvernés par se plus grands ennemis. Suivent moi, elle le te plus malheureuse et plus désonoré que detre gouverné par un vanqueur..." Cited in Antoine, *Histoire des émigrés français depuis 1789 jusqu'en 1828*, vol. 3, Paris, 1828, pp. 238–9. Also compare Louvel's words in response to the prosecution's questions: "Dans l'affliction que me causait la présence des armées étrangères, je voyageois pour me distraire, et pour prendre un parti sur le projet que j'avais conçu." *Louis Pierre Louvel devant la cour des pairs ou Instruction...*, p. 41.

29. Anonymous, *Notice curieuse et historique sur la vie de Louis-Pierre Louvel*, Paris, 1820, p. 2; and Anonymous, *Louis Pierre Louvel devant la cour des pairs ou Instruction...*, p. 90: "Il s'est cru un Brutus, un Décius."

30. "...taille d'un mètre soixante et un centimètres, cheveux blonds, sourcils idem, front petit, yeux bleus, nez petit, bouche petite, menton rond, visage oval, conscrit de l'an XII, entré au bataillon principal du train d'artillerie de l'ex-garde, le 12 vendémiaire an XIV, réformé le 9 mai 1806." *Journal des débats*, 19 February 1820, p. 4.

31. Franz Joseph Gall (1758–1828), the German inventor of phrenology, lived in France from 1807. His controversial theories provoked a stir among French scientists. Johann Caspar Lavater's (1742–1801) ideas were well known in France, too. In 1820, a new edition of his *L'Art de connaître les hommes par la physionomie*, prefaced by M. Moreau, a professor of medicine, was issued in Paris. In it (vol. 9, p. 178) Lavater described homicidal men: "leurs sourcils sont épais et se joignent au milieu du front." The impact of such theories on European painting has been explored in G. Levitine, "The Influence of Lavater and Girodet's Expression des sentiments de l'âme," *Art Bulletin*, March 1954, pp. 33 ff; and B. Stafford, "Peculiar Marks: 'Lavater and the Countenance of Blemished Thought,' " *Art Journal*, Fall 1987, pp. 185 ff.

32. Anonymous, *Notice curieuse et historique sur la vie de Louis Pierre Louvel*, p. 2.

33. "Ses traits caractérisés paraissaient porter l'empreinte d'une profonde et sombre méditation." Anonymous, *Louis Pierre Louvel devant la cour des pairs ou Instruction...*, p. 37.

34. "Il était vêtu d'une redingote noire, boutonnée au dessous d'une cravate de la même couleur." *Ibid.*

35. Anonymous, *Notice curieuse et historique*, p. 1.

36. "Il vivait éloigné de toute société. Farouche, inquiet, silencieux, il évitait les lieux publics..." Anonymous, *Louis Piere Louvel devant la cour des pairs ou Instruction...*, p. 16.

37. Anonymous, *Louvel au Luxembourg ou Le Songe*, p. 2.

38. Prints related to Louvel's murder are listed in great numbers in the *Bibliographie de la France*, especially in late February and March 1820.

39. *Horace Vernet*, exhib. cat., Paris and Rome 1980, p. 61.

40. In 1829, in fact, Delacroix was to accept commissions from the Duchess of Berry, as well, the murdered prince's widow. Escholier, *Delacroix 1798–1832. Peintre, graveur, écrivain*, vol. 1, Paris, 1926, p. 235, remarked on the ambivalence of Delacroix's attitude in this case: "Au début de 1829, la duchesse de Berri, ne sachant pas sans doute qu'Eugène Delacroix, un instant suspect de carbonarisme, avait fait le portrait de Louvel, lui commandait un tableau d'histoire: *La Bataille de Poitiers...*"

41. Anonymous, *Louis Pierre Louvel devant la cour des pairs ou Instruction...*, p. 64.

42. M. Sérullaz et al., *Musée du Louvre. Cabinet des dessins. Inventaire générale des dessins. École française. Dessins d'Eugène Delacroix*, 2 vols, Paris, 1984, vol. 1, p. 318, no. 777.

CHAPTER 5 Censorship is Dead! Long Live Censorship!

1. "Les Français ont le droit de publier et de faire imprimer leurs opinions, en se conformant aux lois qui doivent réprimer les abus de cette liberté." Irene Collins, *The Government and the Newspaper Press in France 1814–1881*, Oxford, 1959, p. xv; see also Charles Ledré, *La Presse à l'assaut de la monarchie 1815–1848*, Paris, 1960, *passim*.

2. E. Hatin, *Bibliographie historique et critique de la presse périodique française*, Paris, 1866, pp. 317–24.

3. "Cette mêlée d'opinions, d'antipathies, de dissertations, de sarcasmes, de haines, de provocations, d'invectives qui passionnaient et scandalisaient les tribunes, se continuait en dehors dans les journaux que la liberté donnée à la presse rendait plus nombreux et plus acharnés. Tous les talents littéraires du temps s'armaient pour leur cause d'une polémique incessante qui changeait en controverse tous les entretiens. L'esprit public, comprimé si longtemps par les armes et par le despotisme, jaillissait par mille voix. On sentait partout l'explosion d'un siècle nouveau dans les âmes. La France fermentait d'idées, d'ardeur, de zèle, de passions..." A. de Lamartine, *Histoire de la Restauration*, vol. 6, Paris, 1851, pp. 175–6.

4. *Le Nain jaune*, 15 December 1814, no. 337, pp. 22–4.

5. E. Hatin, *Histoire politique et littéraire de la presse en France*, vol. 8, Paris, 1861, p. 488.

6. According to E Littré (*Dictionnaire de la langue française*, Paris, 1873), in nineteenth-century popular parlance the name Bridoison was used to mean "niais, sot, stupide."

7. For this nickname of the *Gazette*, see *Le Nain jaune*, 20 December 1814, p. xliv.

8. "Un sentiment de dignité est empreint dans toutes ses lignes; on ne s'y abaisse jamais jusqu'à la plaisanterie ou jusqu'à l'épigramme..." Cited in Hatin, *Histoire politique et littéraire*, p. 194.

9. *Le Nain jaune*, January 1815, 341, p. 22.

10. "Son habit de toutes pièces fait allusion à la bigarrure de ses opinions." *Ibid.*, 15 December 1814, p. 24.

11. "Longtemps il flotta, uncertain à quel parti il devait se vouer." Cited in Hatin, *Histoire politique et littéraire*, p. 205.

12. Collins, *The Government and the Newspaper Press*, pp. 9 ff.

13. In its issue of 25 May 1815 (369, pp. 239–40) *Le Nain jaune* praises this anonymous cartoon while also noting its similarity to its own caricatures, particularly that of *Les Journaux*.

14. Hatin, *Histoire politique et littéraire*, p. 409. In addition to the three Ultra *Nains*, there was also a Liberal *Nain tricolore* which was suppressed in June 1816 for attacking the royal government. See the mention of this journal in *Le Nain jaune réfugié*, 3, 1816, p. 44.

15. Delacroix's etching is not listed in Delteil (*Le Peintre-graveur illustré*, vol. 3 (Ingres-Delacroix), Paris and New York, 1969), but is catalogued by Moreau (*Eugène Delacroix et son oeuvre*, Paris, 1873, no. 56) and Robaut (*L'Oeuvre complet de Eugène Delacroix*, New York, 1969, no. 5) who date it 1816. Laran corrected this date by demonstrating that the print was already deposited by 19 September 1815. He also stated that it was engraved by Pierre Adam after a drawing by Delacroix ("Péchés de jeunesse d'Eugène Delacroix", *Gazette des beaux-arts*, series 6 (3), 1930, p. 56). I was not able to confirm the involvement of Pierre Adam in this etching. The Dépôt Légal register at the Bibliothèque Nationale cites Delacroix as both the engraver and the depositor of the print.

16. Delacroix's journalistic monkeys may have inspired a later political cartoon entitled *Les Singes indépendants* (1819; right), in which monkeys are seen plundering the "liberal" contents of a trunk, including phrygian bonnets and "independent" newspapers.

17. Albert Crémieux, *La Censure en 1820 et 1821. Étude sur la presse politique et la résistance libérale*, Abbeville, 1912, *passim*.

18. J. Godéchot, P. Guiral and F. Terrou, *Histoire générale de la presse française*, vol. 2, Paris, 1969, pp. 67 ff.

19. "Le *Moniteur*, fier de sa taille de tambour-major, se promenait d'un pas grave et mesuré dans l'allée du milieu. L'*Étoile*, qui lui allait à peine à la hanche, se traînait terre-à-terre à ses côtés; elle avait brodé son collet pour se donner un petit air officiel... Sur la droite, trottaient en sautillant, Dame *Quotidienne* en robe détroussée, demoiselle *Gazette* en capuche, Messire *Drapeau blanc*... Vers la gauche, Le *Constitutionnel* et *Le Courrier* suivaient d'un pas ferme une allée droite. Le *Miroir* marchait dans le même sens..." Le *Miroir*, 9 February 1822, p. 2."

20. "La politique qui se glisse partout, quoique on se promette de n'en point parler, fut mise sur le tapis par le *Drapeau blanc*. On discuta d'abord doucement, bientôt on s'aigrit, chacun prit le ton de son journal; la *Quotidienne* devint toute rouge; le *Drapeau blanc* avai déjà la main sur la garde de sa rapière, et M. des *Débats* criait comme un aveugle, lorsque le sage *Moniteur*, voyant qu'on ne s'entend jamais sur la politique, remena la conversation sur la littérature." "Visites des journaux. Le jour de l'an," *Le Miroir*, 2 January 1822, p. 3.

21. Hatin, *Histoire politique et littéraire*, p. 199.

22. "Champ-clos polémique. Grand combat à outrance entre la Quotidienne et le Journal de Paris," *Le Miroir*, 12 September 1821, p. 3.

23. Published by Motte, it is listed in Delteil (no. 34), Moreau (no. 96) and Robaut (no. 45). A brief announcement in the *Miroir* of 29 September 1821, p. 2, accompanied Delacroix's print.

24. Delacroix was a lifelong admirer of Cervantes's novel, as entries in his journal indicate. More generally on Delacroix's interest in Spain, Spanish culture and Spanish art, see M. Florisoone, "La

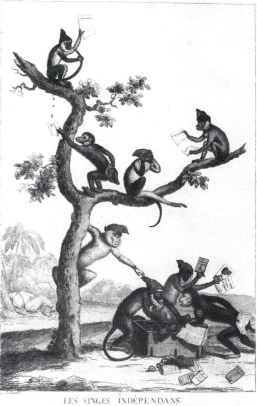

LES SINGES INDÉPENDANS
ou
LE MARCHAND DÉVALISÉ.

Anonymous, *Les Singes indépendants*, 1819. Etching, Paris, Bibliothèque Nationale, Cabinet des Estampes.

Genèse espagnole des Massacres de Scio de Delacroix," *Revue du Louvre*, 4–5, 1963, pp. 195–208; and Ilse Hempel Lipschutz, *Spanish Painting and the French Romantics*, Cambridge, MA, 1972, pp. 93 ff.

25. In the satirical writings of the 1820s the *Journal de Paris* was often described as talking about the weather and barometers. See "Visites des journaux," p. 3.

26. Collins, *The Government and the Newspaper Press*, p. 35.

27. "Ils ne pleurèrent point, vu qu'ils espéraient hériter du petit nombre d'abonnés que laissait la défunte . . ." *Le Miroir*, 15 September 1821, p. 4; and 29 September 1821, p. 2.

28. Collins, *The Government and the Newspaper Press*, pp. 36 ff.

29. Godéchot *et al.*, *Histoire générale*, p. 71.

30. "Aussitôt que la défunte eut rendu le peu d'esprit qu'elle avait, les deux notaires, exécuteurs de ses volontés, se hâtèrent de les accomplir. Les billets de parts furent expédiés à tous les obscurantistes; le corps entier des voltigeurs accourut en grand deuil, et la *Quotidienne*, en pleureuses. . . Afin que la vue de la moderne Gorgone ne fût point dérobée aux regards curieux de ses admirateurs. . .on la suspendrait avec le cordon de ses ciseaux dans un immense bocal d'encre rouge. . .L'opération fut faite en un clin d'oeil, tant la censure était devenue peu de chose depuis qu'elle était morte." *Le Miroir*, 18 February 1822, p. 3. See also, "Souscription ouverte. Pour ériger un monument sépulcral à la Censure," *Le Miroir*, 21 February 1822, p. 3.

31. "Son déménagement l'a réduit aux abois, et, n'ayant plus de feuilles à sucer, l'infortunée chenille est morte d'inanition. . .après avoir fait son testament. . ." *Le Miroir*, 18 February 1822, p. 3.

32. See a discussion of this print in the *Miroir*, 11 February 1822, p. 2. The print was published by Motte. Delteil (no. 35), Moreau (no. 100), and Robaut (no. 56).

33. Firmin-Didot (ed.) *Nouvelle biographie générale*, vol. 39, Paris, 1863, column 54.

34. *Ibid.*, vol. 34, column 611.

35. Crémieux, *La Censure en 1820 et 1821*, pp. 173–4.

36. J. Balteau, M. Barroux and M. Prévost, *Dictionnaire de biographie française*, vol. 2, Paris, 1936, column 981.

37. Crémieux, *La Censure en 1820 et 1821*, pp. 173–4.

38. *Ibid.*, p. 15.

39. Firmin-Didot, *Nouvelle biographie générale*, vol. 32, columns 24–5.

40. The lithograph was published by Motte, and is listed by Delteil (no. 37), Moreau (no. 97) and Robaut (no. 58). On this print, see a brief explanation in Robert Justin Goldstein, "Censorship of Caricature in France, 1815–1914", *French History*, 3(1) 1989, p. 89.

41. *Le Miroir*, 4 April 1822, p. 3.

42. "Nos écrevisses politiques n'en veulent pas démordre, elles s'obstinent à reculer: on leur crie en vain, de tous côtés: 'Avancez sur le terrain de la charte d'une manière franche et loyale; ne craignez rien: même de votre incapacité! La nation française redressera vos bévues, et à force de vous siffler, fera de vous des acteurs supportables.'" Frédéric Royou, membre de la Légion d'Honneur, *L'Écrevisse ministérielle ou L'Observateur de la Charte. De la

marche rétrograde du ministère de 1820*, Paris, 1820, p. 1.

43. Published by Motte, and listed by Delteil (no. 38), Moreau (no. 99) and Robaut (no. 59).

44. *Le Miroir*, 30 May 1822, p. 2.

45. On Artois as Galaor, see Antoine Thomé, *Vie de David*, Paris, 1826, p. 30; and J. Lucas-Dubreton, *Le Comte d'Artois. Charles X, le prince, l'émigré, le roi*, Paris, 1962, p. 11: "Il [le comte d'Artois] réalisait aux yeux de la cour le type accompli du paladin des romans de chevalerie, intrépide, magnanime, amoureux: 'Galaor' fut son surnom."

The *Miroir* notes that Galaor reigned on Monomotapa, the name of an obscure African kingdom used by Jean de la Fontaine in his fable *Les Deux amis* to suggest a remote land, a utopia which served as an ideal alternative to France. In the *Miroir*'s description, as well, Monomotapa may stand for a utopian, albeit hardly ideal, vision of France under Ultra rule. La Fontaine's fable had not been forgotten in the 1820s, as the article "Passion," which includes a reference to it, indicates (*Le Miroir*, 3 September 1822, p. 3).

CHAPTER 6 "Rossinisme" as Modernism

1. "Non certes: je ne crains pas d'avancer, qu'en littérature par exemple, une paire de ciseaux est plus utile aujourd'hui qu'un canif, et que c'est le premier instrument dont doive se munir tout homme qui veut faire fortune, et arriver comme un autre à l'académie. . .Je promets à l'auteur couronné la plus belle paire de ciseaux qui soit dans ma boutique, et j'y ajouterais une gaine, si l'ouvrage est en vers, et surtout si c'est une ode:une ode vaut bien cela." "Les Ciseaux," *Le Miroir des spectacles, des lettres, des moeurs et des arts*, 6 December 1822, p. 3. Also, *ibid.*, 17 July 1821, p. 4. *Le Diable boiteux*, 9 October 1823, pp. 2–3, a satirical journal which rivaled the *Miroir* in anti-government sarcasm, likewise published a story entitled "Les Ciseaux" in which it was observed, with feigned wonder, that scissors had in this century been elevated to a brilliant fortune as they moved from the hands of humble tailors to noble and powerful hands.

2. P. Mesnard, *Histoire de l'Académie française depuis sa fondation jusqu'en 1830*, Paris, 1857, pp. 283–98; E. Edwards, *Chapters of the Biographical History of the French Academy*, New York, 1864, pp. 79–80. Edwards writes: "The names of 'Bonapartist' and too 'liberal' Academicians were indiscriminatingly struck from the roll by a royal ordinance, to be replaced, for the most part, by names of abbés, bishops, counts, and dukes, little known to literature. By the ultra-royalists, this was called the 'Purification of the Academy.'" On the social structure of the Academy, see also R. Pernoud, *Histoire de la bourgeoisie en France*, vol. 2, Paris, 1962, pp. 395–6.

3. P. Mesnard, *Histoire de l'Académie française*; D. Mac Laren Robertson, *A History of the French Academy 1635–1910*, New York, 1910; D. Oster, *Histoire de l'Académie française*, Paris, 1970.

4. "Rendre toutes les Muses royalistes et en faire des interprètes de la France monarchique." Cited in P. Martino, *L'Époque romantique en France 1815–1830*,

Paris, 1944, p. 45. On the Société des Bonnes Lettres, also see Margaret H. Peoples, "La Société des Bonnes Lettres (1821–1830)", *Smith College Studies in Modern Languages*, 5 October 1923, pp. 1–50; and L. Véron, *Mémoires d'un bourgeois de Paris*, vol. 1, Paris, 1856, pp. 239 ff.

5. "Ces soi-disant réformateurs ont la prétention de restaurer dans la littérature cette dignité morale et classique qu'elle avait sous Louis XIV." Stendhal, *Courrier anglais*, vol. 2, Paris, Le Divan, 1935, p. 61.

6. R. Schneider, *Quatremère de Quincy et son intervention dans les arts (1788–1830)*, Paris, 1910, especially pp. 241 ff; R. Schneider, *L'Esthétique classique chez Quatremère de Quincy (1805–1823)*, Paris, 1910, *passim*. Also A. Boime, *The Academy and French Painting in the Nineteenth Century*, New Haven and London, 1986, pp. 5–8.

7. P. Bénichou, *Le Sacre de l'écrivain 1750–1830. Essai sur l'avènement d'un pouvoir spirituel laïque dans la France moderne*, Paris, 1973, pp. 278–9.

8. Bénichou, *Le Sacre de l'écrivain*, pp. 281 ff; Peoples, "La Société des Bonnes Lettres," pp. 4 ff.

9. On the relation of literary romanticism and politics, see P. Martino, *L'Époque romantique*, pp. 86 ff and *passim*; and Bénichou, *Le Sacre de l'écrivain*, pp. 275 ff. More recently, historians Pierre Barbéris and Alan Spitzer, among others, have maintained that the varied and seemingly inconsistent alignments characterizing the relationship of the romantics to the politics of their time had a socioeconomic basis which was itself manifested as a generational conflict. Barbéris, in "Mal du siècle ou D'un Romantisme de droite à un romantisme de gauche," *Romantisme et politique 1815–1851. Colloque de l'École Normale Supérieure de Saint-Cloud (1966)*, Paris, 1969, pp. 164 ff., distinguishes between a conservative, aristocratic romanticism (Madame de Staël's, Chateaubriand's) born out of a sense of existential despair in the aftermath of personal suffering and historical upheaval, and of alienation from the values of a modern, bourgeois society; and a left-wing romanticism, the product of a generational clash within the Liberal middle class, championed, primarily, by a disillusioned and frustrated bourgeois youth which saw its ambitions fizzle in the face of the economic and political power of an established bourgeois gerontocracy.

Spitzer, *The French Generation of 1820*, Princeton, 1987, more explicitly sees the setting for the emergence of romanticism as shaped by the conflict between young and old – independently of political camps – and by the "refusal of the Restoration youth, irrespective of its political or artistic tendencies, to be patronized by its elders" (p. 29). Eager for action, novelty and modernity, these younger men, imbued by divergent ideologies, rose against academic classicism, which they identified with a stifling old guard: "The romanticism of the young royalists of the *Muse française*, like the romanticism of the young liberals of the *Globe*, was conceived in opposition to the neoclassic fossils in all political camps" (p. 29).

A realignment of political sympathies in the conservative romantic camp began after 1824, following Chateaubriand's expulsion from the ministry, in June, and his subsequent joining of the Liberal opposition. This initiated a political rap-

prochement between royalist and Liberal romantics which culminated with Hugo's adherence to Liberalism in the late 1820s.

10. "L'Académie française...s'est toujours attachée à l'ancien ordre des choses" and "La protection que l'aristocratie des lettres donne au genre classique guérira bien vite le public français de ce goût efféminé." Stendhal, *Courrier anglais*, vol. 2, pp. 62–3.

11. "Affiliation à l'ordre de l'écrevisse," *Le Miroir*, 5 March 1822, pp. 3–4.

12. "Réception d'un bonhomme de lettres," *Le Miroir*, 27 March 1821, pp. 3–4.

13. "...de proscrire l'usage d'une foule de mots et de tournures à double sens, à l'aide desquels la vérité se glissait d'une manière inattaquable dans les phrases les plus insignifiantes en apparence. Il représenta que l'équivoque était un rempart inexpugnable derrière lequel les idées de justice, de philosophie et de droit naturel parviendraient à se montrer sans péril..." "Dictionnaire des ignorants," *Le Miroir*, 9 March 1822, p. 3.

14. P. Larousse, *Grand dictionnaire universel du dix-neuvième siècle*, Paris and Geneva, 1982, vol. 2, pp. 968–9: "homme crédule, facile à abuser."

15. "Bon Homme, Bons Hommes: Depuis que la politesse a fait de bonté bêtise, la qualification de *bon* n'indique le plus souvent que l'absence de toute malice, ou, disons mieux, de tout esprit," *Le Miroir*, 27 February 1822, p. 3.

16. On the symbolism of the *bonnet de coton*, see the spoof essay "Chapitre des chapeaux (D'après un fragment retrouvé d'Aristote). Section première. Histoire des bonnets," *Le Miroir*, 21 July 1821, p. 3. Also, P. Larousse, *Grand dictionnaire*, vol. 2, p. 978.

17. "1. De bon sens tu te passeras et d'esprit scrupuleusement. 2. Sous l'éteignoir tu maintiendras la lumière attentivement. 3. Des philosophes médiras et des libéraux mêmement. 4. Jean-Jacques au feu condamneras et Voltaire pareillement. 5. En vers contre eux déclameras comme en prose éternellement. 6. Ce que point tu ne comprendras, tu venteras incessament. 7. Chateaubriand admireras, et Bonald exclusivement. 8. Une fois l'an les reliras par pénitence uniquement. 9. Fidèle à l'honneur tu seras très consciencieusement. 10. Et de couleur ne changeras que par intérêt seulement." "Décalogue des bons hommes de lettres," *Le Miroir*, 7 July 1821, p. 4.

18. The print exists in two slightly different versions, one earlier (Fig. 70a), of May 1821, and one later, of June 1821 (Fig. 70b). The latter was done, allegedly, by a copyist on a different stone, after the first stone was destroyed by accident. L. Delteil, *Le Peintre-graveur illustré*, vol. 3, Paris and New York, 1969, no. 31 and 31bis. See the commentary on the second print in "Lithographie. Un Bonhomme de lettres en méditation," *Le Miroir*, 27 June 1821, p. 2. Also, P. Burty (ed.) *Lettres de Delacroix*, Paris, 1878, p. 350; and M. Tourneux, "Croquis d'après nature. Notes sur quelques artistes contemporains par Philippe Burty", *Revue retrospective*, new series, 103–5, November 1892, p. 295.

The two prints are not identical. There are several changes between first and second version such as, for example, the replacement by a bow, in the second print, of the handle that transformed the

bonhomme's cotton bonnet into a seditious *éteignoir*. Although such differences can be attributed to the copyist's hand, their critical nature suggest a censor's intervention. The various states of the lithograph with a detailed account of the differences between the original and the ammended version are discussed by Adolphe Moreau, *Eugène Delacroix et son oeuvre*, Paris, 1873, pp. 70–1, no. 101. See also Alfred Robaut, *L'Oeuvre complet de Eugène Delacroix*, New York, 1969, no. 42.

Although I strongly suspect the intervention of censorhip here I have not been able to locate evidence that would confirm it.

19. Bonald's *Législation primitive* was considered the epitome of reaction in *Le Constitutionnel*, 17 March 1817, p. 3: "Un nouvel adversaire de Voltaire s'est mis sur les rangs dans le *Journal des débats*: c'est M. de Bonald, auteur de la *Législation primitive* et de quelques autres ouvrages où le despotisme est réduit en système. Cet écrivain qui a dépensé beaucoup de métaphysique en faveur du pouvoir arbitraire, a conçu une haine implacable contre les philosophes, et surtout contre l'auteur de la *Henriade* [i.e. Voltaire]. Il voudrait que le gouvernement prohibat toutes les nouvelles éditions de ses *Oeuvres complètes*...Les temps où la raison était une marchandise de contrebande sont un peu loin de nous, et nous n'y reviendrons pas plus qu'à ces époques d'intolérance religieuse que M. Bonald regrette si vivement."

Alluding to Academicians by means of suggestive nicknames or by citing their works was a common concealment device used by the *Miroir*. See, for example, "Confrérie des bonnes lettres," *Le Miroir*, 22 April 1821, p. 3; and "Nouveau dictionnaire de l'Académie," *Le Miroir*, 4 July 1822, p. 3.

20. Catholic missionaries roamed the provinces calling for "Guerre aux mauvais livres!" and setting up public burnings of books by the eighteenth-century *philosophes*. S. Charléty, *La Restauration*, vol. 4 of E. Lavisse's *Histoire de France contemporaine*, Paris, n.d., p. 133.

21. Marlborough's defeat of the French at Malplaquet (1709) inspired the popular song "Malbrough s'en va t'en guerre" which also carried Ancien Régime overtones: it was first sung at Versailles in the entourage of Queen Marie-Antoinette. P. Larousse, *Grand dictionnaire*, vol. 10, p. 1001.

22. See the essay "Les Perruques," *Le Miroir*, 16 May 1821, p. 3, a tongue-in-cheek history of wigs, wigstands, and wig-wearing, in which it was suggested that the Phrygian king Midas first used a wig to conceal his infamous donkey-ears, the proof to his stupid misjudgement. The *Miroir*, 3 January 1822, p. 2, offered a caricature depicting wigs, accompanied with a spoof explanation. A satirical piece on wigs also appeared in the magazine *Le Diable boiteux*, 4 September 1823, pp. 2–3.

23. "Rien n'est plus simple que cela: un gentilhomme de nom et d'armes...est militaire sans faire la guerre, de l'Académie sans savoir lire. 'La coutume en France ne veut pas,' dit Molière, 'qu'un gentilhomme sache rien faire,' et la même coutume veut que toute place lui soit dévolue, même celle de l'Académie" (p. 274). And "La noblesse, messieurs, n'est pas une chimère, mais quelque chose de très réel, très solide, très bon, dont on sait tout le prix...Car voyez ce que c'est et la différence qu'on fait du gentilhomme au roturier, dans le pays même de l'égalité, dans la république des lettres" (pp. 273–4). P. L. Courier, *Oeuvres complètes*, Paris, La Pléiade, 1951.

24. M. Sérullaz, *et al. Musée du Louvre. Cabinet des dessins. Inventaire générale des dessins. École française. Dessins d'Eugène Delacroix*, 2 vols, Paris, 1984, vol. 1, no. 756. Joubin has suggested that the younger Academician might be a self-portrait of Delacroix alluding, perhaps, to the painter's academic aspirations, which, as we know, were not fulfilled until 1857. A. Joubin, "Delacroix vu par lui-même", *Gazette des beaux-arts*, May–June 1939, p. 314.

25. Both prints were issued by Motte. Delteil (nos. 32 and 33), Moreau (nos. 93 and 94), Robaut (nos. 43 and 44). The *Grand Opéra* is discussed in the *Miroir*, 26 July 1821, p. 4; and *Théâtre italien*, in the *Miroir*, 13 August 1821, p. 2.

26. See L. H. Lecomte, *Napoléon et le monde dramatique*, Paris, 1912; L. H. Lecomte, *Histoire des théâtres de Paris 1402–1904*, Paris, 1905; and M. Carlson, *The French Stage in the Nineteenth Century*, Metuchen, NJ, 1972, especially the chapter "Neoclassicism and Melodrama", pp. 12–53.

27. Jules Guex, *Le Théâtre et la société française de 1815 à 1848*, Geneva, 1973, *passim*; and Henri D'Alméras, *La Vie parisienne sous la Restauration*, Paris, 1968, especially pp. 151 ff.

28. *Le Nain jaune*, 15 January 1815, 343, p. 72. According to the *Nain jaune*'s commentary, the *Grand Opéra* "...un Zephyr de soixante-ans, répand des pavots sur tout ce qui l'entoure avec une grâce et un esprit qui se trouvent plus communément, comme il le dit lui-même, dans ses jambes que dans sa physionomie."

29. On Vestris see Gaston Capon, *Les Vestris. Le "Diou de la dance" et sa famille 1730–1808*, Paris, 1908; Serge Lifar, *Auguste Vestris le dieu de la danse*, Paris, 1950; Firmin-Didot (ed.) *Nouvelle biographie générale*, vol. 46, Paris, 1870, columns 65–6; and P. Larousse, *Grand dictionnaire*, vol. 15, pp. 962–3.

30. "Si Auguste ne craignait pas d'humilier ses camarades, il resterait toujours en l'air." Cited in Firmin-Didot, *Nouvelle biographie générale*, column 65. Madame Vigée-Lebrun wrote in her *Mémoires*: "C'étoit le danseur le plus surprenant qu'on puisse voir, tant il avait à la fois de grâce et de légèreté. Quoique nos danseurs actuels n'épargnent point les pirouettes, personne bien certainement n'en fera jamais autant qu'il en a fait; puis tout à coup il s'élevait au ciel d'une manière si prodigieuse qu'on lui croyait des ailes." Cited in E. Campardon, *L'Académie royale de musique au XVIII siècle. Documents inédits découverts aux Archives Nationales*, vol. 2, Paris, 1884, p. 347.

31. P. Larousse, *Grand dictionnaires*, vol. 15, p. 963; and Campardon, *L'Académie royale de musique*, vol. 2, pp. 350–4.

32. Robaut, *L'Oeuvre complet*, no. 43.

33. F. Claudon, "L' Idée de l'influence de la musique chez quelques romantiques français et notamment chez Stendhal," Ph. D. diss. Lille, 1979. pp. 14 ff.; and J. Mongrédien, *La Musique en France des lumières au Romantisme 1789–1830*, Paris, 1986, pp. 61 ff.

34. "...rassasié des sublimes productions de Glück

qu'on lui donne depuis vingt-cinq ans, n'a rien entendu qui puisse les égaler." *Journal des spectacles*, 25 November 1801, cited in Mogrédien, *La Musique en France*, p. 71.

35. "La bonne société n'arrive plus à l' Opéra qu'au moment du ballet; on entend voler une mouche quand Vestris, Melle Clotilde, Mme Gardel dansent, on tousse, on crache, on jase, on minaude quand Alceste ou Iphigénie chantent." *Ibid.*

36. "La musique fait peu de progrès à ce théâtre...et Terpsichore à tout-à-fait envahi le domaine de Polymnie". *Le Miroir*, 9 October 1822, p. 2.

37. A. Soubiès, *Le Théâtre italien de 1801 à 1913*, Paris, 1913, *passim*; Claudon, "L' Idée de l'influence de la musique," pp. 34 ff; and Mongrédien, *La Musique en France*, pp. 106 ff.

38. H. Weinstock, *Rossini. A Biography*, New York, 1968. On Rossini's success in Restoration Paris, see also Soubiès, *Le Théâtre italien*, pp. 66 ff; Claudon, "L' Idée de l'influence de la musique"; and Mongrédien, *La Musique en France*, pp. 126 ff.

39. F. Claudon, "L'Idée de l'influence de la musique," pp. 55 ff.

40. "Il n' y a plus de bals sans qu'on y entende du Rossini. On ne danse plus sans la *Gazza Ladra*, on ne walse plus sans le *Barbiere*. Les détracteurs les plus déterminés du *Giovine di gran genio* ne peuvent pas disconvenir qu'il ne soit du moins le compositeur le plus dansant de l'époque." *Le Miroir*, 31 January 1822, p. 3.

41. "Le triste état de notre Grand Opéra...le peu de succès des dernières partitions de nos musiciens, la vogue qu'obtient Rossini, plus brillant que solide, tout concourt à l'empressement que le public a pour le Théâtre italien." *Le Miroir*, 23 February 1821, cited in Mongrédien, *La Musique en France*, p. 83.

42. Delacroix's passion for theater and music has been discussed in R. Duhamel, *Eugène Delacroix et la musique*, Milan, 1939; B. Farwell, "Sources for Delacroix's *Death of Sardanapalus*," *Art Bulletin*, March 1958, pp. 66 ff.; G. Mras, "Ut Pictura Musica: A Study of Delacroix's Paragone," *Art Bulletin*, September 1963, pp. 266 ff.; T. A. Regelski, *The Role of Music in the Paragon of Eugène Delacroix*, Ohio, 1971; R. Jullian, "Delacroix et la scène d'Hamlet au cimetierre," *Bulletin de la Société d'histoire de l'art français*, 1975, pp. 245–59; and Lee Johnson, "Delacroix, Dumas and Hamlet," *Burlington Magazine*, December 1981, 945, pp. 717 ff.

43. J. Stewart (ed.) *Eugène Delacroix. Selected Letters 1813–1863*, London, 1971, p. 68.

44. *Ibid.*, p. 69. Letter of 1 May 1820.

45. *Ibid.*, p. 100. Letter of 30 March 1821.

46. "Je n'ai que le regret de n'être pas plus musicien qu'italien." Letter of 27 October 1819. A. Dupont (ed.) *Eugène Delacroix. Lettres intimes*, Paris, 1954, pp. 70–3.

47. "Les Italiens, depuis des siècles, aiment la musique avec transport...La gaîté même que la musique bouffe sait si bien exciter n'est point une gaîté vulgaire qui ne dit rien à l'imagination. Au fond de la joie qu'elle donne, il y a des sensations poétiques, une rêverie agréable que les plaisanteries parlées ne sauraient jamais inspirer." R. Labourdette (ed.) *Eugène Delacroix. Journal 1822–1863*, Paris, 1980, p. 22. Entry of 7 September 1822.

48. See Delacroix's diary of 8 October 1822: "Jeudi dernier, j'avais vu *Tancrède* pour la troisième fois. J'y ai éprouvé bien du plaisir." (Labourdette, *Delacroix. Journal*, p. 28). Delacroix's enthusiasm for Rossini lasted throughout his life. In 1824 he attended Rossini's *Mosé in Egitto* twice, and even considered painting a picture inspired by it (*Ibid.*, pp. 54, 90). In April of that same year he saw *L'Italiana in Algeri* (*Ibid.*, p. 59) and *Tancredi* (p. 62). On 15 April 1853, disappointed by what he considered the crude realism of Courbet's paintings at the Salon, he exclaimed: "O Rossini! O Mozart! O les génies inspirés dans tous les arts, qui tirent des choses seulement ce qu'il faut en montrer à l'esprit! Que diriez-vous devant ces tableaux? (*Ibid.*, p. 328).

On the other hand, Delacroix's perennial opponent, Ingres, strongly disapproved of Rossini, whose music he dubbed "the work of an underbred man," according to Hector Berlioz, who harbored an equally passionate dislike for the Italian composer. Berlioz wrote: "As to Rossini and the rage for him which possessed the fashionable Parisian world, it aroused my passionate indignation, all the more because the new school was the antithesis of that of Glück and Spontini. I could conceive of nothing more grand, sublime, or true than the works of those great composers; and Rossini's melodious cynicism, his contempt for the traditions of dramatic expression...exasperated me to such a degree as to blind me to the real beauties of his masterpiece, the *Barbiere*...I used often to speculate on the possibility of undermining the Théâtre-Italien, so as to blow it and its Rossini worshippers into space. And when I met one of those hated *dilettanti*, I used to mutter to myself as I eyed him with a Shylockian glance, 'Would that I might impale thee on a red-hot stake, thou scoundrel!'" H. Berlioz, *Memoirs from 1803 to 1865*, New York, 1960, p. 50.

49. "Quand je vais au spectacle, aux Italiens surtout, vous pouvez penser si vous me faites faute. Cette Ronzi a toujours les beaux yeux que nous avons admirés tous deux." Letter of 26 January 1821. *Lettres de Eugène Delacroix*, Ph. Burty (ed.), vol. 1, Paris, 1880, p. 54.

50. "Que ces Italiens me plaisent! Je me consume, à Louvois, à écouter leur belle musique et à dévorer des yeux leurs délicieuses actrices. Nous avons une autre espèce de Ronzi à ce théâtre...C'est Mme Pasta. Il faut la voir pour se figurer sa beauté, sa noblesse et son jeu admirable." Letter of 15 September 1821, *ibid.*, p. 64.

51. R. L. Evans, *Les Romantiques français et la musique*, Bibliothèque de la Revue de littérature comparée, vol. 100, Paris, 1934, pp. 49 ff; and R. A. Seckold, "Stendhal devant le Romantisme en musique et en littérature," Ph. D. Diss., Melbourne, 1966, which I have not been able to consult. A useful critical bibliography charting the literature on the subject of Stendhal's relation to music, including Seckold, is provided by H. C. Jacobs, *Stendhal und die Musik*, Bonner Romanistische Arbeiten, no. 17, Frankfurt, 1983.

52. H. de Prunières, Preface to Stendhal's *Vie de Rossini*, vol. 1, Cercle du bibliophile, vol. 22, Geneva, 1968, p. xvii.

53. F.-J. Fétis, *Biographie universelle des musiciens*, vol. 1, Paris, 1873, pp. 388–91.

54. A. Eymery (ed.) *Dictionnaire des girouettes ou Nos Contemporains peints d'après eux-mêmes...par une société de girouettes*, Paris, 1815, p. 44. Berton is awarded four "girouettes' for having undergone an equal number of political shifts.

55. Berton's three articles appeared in *L'Abeille*, 3, Paris, 1821, pp. 149–56, 195–206, 292–8. On the Berton–Stendhal controversy see J. Mongrédien, "A propos de Rossini: Une polémique Stendhal–Berton", in *Stendhal e Milano: Atti del 14e Congresso Internazionale Stendhaliano* (Milan 1980), Florence, 1982, pp. 673 ff.

56. "...une profusion sans bornes de moyens accessoires et incohérens entre eux, par une succession spontanée de motifs sans liaison et étrangers les uns aux autres, et enfin par une violation presque totale des convenances dramatiques." *L'Abeille*, 3, 1821, p. 293.

57. "...la grosse artillerie, des trompettes, trombones, timbales et tams-tams, viennent incessament envahir le théâtre et le faire courber sous le joug impérieux des lois de l'orchestre, le tout pour la plus grande gloire de l'art dramatique et pour produire ce qu'on appelle de l'effet." *Ibid.*, p. 294.

58. On the early nineteenth-century critical debate regarding the term and concept of "classique," its dual significance – laudatory (works and artists to be used as models) and pejorative (unthinking and repetitive latter-day emulators such as J. L. David's followers) – and its ambiguous relationship with its presumed opposite, "romantique," see J. J. Whiteley, "The Origin and the Concept of 'classique' in French Art Criticism," *Journal of the Warburg and Courtauld Institutes*, 39, 1976, pp. 268 ff. Also, J. H. Rubin, "'Pygmalion and Galatea': Girodet and Rousseau," *Burlington Magazine*, August 1985, pp. 517 ff.

On Stendhal's ambivalent attitude toward his contemporary classicism see F. Claudon, "Stendhal et le néo-classicisme", in *Stendhal et le Romantisme. Actes du 15e Congrès International Stendhalien* (Mainz 1982), Aran (Switzerland), 1984, pp. 191 ff. Claudon argues that in real life Stendhal opted for a romantic art that was, in fact, a modified version of classicism, an art uniting classical form and romantic sentiment (a "new classicism," or a "romantic classicism"). Characteristically, his preferred "romantic" artist was Canova.

On Stendhal's aesthetic theory, A. Brookner, *Genius of the Future*, London and New York, 1971, pp. 33 ff.; D. Wakefield, *Stendhal and the Arts*, London, 1973; D. Wakefield, "Art Historians and Art Critics: Stendhal," *Burlington Magazine*, December 1975, pp. 803 ff.; and E. J. Talbot, *Stendhal and Romantic Esthetics* (French Forum Monographs, no. 61), Lexington, KY, 1985, especially pp. 142 ff.

59. "M. Berton ne se contente pas d'admirer les anciens, il s'efforce encore de les imiter." *Le Miroir*, 11 August 1821, p. 2. Stendhal reprinted his two *Miroir* letters, as well as one of Berton's *Abeille* essays, in a long note of his *Vie de Rossini*, vol. 1, Geneva, Cercle du bibliophile, 1968, pp. 129–35.

60. "...musiciens anatomistes pour qui le mérite de l'originalité, de l'esprit, et de la verve dramatique disparaît devant l'irrégularité d'un finale ou les imperfections d'un quintetti." *Le Miroir*, 5 August 1821, p. 2. Stendhal's term "musiciens anatomistes" for Academy composers may be an unconscious hint at the eighteenth-century perception of music as an exact science, comparable to medicine, rather than as an art. This accounted for the fact that, in the Ancien Régime organization of the Academy, music was part of the Académie des Sciences, whose members also included doctors-anatomists. A. Cohen, *Music in the French Royal Academy of Sciences. A Study in the Evolution of Musical Thought*, Princeton, 1981.

61. "Il n'attend pas pour s'émouvoir qu'il y soit autorisé par les puristes de la rue Bergère, et ses bravos sont indépendants de la justesse du contrepoint." *Le Miroir*, 5 August 1821, p. 2.

62. "Qu'il y ait ailleurs plus d'harmonie musicale, un style plus sévère et plus correct, une obéissance plus scrupuleuse aux règles de la composition, toutes ces qualités sont, pour l'effet dramatique, d'utiles auxiliaires, mais elles ne le constituent pas essentiellement...Quand je vais au spectacle je cherche le rire ou l'émotion." *Ibid.*, 11 August 1821, p. 3. On the role of expression in Stendhal's aesthetic theory, see M. Iknayan, *The Concave Mirror. From Imitation to Expression in French Esthetic Theory 1800–1830*, (Stanford French Italian Studies, vol. 30), Saratoga, NY, 1983.

63. "Que Mozart soit plus riche et plus harmonieux, Pergolese plus fini et plus correct, Sacchini plus suave et plus pur, tout cela peut être vrai sans que le public et moi nous ayons tort de trouver que Rossini se met mieux en rapport avec notre intelligence, et possède plus intimement le secret de nos goûts et de nos impressions. Il y a dans la musique de Rossini je ne sais quoi de vivant et d'actuel qui manque aux magnificences de Mozart." *Le Miroir*, 5 August 1821, p. 2.

64. "Le travail de composition n'est rien pour lui." Alceste (pseudonym for Stendhal), "Rossini," *Paris Monthly Review of British and Continental Literature*, January 1822, reprinted in Stendhal, *Courrier anglais*, vol. 1, p. 282. The *Paris Monthly Review* was founded in 1822. It contained materials in both English and French (Stendhal's article was written in French). In 1823 the review was absorbed by *Galignani's Monthly Review and Magazine*.

On the "vegetable" metaphor for romantic genius see M. H. Abrams, *The Mirror and the Lamp. Romantic Theory and the Critical Tradition*, Oxford, 1964, especially pp. 198 ff.

65. "Son portemanteau plus rempli de papiers de musique que de linge fin et d'objets de valeur..." Alceste (Stendhal), "Rossini," *Paris Monthly Review*, p. 285.

66. "A Bologne, M. Gherardi répondait aux déclamations des pédants, qui reprochaient amèrement à Rossini des infractions nombreuses aux règles de la composition: 'Qui a fait ces règles? Sont-ce des gens supérieurs en génie à l'auteur de *Tancrède*?'" Stendhal, *Vie de Rossini*, vol. 1, p. 127.

67. P. Martino, Preface to Stendhal, *Racine et Shakspeare*, in *Oeuvres complètes*, vol. 37, Cercle du bibliophile, Geneva, 1970, pp. lxxxi ff. R. A. Seckold, "Stendhal devant le Romantisme", also writes: "A ses yeux, toutes les influences conservatrices ultras dans la société se rengeaient néces-

sairement du côté des pédants et des classiques"; and ". . . pour cet homme aux partis pris violents, le romantisme était synonyme du libéralisme, tandis que le classicisme voulait dire royalisme et conservatisme religieux." Cited in H. Jacobs, *Stendhal und die Musik*, p. 165. One will also remember, here, Stendhal's opening statement in his review of the Salon of 1824: "Mes opinions, en peinture, sont de l'extrème gauche." Stendhal, *Mélanges d'art*, Paris, le Divan, 1932, p. 6. More generally, see M. Brussaly, "The Political Ideas of Stendhal", Ph.D. Diss., Columbia University, New York, *c.* 1933; M. Gordon-Brown, *Les Idées politiques et religieuses de Stendhal*, Paris, 1939; and F. Rudé, *Stendhal et la pensée sociale de son temps*, Paris, 1967. Also, J. H. Rubin, *Eugène Delacroix. Die DanteBarke. Idealismus und Modernität*, Frankfurt, 1987, discusses Stendhal's modernism and progressive politics in relation to the imagery and style of Delacroix's *Barque of Dante* of 1822.

68. ". . . les partisans de l'ancien régime musical." *Le Miroir*, 5 August 1821, p. 2.

69. "Les rigoristes de Bologne, célèbres en Italie, et qui jouent en musique à peu près le même rôle que les membres de l'Académie française pour les trois unités. . ." Stendhal, *Vie de Rossini*, vol. 1, p. 126.

70. "Depuis la mort de Napoléon, il s'est trouvé un autre homme duquel on parle tous les jours à Moscou comme à Naples, à Londres comme à Vienne, à Paris comme à Calcutta.

 La gloire de cet homme ne connait d'autres bornes que celles de la civilisation, et il n'a pas trente-deux ans!" *Ibid.*, p. 3.

71. F. Schiller, *Naive and Sentimental Poetry and On the Sublime*, trans. and ed. J. Elias, New York, 1966, p. 96.

72. "Nous ne savons pas si le grand Opéra se vouera un peu plus au culte de Polymnie. . . mais comme jusqu'à ce jour, il n'a guère voulu sacrifier qu'à Terspicore, nous le présentons au public appuyé sur ses ballets." *Le Miroir*, 26 July 1821, p. 4.

73. In his essay on Rossini, in *La Presse*, 8 November 1852, Gautier wrote: "Il ne réfléchit pas plus pour faire un opéra qu'un oranger pour arrondir et dorer une orange; seulement il y met moins de temps, c'est son fruit naturel." Cited in Evans, *Les Romantiques français et la musique*, p. 124.

74. Sérullaz *et al.*, *Dessins d'Eugène Delacroix*, vol. 1, no. 792. Sérullaz considers this to be a drawing for Delacroix's caricature *Artistes dramatiques en voyage*, although no figure in the print is directly linked to the drawing.

75. Delteil (no. 28), Moreau (no. 92) and Robaut (no. 6) date the print variously as 1816 and 1818. Laran has conclusively demonstrated that it dates, instead, to 1819. "Péchés de jeunesse d'Eugène Delacroix", *Gazette des beaux-arts*, series 6(3), 1930, p. 59.

 Delacroix's ideas about classicism, expressed in the metaphorical setting of the theater, may also underlie one of two caricatures he did in 1817 on the theme of the Calicots, *Retour de Calicot* (right, top) and *M. Calicot à la réforme* (right, bottom). The Calicots were fabric-store employees (and the heroes of a vaudeville by Scribe and Dupin, *The War of the Mountains or The Folie Beaujon*, performed in 1817 at the *Théâtre des Variétés*) who became

objects of ridicule in Restoration society with their attempts to give a fashionably military look to their appearance by borrowing the attributes of Napole-

Delacroix, *Le Retour de Calicot ou Les Calicots n'ont pas fait baisser la toile*, 1817. Etching, Paris, Bibliothèque Nationale, Cabinet des Estampes.

Delacroix, *M. Calicot à la réforme*, 1817. Etching, Paris, Bibliothèque Nationale, Cabinet des Estampes.

onic officers: moustaches, boots and spurs. Consequently the name "Calicot" came to mean impostor and false modernist.

In Delacroix's *M. Calicot à la réforme*, Calicot's sham modernism is unmasked by actors in ancient costume who symbolize reactionary classicism. One actor wraps his arm around the shoulders of the downcast Calicot, as if to suggest that they are alike, exponents of the same reactionary spirit.

The two Calicot prints were identified as the works of Delacroix by Jean Laran, who also dated them 1817, based on the Dépôt Légal register ("Péchés de jeunesse d' Eugène Delacroix," pp. 57–8). On the Calicots, Ed. de Keyser, "Un Thème de l'imagerie parisienne sous la Restauration. Le Combat des montagnes et la guerre des calicots," *Le Vieux Papier*, Paris, 1964, pp. 1–12; and Th. Muret, *L'Histoire par le théâtre 1789–1851*, vol. 2, Paris, 1865, pp. 103 ff.

76. "...cette nouvelle agression des détracteurs de l'ancien régime musical." *Le Miroir*, 13 August 1821, p. 2.

77. "Théâtre italien," *Le Miroir*, 19 February 1821, p. 4.

78. See A. Jardin and A. J. Tudesq, *Restoration and Reaction 1815–1848*, Cambridge, New York and Paris, 1983, pp. 89 ff. for a broader outlook on the relation of Italian to French music since the eighteenth century.

79. "Le plus tôt possible serait certainement le mieux; car notre Grand Opéra est menacé d'une éclipse totale; il n'y a que Rossini qui puisse lui rendre de l'éclat et de la chaleur." Cited in Mongrédien, *La Musique en France*, p. 85.

80. Mongrédien, "A propos de Rossini", p. 678. See also the articles, "Entrée triomphale de Rossini à Paris," *Le Diable boiteux*, 2 November 1823, p. 3; "Conspiration Rossiniste," *ibid.*, 15 November 1823, p. 3; and "Grand dîner du veau qui tète," *ibid.*, 18 November 1823, p. 2.

81. Weinstock, *Rossini*, pp. 130 ff.; Mongrédien, *La Musique en France*, p. 132.

82. F. Claudon, "Stendhal et le néo-classicisme," *passim*.

83. "Il y a un *Massacre de Scio* de M. Delacroix, qui est en peinture ce que les vers de MM. Guiraud et de Vigny sont en poésie, l'exagération du triste et du sombre. Mais le public est tellement ennuyé du genre académique et des copies de statues si à la mode qu'il s'arrête devant les cadavres livides et à demi terminés que nous offre le tableau de M. Delacroix." Stendhal, "Salon de 1824," in *Mélanges d'art*, Paris, Le Divan, 1932, p. 18.

CHAPTER 7 The Comic as Dissent and Modernity

1. J. Stewart (ed.) *Eugène Delacroix. Selected Letters 1813–1863*, London, 1971, pp. 36–7.

2. Delacroix's narrative reflects the chapters "The Temptation" and "The Conquest," from Sterne's *A Sentimental Journey through France and Italy*. Delacroix's "Eliza" is his sister's English maid Elisabeth Salter, with whom he was in love. Given that Yorick's "Eliza" referred to Sterne's real-life beloved, Elisabeth Draper, it is possible that through the fictive Yorick, Delacroix may have identified

with Laurence Sterne himself who, like him, suffered chronic ill-health and pursued unhappy love affairs. For a study of the character of Yorick in Sterne's novels see Henri Fluchère, *Laurence Sterne: From Tristram to Yorick. An Interpretation of Tristram Shandy*, London, 1965, *passim* and pp. 344 ff.

3. On the popularity of English literature in France after 1815, see E. Partridge, *The French Romantics' Knowledge of English Literature 1820–1848*, New York, 1968. Partridge mentions that Sterne's *Sentimental Journey* was translated into French in 1801, and was followed, in 1818, by a translation of Sterne's complete works (pp. 40–1). Also, in 1800, a stage adaptation of Sterne's *Tristram Shandy* was produced in a Paris theater (p. 26).

Delacroix, who could read English, may have read Sterne in the original.

4. G. H. Hamilton, "Eugène Delacroix and Byron, I," *Gazette des beaux-arts*, February 1943, pp. 99–110; and "Hamlet or Childe Harold? Delacroix and Byron, II," *Gazette des beaux-arts*, July–December 1944, pp. 365–86.

5. G. R. Ridge, *The Hero in French Romantic Literature*, Athens, GA, 1959; and L. Bishop, *The Romantic Hero and his Heirs in French Literature*, American University Studies, Series 2. Romance Languages and Literature, vol. 10, New York, 1984.

6. Stewart (ed.) *Delacroix. Selected Letters*, pp. 60–1.

7. "Là, à la lumière de la chandelle toute unie, on s'établit sur une table où l'on s'appuie les coudes, et on boit et mange beaucoup, pour avoir beaucoup de ce bon esprit d'homme échauffé..." E. Moreau-Nélaton, *Delacroix raconté par lui-même*, vol. 1, Paris, 1916, p. 39.

8. M. Sérullaz et al., *Musée du Louvre. Cabinet des dessins. Inventaire général des dessins. École française. Dessins d'Eugène Delacroix*, 2 vols, Paris, 1984, vol. 2, no. 1739 (RF 9140).

9. Illustrated and discussed in A. Boime, "Jacques-Louis David, Scatological Discourse in the French Revolution, and the Art of Caricature," in *French Caricature and the French Revolution, 1789–1799*, exhib. cat., Los Angeles, 1988, pp. 67 ff.

10. Lynn Hunt, "The Political Psychology of Revolutionary Caricatures", in *French Caricature and the French Revolution, 1789–1799*, exhib. cat., Los Angeles, 1988, p. 38. Similar images are also to be found on pp. 189–91 of the catalog.

11. H. Bessis, "L'Inventaire après décès d'Eugène Delacroix," *Bulletin de la Société de l'histoire de l'art français* (1969), Paris, 1971, p. 211, no. 39.

12. For Delacroix's drawings copying English cartoonists, see Sérullaz et al., *Dessins d'Eugène Delacroix*, vol. 2, ch. "D'après les maîtres anglais," pp. 37 ff., nos. 1302–11.

13. W. Hazlitt, "Lectures on the Comic Writers, etc. of Great Britain," (1819), in P. P. Howe (ed.), *The Complete Works of William Hazlitt*, vol. 6, London and Toronto, 1931, pp. 5 ff.; and Hazlitt, "On Modern Comedy," (1817), *ibid.*, vol. 4, 1930, pp. 10 ff. Also J. Kinnaird, *William Hazlitt. Critic of Power*, New York, 1978, p. 233: "The Modern Difference: Comedy and the Novel."

14. From Jean-Paul's *Vorschule der Aesthetik* (1804), translated in P. Lauter, *Theories of Comedy*, New York, 1964, pp. 319, 321.

15. F. Schiller, *Naive and Sentimental Poetry and On the*

Sublime, trans. and ed. J. Elias, New York, 1966, pp. 120–2. Schiller writes: "Even if tragedy proceeds from a more significant point, one is obliged to concede, on the other hand, that comedy proceeds toward a more significant purpose and it would, were it to attain it, render all tragedy superfluous and impossible."

16. A. W. Schlegel, *Cours de littérature dramatique*, vol. 1, Paris and Geneva, 1814, pp. 365–8.

17. *Ibid.*, vol. 3, p. 5. Schlegel writes about Shakespeare's comedies: "Aucune ne se renferme entièrement dans le cercle des relations domestiques et bourgeoises, toutes ont une parure poétique et quelques unes entrent dans la région du merveilleux."

18. F. Guizot, "Shakespeare and his Times," in St Mellon (ed.) *François Guizot. Historical Essays and Lectures*, Chicago and London, 1972, pp. 116–17.

19. F. Guizot, *Shakespeare and his Times*, London, 1852, pp. 86–7. The original French title of Guizot's essay was *Notice biographique et littéraire sur Shakspeare*.

20. Germaine de Staël, *De l'Allemagne*, vol. 2, Paris, Garnier, 1967, pp. 22 ff. On de Staël's relationship to A. W. Schlegel, L. M. Pange (comtesse Jean de), *Auguste-Guillaume Schlegel et Madame de Staël d'après des documents inédits*, Paris, 1938, *passim*.

21. A. W. Schlegel, *Cours de littérature dramatique*, vol. 1, pp. 367–68: "Ce genre ["avowed comic"] suppose toujours un personnage en quelque manière double, dont la moitié raisonnable qui plaisante l'autre moitié, a dans son humeur et son emploi assez de rapport avec l'auteur comique lui-même. Celui-ci se transporte tout entier dans ce représentant, il le charge de se dessiner en caricature bien prononcée, et d'entretenir une intelligence secrète avec les spectateurs, pour se moquer ensemble des autres personnages... Le bouffon privilégié, (car presque tous les théâtres en ont un, tantôt fin et spirituel, tantôt épais et balourd) a hérité quelque chose de l'inspiration, de l'abandon plein de franchise, et de la liberté de tout dire, qu'avoient à un si grand degré les premiers poètes comiques."

22. W. Kayser, *The Grotesque in Art and Literature*, New York and Toronto, 1966, pp. 98 and 200–1 (note 37); and G. Roeth, "Brentano's Ponce de Leon, eine Saeculärstudie," *Abhandlungen des Königlichen Gesellschaft der Wissenschaften zu Göttingen*, new series 5 (I) Berlin, 1904, pp. 14 ff.

23. Schlegel, *Cours de littérature dramatique*, vol. 3, p. 12.

24. "Dans la pensée des Modernes...le grotesque a un rôle immense. Il y est partout"; and "...ce germe de la comédie recueilli par la muse moderne." V. Hugo, *Cromwell*, Paris, Garnier, 1968, pp. 71, 73. Also, M. Bakhtin, *Rabelais and his World*, Cambridge, MA, 1965, pp. 30 ff. and *passim*; Kayser, *The Grotesque*, *passim*, and pp. 48 ff.: "The Grotesque in the Age of Romanticism," and G. G. Harpham, *On the Grotesque. Strategies of Contradiction in Art and Literature*, Princeton, 1982.

25. F. Schlegel, "Letter about the Novel" in *Dialogue on Poetry and Literary Aphorisms*, ed. and trans. E. Behler and R. Struc, University Park and London, 1968, p. 95. Schlegel's "Letter" was part of his essay "Dialogue on Poetry" (*Gespräch über die Poesie*) published in 1799 in the last volume of the *Athenaeum*, a landmark journal for early romantic aesthetic issued by the Schlegels.

26. Schlegel, *Dialogue on Poetry*, p. 104. Present in Western culture since antiquity, in the romantic age the taste for the grotesque was transformed into a vehicle of private world view. In Bakhtin's words, it became "the expression of subjective, individualistic world outlook very different from the carnival folk concept of previous ages, although still containing some carnival elements." *Rabelais and his World*, p. 36.

27. Schiller, *Naive and Sentimental Poetry*, p. 124.

28. Schlegel, *Dialogue on Poetry*, pp. 95–6.

29. Laurence Sterne, *The Life and Opinions of Tristram Shandy, Gentleman*, Harmondsworth, 1967, pp. 56–7.

30. Schlegel, *Dialogue on Poetry*, pp. 96–7.

31. "Karikatur ist eine passive Verbindung des Naiven und Grotesken. Der Dichter kann sie eben so wohl tragisch als komisch gebrauchen." Cited in K. K. Polheim, *Die Arabeske. Ansichten und Ideen aus Friedrich Schlegel's Poetik*, Munich, Paderborn and Vienna, 1966, p. 31.

32. G. M. Moinet, "La Quête de la comédie chez Stendhal," in *Stendhal et l'Allemagne, Actes du 13ᵉ Congrès International Stendhalien* (Brunswick, Germany, 1978), Paris, 1983, pp. 135 ff.

33. "Qu'est ce que le rire? Hobbes répond: Cette convulsion physique, que tout le monde connait, est produite par la vue imprévue de notre superiorité sur autrui." Cited in Moinet, "La Quête de la comédie chez Stendhal," p. 136. On Hobbes's ideas in the context of theories of laughter and the comic, see Willard Smith, *The Nature of Comedy*, Boston, 1930, pp. 37 ff.

34. "La caricature montrant un mari chargé du petit chien qui s'échappe, du parapluie, de la petite fille etc., etc., fait rire de la même manière que telle situation comique de Molière, ou que dans un ballet comique un important qui en voulant faire de la dignité tombe et se casse le nez." Stendhal, "Traité de l'art de faire des comédies," in *Molière, Shakspeare, la comédie et le rire*, Paris, Le Divan, 1930, p. 232.

35. "Parmi nous, l'homme ridicule serait celui qui, méprisant et négligeant les richesses, prendrait une autre voie pour arriver au bonheur, et se tromperait." Stendhal, *Pensées. Filosofia nova*, vol. 2, Paris, Le Divan, 1931, p. 10.

36. "Quelque chose d'aérien, de fantastique dans le comique, quelque chose qui donne des sensations analogues à celles que produit la musique...Pour que ce genre de gaîté me plaise il ne faut pas que le bel esprit ivre songe à tous moments qu'il fait de jolis choses...Je veux que l'auteur soit un homme heureux par une grande imagination qui s'amuse, qui soit dans un doux délire." Stendhal, "Traité de l'art de faire des comédies," pp. 264–5.

37. Cited by H. Martineau in his preface to Stendhal, *Théâtre*, vol. 1, Paris, Le Divan, 1931, p. xii.

38. Moinet, "La Quête de la comédie chez Stendhal," p. 145.

39. "Ces pauvres gens allèguent le prétexte gothique et peu académique qu'ils veulent conserver le privilège de dire sur toutes choses ce qui leur semble la vérité. Ils ajoutent...cette maxime dangereuse, subversive de toute décence en littérature: RIDENDO DICERE VERUM QUID VETAT? *Ce qui nous semble vrai pourquoi ne pas le dire en riant?*"

Stendhal, *Racine et Shakspeare*, Paris, Le Divan, 1928, p. 69.

40. "Voilà le sens dans lequel moi, poète comique, je dois travailler pour être utile à la nation, en détruisant la prise des tyrans sur elle, et la rapprochant par-delà de la divina libertà." Stendhal, *Pensées*, vol. 2, p. 9.

41. Stendhal, *Courrier anglais*, vol. 2, Paris, Le Divan, 1935, p. 356.

42. "...petits écrits éphémères, ces papiers qui vont de main en main, et parlent aux gens d'à présent des faits, des choses d'aujourd'hui." P. L. Courier, "Pamphlet des pamphlets," in *Oeuvres complètes*, La Pléiade, Paris, 1951, p. 212.

43. Cited in M. Souriau, *Histoire du romantisme en France*, vol. 1, Geneva, 1973, p. 6.

44. "Oui, des sottises, des calembours, de méchantes plaisanteries." Courier, "Pamphlet des pamphlets," p. 211.

45. "...ce jargon, ce ton de cour, infectant le théâtre et la littérature sous Louis XIV et depuis, gâtèrent d'excellents esprits..." P. L. Courier, "Fragments d'une traduction nouvelle d'Hérodote," in *Oeuvres complètes*, p. 497.

46. "Le style de M. Courier, rapide, concis, plaisant, *naif*, et intelligible pour l'esprit le plus humble aussi bien que pour le plus élevé, fait un contraste singulier avec la manière ambitieuse, académique, et parfois obscure de M. Chateaubriand." Stendhal, *Courrier anglais*, vol. 2, p. 357.

47. Cited in Moïse le Yaouanc, "Le Romantisme du libéral Béranger," in *Romantisme et politique 1815–1851. Colloque de l'École Normale Supérieure de Saint-Cloud (1966)*, Paris, 1969, p. 63.

48. "Ce que la comédie de l'époque a de plus romantique..." Stendhal, *Racine et Shakspeare*, pp. 48–9.

49. "Procès fait a M. P. J. de Béranger," in P. J. Béranger, *Oeuvres complètes*, vol. 3, Paris, H. Fournier aîné, 1836, p. 217.

50. "I thus abandon Thalia and Melpomene/ For the song, free despite the kings./ Without ruling it, I increase its territory;/ Others one day will draft its laws./ That in a republic we can still live,/ This is a state that is not without pleasure./ Poor Frenchmen, O! may God deliver you/ At least deliver you of the censor." "Le Censeur," in P. J. Béranger, *Oeuvres complètes*, vol. 2, p. 185.

51. Béranger's poems did, in fact, inspire a number of caricatures. One such caricature, according to Champfleury, appeared in *La Minerve* of 1819. It represented black-clad missionaries burning books and holding up candle-snuffers, and was inspired by Béranger's poem *Les Missionnaires* (1819). Champfleury, *Histoire de la caricature sous la République, l'Empire et la Restauration*, Paris, 1874, p. 325.

52. On the deliberately coarse and popular language of Béranger's poems as a feature of modernism see Le Yaouanc, "Le Romantisme du libéral Béranger," pp. 70–1. Le Yaouanc argues that this was one of the aspects in which Béranger's poetry championed the literary innovations associated with romanticism, and that in fact, his unassuming works were ahead of, and even inspired, major exponents of the movement, such as Victor Hugo.

53. "1o Un esprit extrêmement vif./ 2o Beaucoup de grâces dans les traits./ 3o L'oeil étincelant, non pas du feu sombre des passions, mais du feu de la saillie.../ 4o Beaucoup de gaîté./ 5o Un fonds de sensibilité./ 6o Une taille svelte, et surtout l'air agile de la jeunesse." Stendhal, *Histoire de la peinture en Italie*, vol. 2, Paris, Le Divan, 1929, p. 156.

54. Guizot, *Shakspeare and his Times*, pp. 27 and 29.

55. "Rossini a l'esprit vif et ardent, sensible aux plus légères impressions..." Alceste (Stendhal), "Rossini," *Paris Monthly Review*, January 1822, reprinted in Stendhal, *Courrier anglais*, vol. 1, p. 281.

56. "Le directeur du théâtre à qui on le destinait n'avait qu'une très médiocre opinion du compositeur, tant à cause de son extrême jeunesse que de son excessive gaîté qui ne différait en rien de l'insouciante espièglerie d'un écolier." *Ibid*, p. 273.

57. J. Starobinski, "Note sur le bouffon romantique," *Cahiers du sud*, 53 (387–8), 1966, pp. 270 ff.; and *Portrait de l'artiste en saltimbanque*, Geneva, 1970. Also, L. Jones, *Sad Clowns and Pale Pierrots. Literature and the Popular Comic Arts in Nineteenth Century France*, Lexington, KY, 1984.

58. The manifesto for such aesthetic alliances was Victor Hugo's Preface to his play *Cromwell*, of 1827. See Hugo, *Cromwell*, with an excellent introduction by Annie Ubersfeld. In his Preface, Victor Hugo magisterially summed up ideas from various international sources that had been "in the air" since the eighteenth century. M. Souriau, *La Préface de Cromwell*, Geneva, 1973.

59. Trapp, for example, noticed the similarity between the figure of the flying Mephistopheles, in Delacroix's opening lithograph for Goethe's *Faust*, and the winged demon leading away the chariot of the censors in *Le Déménagement*. F. A. Trapp, *The Attainment of Delacroix*, Baltimore and London, 1971, p. 146, n. 22.

60. L. Rudrauf, "De la Bête à l'ange. Les étapes de la lutte vitale dans la pensée et l'art d'Eugène Delacroix," *Acta Historiae Artium Academiae Scientiarum Hungaricae*, vol. 9 (3–4), 1963, pp. 295–341. A similar ideological position also governed Delacroix's major paintings of the 1820s inspired by the Greek-Turkish war, as I have shown in my *French Images from the Greek War of Independence 1821–1830: Art and Politics under the Restoration*, New Haven and London, 1989, *passim*.

61. G. Mras, *Eugène Delacroix's Theory of Art*, Princeton, 1966, pp. 105 ff.

62. F. D. Klingender, *Hogarth and English Caricature*, exhib. cat., London and New York, 1946, pp. 22–3.

63. Like his fellow-Italian, Rossini, Paganini rose to fame in France in the early 1820s. For this, see *Le Miroir*, 21 January 1822, p. 3. For a thorough and insightful entry on the picture, see L. Johnson, *The Paintings of Eugène Delacroix. A Critical Catalogue*, vol. 1, Oxford, 1981, no. 93.

EPILOGUE

1. R. J. Goldstein, *Censorship of Political Caricature in Nineteenth-Century France*, Kent (Ohio) and London, 1989, pp. 99–118.

2. M. Tourneux, "Croquis d'après nature. Notes sur quelques artistes contemporains par Philippe Burty," *Revue retrospective*, new series, nos. 103–5, November 1892, pp. 297–8.

3. Delacroix "Charlet," in A. Piron, *Eugène Delacroix. Sa vie et ses oeuvres*, Paris, 1865, pp. 362 ff. The article first appeared in the *Revue des deux mondes* of July 1862. Burty also reported: "Il professe un véritable culte pour Charlet: il a prononcé, à plusieurs reprises, les mots *gigantesque, homme de génie, grand homme,* un *des plus grands artistes.*" Tourneux, "Croquis d'après nature," p. 297. According to Burty, Delacroix would have further said that Charlet's importance came from the fact that he used the lithographic medium in the most appropriate fashion: he emphasized its potential to suggest emotion and capture the artist's thought, rather than produce technical perfection.

4. "Il est impitoyable pour l'affectation et la fausse sensibilité...Encore moins a-t-il été un homme de salon: la robuste complexion de son esprit ne pouvait s'accomoder de cette singulière société qui ne vit qu'aux bougies et qui ne voit la nature qu'à travers l'Opéra, qui méprise Rubens et trouve le beau dans les poses d'une danseuse." Delacroix, "Charlet," p. 373.

5. In his Preface to *Cromwell*, Victor Hugo specifically linked naturalism, Rubens and the grotesque as part of the romantic aesthetic: "Il y aurait, à notre avis, un livre bien nouveau a faire sur l'emploi du grotesque dans les arts. On pourrait montrer quels puissants effets les Modernes ont tiré de ce type fécond, sur lequel une critique étroite s'acharne encore de nos jours...Nous dirons seulement ici que, comme objectif auprès du sublime, comme moyen de contraste, le grotesque est selon nous, la plus riche source que la nature puisse ouvrir à l'art. *Rubens* le comprenait sans doute ainsi..." V. Hugo, *Cromwell*, Paris, Garnier, 1968, p. 72.

6. Ch. Rosen and H. Zerner, *Romanticism and Realism. The Mythology of Nineteenth Century Art*, New York, 1984, *passim*.

7. See also Ainslie Armstrong McLees, *Baudelaire's "Argot Plastique." Poetic Caricature and Modernism*, Athens (Georgia) and London, 1989, in which the author suggests that in his poems Baudelaire actually embraced the themes, strategies and structures of contemporary graphic satire as a means of achieving a modernist aesthetic.

8. "...professeurs jurés de sérieux, charlatans de la gravité, cadavres pédantesques sortis des froids hypogées de l'Institut, et revenus sur la terre des vivants, comme certains fantômes avares, pour arracher quelques sous à de complaisants ministères? D'abord, diraient-ils, la caricature est-elle un genre? Non, répondraient leurs compères, la caricature n'est pas un genre. J'ai entendu résonner à mes oreilles de pareilles hérésies dans des dîners d'académiciens." Charles Baudelaire, "De l'essence du rire et généralement du comique dans les arts plastiques," *Oeuvres complètes*, La Pleiade, Paris, 1961, p. 976.

9. "...un bon dessin n'est pas une ligne dure, cruelle, despotique, immobile, enfermant une figure comme une camisole de force; que le dessin doit être comme la nature, vivant et agité; que la simplification dans le dessin est une monstruosité, comme la tragédie dans le monde dramatique." C. Baudelaire, "Exposition Universelle de 1855," *Oeuvres complètes*, p. 973.

10. "...une protestation perpétuelle et efficace contre la barbare invasion de la ligne droite, cette ligne tragique et systématique, dont actuellement les ravages sont déjà immenses dans la peinture et dans la sculpture?" *Ibid.*

SELECTED BIBLIOGRAPHY

Almeras, H. d' *La Vie parisienne sous la Restauration*, Paris, 1968.

André, R. *L'Occupation de la France par les alliés en 1815*, Paris, 1924.

(Anonymous), *Louvel au Luxembourg ou Le Songe*, Paris, 1820.

(Anonymous), *Notice curieuse et historique sur la vie de Louis Pierre Louvel*, Paris, 1820.

(Anonymous), *Louis Pierre Louvel devant la cour des pairs, ou Instruction du procès de l'exécrable assassin de S.A.R. Mgr le duc de Berri*, Paris, 1820.

Antoine, A. *Histoire des émigrés français depuis 1789 jusqu'en 1828*, 3 vols, Paris, 1828.

Athanassoglou-Kallmyer, N. "Sad Cincinnatus: The *Soldat Laboureur* as an Image of the Napoleonic Veteran after the Empire," *Arts Magazine*, May, 1986.

Athanassoglou-Kallmyer, N. *French Images from the Greek War of Independence 1821–1830: Art and Politics under the Restoration*, New Haven and London, 1989.

Bakhtin, M. *Rabelais and his World*, Cambridge (Mass.), 1965.

Barbin, M. and Cl. Bouret, *Inventaire du fonds français. Graveurs du XIX siècle*, vol. 15, Paris, 1985.

Baudelaire, Ch. *Oeuvres complètes*, La Pléiade, Paris, 1961.

Bénichou, P. *Le Sacre de l'écrivain 1750–1830. Essai sur l'avènement d'un pouvoir spirituel laïque dans la France moderne*, Paris, 1973.

Béranger, P. J. *Oeuvres complètes*, 3 vols, Paris, H. Fournier aîné, 1836-7.

Berlioz, H. *Memoirs from 1805 to 1865*, New York, 1960.

Bertier de Sauvigny, G. *The Bourbon Restoration*, Philadelphia, 1966.

Bessis, H. "L'Inventaire après décès d' Eugène Delacroix," *Bulletin de la Société de l'histoire de l'art français*, année 1969, Paris, 1971.

Bishop, L. *The Romantic Hero and his Heirs in French Literature* (American University Studies. Series 2. Romance Languages and Literature, vol. 10), New York, 1984.

Blum, A. *La Caricature révolutionnaire*, Paris, 1916.

Blum, A. "La Caricature politique en France sous la Restauration," *La Nouvelle revue*, 35, 1918.

Boilly 1761–1845, un grand peintre français de la Révolution à la Restauration, exhib. cat., Lille, 1988.

Boime, A. *The Academy and French Painting in the Nineteenth Century*, New Haven and London, 1986.

Bonnal, E. *Les Royalistes contre l'armée (1815–1820) d'après les archives du ministère de la guerre*, 2 vols, Paris, 1906.

Bouchot, H. *La Lithographie*, Paris, 1895.

Braudel, F and E. Labrousse eds, *Histoire économique et sociale de la France*, 4 vols, Paris, 1970–82.

Brookner, A. *Genius of the Future*, London and New York, 1971.

Brussaly, M. *The Political Ideas of Stendhal*, Ph.D. diss. Columbia University, New York, [1933].

Burty Ph. ed., *Lettres de Delacroix*, Paris, 1878.

Burty, Ph. ed. *Lettres de Eugène Delacroix*, 2 vols, Paris, 1880.

Carlson, M. *The French Stage in the Nineteenth Century*, Metuchen (New Jersey), 1972.

Centenaire d'Eugène Delacroix 1798–1863, exhib. cat., Paris, 1963.

Champfleury (Jules Fleury), *Histoire de la caricature sous la République, l'Empire, et la Restauration*, Paris, 1874.

Charléty, S. *La Restauration*, in E. Lavisse ed. *Histoire de France contemporaine*, vol. 4, Paris, 1921.

Chateaubriand, F. R. de "De Buonaparte et des Bourbons," in *Oeuvres complètes*, vol. 7, Paris, Garnier, n.d.

Chesneau, E. *La Peinture française au XIX siècle. Les Chefs d'école*, "Eugène Delacroix," Paris, 1872.

Claudon, F. *L'Idée de l'influence de la musique chez quelques romantiques français et notamment chez Stendhal*, doctoral diss., University of Paris IV (1977), Lille 1979.

Claudon, F. "Stendhal et le néo-classicisme," *Stendhal et le romantisme. Actes du 15e congrès international Stendhalien*, (Mainz, Germany, 1982), Aran (Switzerland), 1984.

Collins, I. *The Government and the Newspaper Press in France 1814–1881*, Oxford, 1959.

Courier, P. L. *Oeuvres complètes*, Paris, La Pléiade, 1951.

Crémieux, A. *La Censure en 1820 et 1821. Étude sur la presse politique et la résistance libérale*, Abbeville, 1912.

Daumard, A. *La Bourgeoisie parisienne de 1815 à 1848* (École Pratique de Hautes Études. VI section. Centre de recherches historiques. Démographie et sociétés, no. 8), Paris, 1963.

Delteil, L. *Le Peintre-graveur illustré*, vol. 3, Paris and New York, 1969.

Desternes, L. *Paul-Louis Courier et les Bourbons. Le Pamphlet et l'histoire*, Moulins, 1962.

Dupont, A. ed. *Eugène Delacroix. Lettres intimes: Correspondance inédite*, Paris, 1954.

Edwards, E. *Chapters of the Biographical History of the French Academy*, New York, 1864.

Escholier, R. *Delacroix. Peintre, graveur, écrivain 1798–1863*, 3 vols, Paris, 1926–9.

Escholier, R. *Delacroix, citoyen de Paris*, exhib. cat., Paris, 1963.

Eugène Delacroix. Themen und Variationen. Arbeiten auf Papier, exhib. cat., Fankfurt-am-Main, 1987.

Evans, R. L. *Les Romantiques français et la musique* (Bibliothèque de la Revue de littérature comparée, vol. 100), Paris, 1934.

Eymery, A. ed. *Dictionnaire des girouettes ou Nos Contemporains peints d'après eux-mêmes*, Paris, 1815.

Farwell, B. *The Cult of Images. Baudelaire and the Nineteenth-Century Media Explosion*, exhib. cat., Santa Barbara, 1977.

Farwell, B. *French Popular Lithographic Imagery 1815–1870*, 12 vols, Chicago, 1981–

Farwell, B. *The Charged Image. French Lithographic Caricature 1816–1848*, exhib. cat., Santa Barbara, 1989.

Fluchère, H. *Lawrence Sterne: From Tristram to Yorick. An Interpretation of Tristram Shandy*, London, 1965.

French Caricature and the French Revolution 1789–1799, exhib. cat., Los Angeles, 1988.

Gaudibert, P. "Eugène Delacroix et le romantisme révolutionnaire. A propos de la *Liberté sur les barricades*," *Europe*, no. 408, April 1963.

Godéchot, J., Guiral, P. and F. Terrou *Histoire générale de la presse française*, Paris, 1969.

Goldstein, R. *Censorship of Political Caricature in Nineteenth-Century France*, Kent (Ohio) and London (England), 1989.

Gombrich, E. M. *Meditations on a Hobby Horse and Other Essays on the Theory of Art*, London and New York, 1971.

Gordon-Brown, M. *Les Idées politiques et religieuses de Stendhal*, Paris, 1939.

Grand-Carteret, J. *Les Moeurs et la caricature en France*, Paris, 1888.

Guex, J. *Le Théâtre et la société française de 1815 à 1848*, Geneva, 1973.

Guillon, E. *Les Complots militaires sous la Restauration*, Paris, 1895.

Guizot, F. *Shakspeare and his Times*, London, 1852.

Hallam, J. S. *The Genre Works of Louis-Léopold Boilly*, Ph.D. diss., University of Winsconsin, Seattle, 1979.

Harpham, G. G. *On the Grotesque. Strategies of Contradiction in Art and Literature*, Princeton, 1982.

Harisse, H. *L. L. Boilly, peintre, dessinateur et lithographe*, Paris, 1898.

Hatin, E. *Bibliographie historique et critique de la presse périodique française*, Paris, 1866.

Hatin, E. *Histoire politique et littéraire de la presse en France*, 8 vols, Paris, 1859–61.

Hautecoeur, L. "Une Famille de graveurs et d'éditeurs parisiens. Les Martinet et les Hautecoeurs (XVIII et XIX siècles)," *Paris et Île-de-France*, vols 18–19 (1967–8), Paris, 1970.

Hazlitt, W. "On Modern Comedy (1817)," in P. P. Howe ed. *The Complete Works of William Hazlitt*, vol. 4, London and Toronto, 1930.

Hazlitt, W. "Lectures on the Comic Writers etc. of Great Britain (1819)," in P. P. Howe ed. *The Complete Works of William Hazlitt*, vol. 6, London and Toronto, 1931.

Horace Vernet, exhib. cat., Paris and Rome, 1980.

Hugo, V. *Cromwell*, Paris, Garnier, 1968.

Huygue, R. *Delacroix*, London, 1963.

Iknayan, M. *The Concave Mirror. From Imitation to Expression in French Esthetic Theory 1800–1830* (Stanford French and Italian Studies, vol. 30), Saratoga, 1983.

Jardin, A. and A. J. Tudesq *Restoration and Reaction 1815–1848*, Cambridge, New York and Paris, 1983.

146

Johnson, L. *The Paintings of Eugène Delacroix*, 6 vols, Oxford, 1981–.

Jones, L. *Sad Clowns and Pale Pierrots. Literature and the Popular Comic Arts in Nineteenth-Century France*, Lexington (Kentucky), 1984.

Joubin, A. ed. *Correspondance générale d'Eugène Delacroix*, 5 vols, Paris, 1935.

Kayser, W. *The Grotesque in Art and Literature*, New York and Toronto, 1966.

Keyser, E. de "Un Thème de l'imagerie parisienne sous la Restauration. Le Combat des montagnes et la guerre des calicots," *Le Vieux papier*, Paris, 1964.

Kinnaird, J. *William Hazlitt. Critic of Power*, New York, 1978.

Klingender, F. D. *Hogarth and English Caricature*, exhib. cat., London and New York, 1946.

Labourdette, R. ed. *Eugène Delacroix. Journal 1822–1863*, Paris, 1980.

La Combe, J. F. Le Blanc de *Charlet, sa vie, ses lettres suivi d'une description raisonnée de son oeuvre lithographique*, Paris, 1856.

Lamartine, A. de *Histoire de la Restauration*, 8 vols, Paris, 1851.

Laran, J. "Péchés de jeunesse d'Eugène Delacroix," *Gazette des beaux-arts*, 6 series, vol. 3, 1930.

Larousse, P. *Grand dictionnaire universel du dix-neuvième siècle*, 17 vols, Geneva, 1982.

Lauter, P. *Theories of Comedy*, New York, 1964.

Lecomte, L. H. *Histoire des théâtres de Paris 1402–1904*, Paris, 1905.

Lecomte, L. H. *Napoléon et le monde dramatique*, Paris, 1912.

Ledré, Ch. *La Presse à l'assaut de la monarchie 1815–1848*, Paris, 1960.

Lucas-Dubreton, J. *Louvel régicide*, Paris, 1923.

Lucas-Dubreton, J. *Le Comte d'Artois. Charles X, le prince, l'émigré, le roi*, Paris, 1962.

Marchand, J. "Eugène Delacroix, homme de lettres d'après trois oeuvres de jeunesse inédites," *Le Livre et l'estampe*, 19, no. 3, 1959.

Marchand, J. ed. *E. Delacroix. Les Dangers de la cour*, Avignon, 1960.

Martino, P. *L'Époque romantique en France 1815–1830*, Paris, 1944.

Magraw, R. *France 1815–1914: The Bourgeois Century*, New York and Oxford, 1986.

McAllister Johnson, W. *French Lithography. The Restoration Salons 1817–1824*, exhib. cat., Kingston (Ontario), 1976.

McLaren Robertson, D. *A History of the French Academy 1635–1910*, New York, 1910.

McLees Armstrong, A. *Baudelaire's 'Argot Plastique.' Poetic Caricature and Modernism*, Athens (Georgia) and London, 1989.

Mellon, S. ed. *François Guizot. Historical Essays and Lectures*, Chicago and London, 1972.

Mesnard, P. *Histoire de l'Académie française depuis sa fondation jusqu'en 1830*, Paris, 1857.

Moinet, G. M. "La Quête de la comédie chez Stendhal," in "Stendhal et l'Allemagne," *Actes du 13e Congrès International Stendhalien* (Brunswick, Germany, 1978), Paris, 1983.

Mongrédien, J. "A propos de Rossini: Une polémique Stendhal-Berton," in "Stendhal e Milano," *Atti del 14e Congresso Internazionale Stendhaliano* (Milan 1980), Florence, 1982.

Mongrédien, J. *La Musique en France des lumières au Romantisme 1789–1830*, Paris, 1986.

Moraud, M. *La France de la Restauration d'après les visiteurs anglais 1814–1821*, Paris, 1983.

Moreau, A. *Eugène Delacroix et son oeuvre*, Paris, 1873.

Moreau-Nélaton, E. *Eugène Delacroix raconté par lui-même*, 2 vols, Paris, 1916.

Mras, G. *Eugène Delacroix's Theory of Art*, Princeton, 1966.

Muret, Th. *L'Histoire par le théâtre 1789–1851*, 2 vols, Paris, 1865.

Oster, D. *Histoire de l'Académie française*, Paris, 1970.

Partridge, E. *The French Romantics' Knowledge of English Literature 1820–1848*, New York, 1968.

Pernoud, R. *Histoire de la bourgeoisie en France*, 2 vols, Paris, 1960–2.

Piron, A. *Eugène Delacroix. Sa vie et ses oeuvres d'après les souvenirs inédits du baron Rivet*, Paris, 1865.

Polheim, K. K. *Die Arabeske. Ansichten und Ideen aus Friedrich Schlegels Poetik*, Munich, Paderborn and Vienna, 1966.

Porch, D. *Army and Revolution. France 1815–1848*, London and Boston, 1974.

Richardson, N. *The French Prefectoral Corps 1814–1830*, Cambridge, 1966.

Ridge, G. R. *The Hero in French Romantic Literature*, Athens (Georgia), 1959.

Robaut, A. *L'Oeuvre complet de Eugène Delacroix. Peintures, dessins, gravures, lithographies*, New York, 1969.

Romantisme et politique 1815–1851. Colloque de l'École Normale Supérieure de Saint-Cloud (1966), Paris, 1969.

Rosen Ch. and H. Zerner, *Romanticism and Realism. The Mythology of Nineteenth Century Art*, New York, 1984.

Royou, F. *L'Écrevisse ministérielle ou L'Observateur de la Charte. De la marche rétrograde du ministère de 1820*, Paris, 1820.

Rubin, J. H. "Pygmalion and Galatea: Girodet

and Rousseau," *Burlington Magazine*, August, 1985.

Rubin, J. H. *Eugène Delacroix. Die Dantebarke. Idealismus und Modernität*, Frankfurt, 1987.

Sands, P. H. "L. L. Boilly and the Politics of Dress," *Marsyas. Studies in the History of Art*, vol. 22, 1983–5, New York, 1986.

Schiller, F. *Naive and Sentimental Poetry and On the Sublime*, New York, 1966.

Schlegel, A. W. *Cours de littérature dramatique*, 3 vols, Paris and Geneva, 1814.

Schlegel, F. *Dialogue on Poetry and Literary Aphorisms*, University Park and London, 1968.

Schneider, R. *Quatremère de Quincy et son intervention dans les arts (1788–1830)*, Paris, 1910.

Schneider, R. *L'Esthétique classique chez Quatremère de Quincy (1805–1823)*, Paris, 1910.

Seckold, R. A. *Stendhal devant de Romantisme en musique et en littérature*, doctoral diss., Melbourne, 1966.

Sérullaz, M. *Mémorial de l'exposition Eugène Delacroix*, Paris, 1963.

Sérullaz, M. et al. *Musée du Louvre. Cabinet des dessins. Inventaire général des dessins. École française. Dessins d'Eugène Delacroix*, 2 vols, Paris, 1984.

Shikes R. and Heller St. "The Art of Satire. Painters as Caricaturists and Cartoonists from Delacroix to Picasso," *Pratt Graphic Center Print Review*, no. 19, New York, 1984.

Smith, W. *The Nature of Comedy*, Boston, 1930.

Soubiès, A. *Le Théâtre italien de 1801 à 1913*, Paris, 1913.

Souriau, M. *La Préface de Cromwell*, Geneva, 1973.

Spitzer, A. *Old Hatreds and Young Hopes. The French Carbonari against the Bourbon Restoration*, Cambridge, 1971.

Spitzer, A. *The French Generation of 1820*, Princeton, 1987.

Staël-Holstein, G. de *De l'Allemagne*, 2 vols, Paris, Garnier, 1867.

Starobinski, J. *Portrait de l'artiste en saltimbanque*, Geneva, 1970.

Stendhal, *Courrier anglais*, 5 vols, Paris, Le Divan, 1935–6.

Stendhal, *Histoire de la peinture en Italie*, 2 vols, Paris, Le Divan, 1929.

Stendhal, *Mélanges d'art*, Paris, Le Divan, 1932.

Stendhal, *Molière, Shakspeare, la comédie et le rire*, Paris, Le Divan, 1930.

Stendhal, *Pensées. Filosofia nova*, 2 vols, Paris, Le Divan, 1931.

Stendhal, *Racine et Shakspeare*, Paris, Le Divan, 1928.

Stendhal, *Vie de Rossini*, Cercle du bibliophile, vol. 22, Geneva, 1968.

Sterne, L. *The Life and Opinions of Tristram Shandy, Gentleman*, Penguin Books, 1967.

Sterne, L. *A Sentimental Journey through France and Italy*, Penguin Books, 1983.

Stewart, J. ed. *Eugène Delacroix. Selected Letters 1813–1863*, London, 1971.

Talbot, E. *Stendhal and Romantic Esthetics* (French Forum Monographs no. 61), Lexington (Kentucky), 1985.

Terrou, F. *Histoire générale de la presse française*, Paris, 1969.

Tourneux, M. "Croquis d'après nature. Notes sur quelques artistes contemporains par Philippe Burty," *Revue rétrospective*, new series, nos. 103–5, November 1892.

Trapp, F. A. *The Attainment of Delacroix*, Baltimore and London, 1971.

Vaulabelle, A. de *Histoire des deux Restaurations*, 8 vols, Paris, 1858.

Véron, L. D. *Mémoires d'un bourgeois de Paris*, 5 vols, Paris, 1856.

Véron, E. *Eugène Delacroix*, Paris, 1887.

Vidalenc, J. *Les Demi-solde. Étude d'une catégorie sociale*, Paris, 1955.

Vidalenc, J. *Les Émigrés français 1789–1825*, Paris, 1963.

Vidalenc, J. *La Restauration 1814–1830*, Paris, 1966.

Wakefield, D. *Stendhal and the Arts*, London, 1973.

Wakefield, D. "Art Historians and Art Critics: Stendhal," *Burlington Magazine*, December, 1975.

Wechsler, J. ed. "The Issue of Caricature," *The Art Journal*, Winter 1983.

Weinstock, H. *Rossini. A Biography*, New York, 1968.

Whiteley, J. "The Origin of the Concept of 'classique' in French Art Criticism," *Journal of the Warburg and Courtauld Institutes*, 39, 1976.

Woloch, I. *The French Veteran from the Revolution to the Restoration*, Chapel Hill, 1979.

Nineteenth Century Newspapers and Journals Consulted

L'Abeille
Le Conservateur littéraire
Le Constitutionnel
Le Diable boiteux
La Gazette de France
L'Homme gris ou Petite chronique
Le Journal des débats

INDEX